HENRY VIII

IMAGES OF A TUDOR KING

King Henry VIII appreciated Holbein, esteemed him highly, and was glad to have the
great artist with him. Holbein, in the service of the King, made many beautiful
portraits of the King and other persons, which can still be seen in London, as I shall
tell later. The King's affection for Holbein increased, and he favoured him more and
more, as the artist served him so well
according to his wishes.

Carel van Mander, *Schilderboeck* (1604), trans. C. van de Wall (New York, 1936)

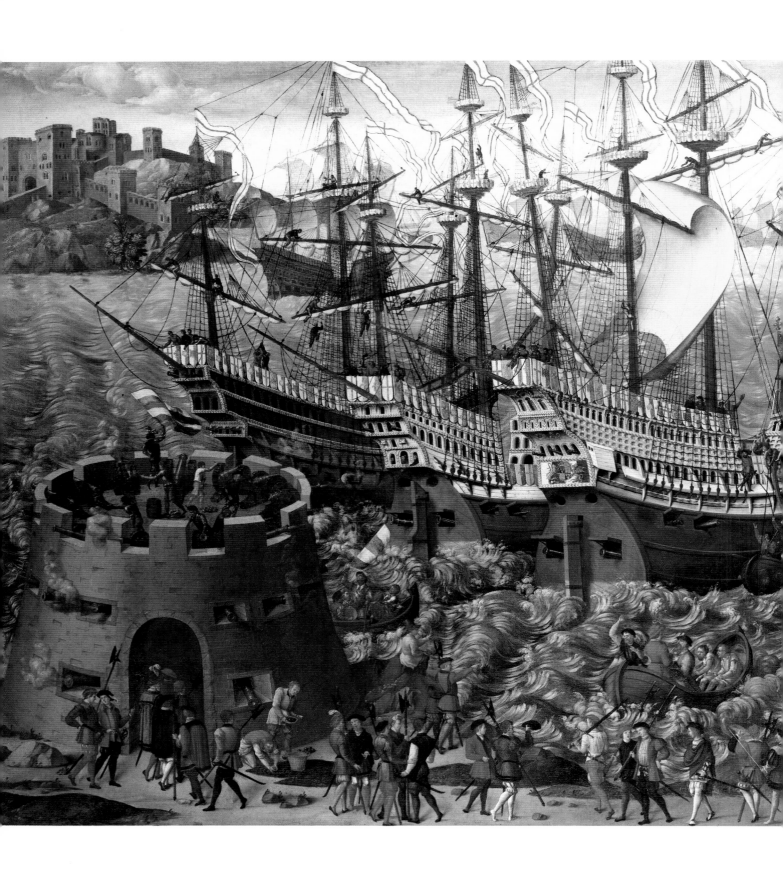

HENRY VIII

IMAGES OF A TUDOR KING

Christopher Lloyd and Simon Thurley

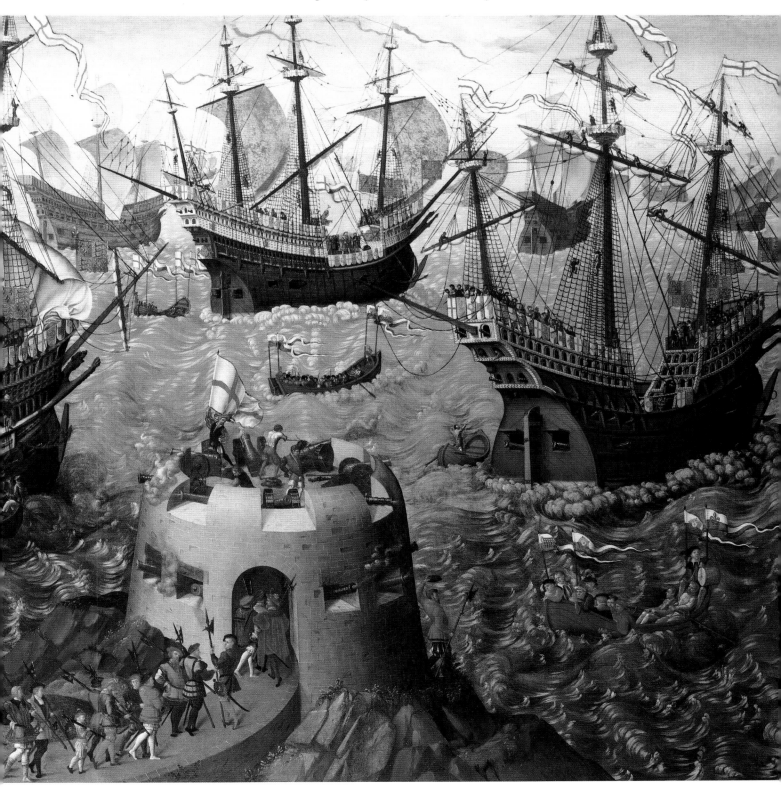

Phaidon Press Limited
Regent's Wharf
All Saints Street
London N1 9PA

First published 1990
Reprinted 1995
© 1990 Phaidon Press Limited
Text © 1990 Christopher Lloyd and Simon Thurley

ISBN 0 7148 2699 5

Printed in Singapore

Title page:
The Embarkation of Henry VIII at Dover
by an unknown artist, c. 1545.
Canvas, 168.9 x 346.7 cm.
The Royal Collection. (Cat. No. 22)

CONTENTS

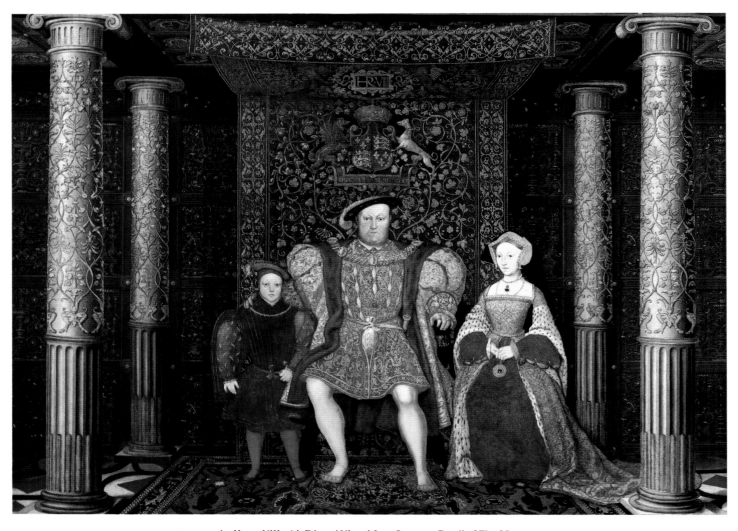

1. *Henry VIII with Edward VI and Jane Seymour*. Detail of Fig. 35

 The inspiration for this publication was provided by the generous loan by Baron Thyssen Bornemisza of the *Portrait of Henry VIII* by Hans Holbein the Younger to Hampton Court Palace for six months, from September 1990 to March 1991. The association of Henry VIII with Hampton Court Palace is well known and it seemed appropriate to honour Baron Thyssen's loan with an exhibition devoted to the reign of this popular Tudor monarch, particularly since the five hundredth anniversary of his birth occurred in 1991. The selection of items from various sources was intended to set Holbein's portrait in its historical context and at the same time to focus on various aspects of Henry VIII's reign, as well as give a brief account of his changing reputation.

Discussion in this book incorporates such issues as Henry VIII's dynastic ambitions, his ecclesiastical and foreign policies, the Tudor court and the development of the antiquarian tradition and popular conception of the king culminating in film and television drama. Works of art in this publication therefore are not only treated as aesthetic objects in their own right, but also as historical evidence.

Hampton Court Palace was severely damaged by fire in 1986 and several of the Tudor paintings from the Royal Collection normally on view there were damaged by smoke and water. Restoration of both the Palace and the works of art has taken several years, but many of the paintings contained in this short book have now been rehung along the Tudor Route opened in 1994 and others can be seen in the Renaissance Galleries.

Christopher Lloyd
London, 1995

1485 Battle of Bosworth, Henry Tudor becomes king.
1486 Henry VII marries Elizabeth of York. Birth of Prince Arthur.
1491 Birth of Prince Henry.
1493 Accession of Emperor Maximilian I.
1497 Birth of Hans Holbein the Younger.
1501 Prince Arthur marries Catherine of Aragon.
1502 Death of Prince Arthur.
1503 Death of Elizabeth of York.
1509 Death of Henry VII and accession of Henry VIII. Henry marries Catherine of Aragon. The *Mary Rose* built.
1512–13 War with France: the siege of Thérouanne, the Battle of the Spurs. War with Scotland: the Battle of Flodden.
1514 Thomas Wolsey becomes Cardinal and Lord Chancellor.
1515 Accession of Francis I of France.
1516 Birth of Princess Mary (future Mary I).
1518 Treaty of London.
1520 Field of the Cloth of Gold.
1521 Henry VIII is awarded the title *Fidei defensor*.
1525 Battle of Pavia. The Hornebolte family arrives in England.
1526 Hans Holbein the Younger visits England (until 1528).
1529 Wolsey is deprived of the Great Seal. Thomas More is appointed Chancellor.
1530 Death of Wolsey at Leicester Abbey.
1531–2 Henry separates from Catherine of Aragon in favour of Anne Boleyn. Convocation acknowledges Royal Supremacy. More resigns as Chancellor. Holbein moves to England permanently.
1533 Thomas Cranmer becomes Archbishop of Canterbury. Henry's marriage to Catherine is dissolved and his marriage to Anne Boleyn is acknowledged. Birth of Princess Elizabeth (future Elizabeth I). Appeals to Rome are abolished by statute.
1534 Abolition of papal authority in England. Act of Supremacy. Act of Succession. Execution of Thomas More and John Fisher.
1535 Publication of the Coverdale Bible.
1536 Henry's marriage with Anne Boleyn is dissolved; Anne is beheaded. Catherine of Aragon dies. Dissolution of smaller monasteries. Henry marries Jane Seymour.
1537 Jane Seymour dies giving birth to Prince Edward (future Edward VI). Holbein paints *The Whitehall Mural*.
1538 The Great Bible is issued, in English.
1539–40 Henry marries Anne of Cleves. The greater monasteries are dissolved.
1540 Henry's marriage with Anne of Cleves is annulled. Attainder and execution of Thomas Cromwell. Henry marries Catherine Howard.
1542 Catherine Howard is beheaded.
1543 Henry marries Katherine Parr.
1544 War with France: the siege of Boulogne.
1545 Death of Holbein. The *Mary Rose* sinks during a French attempt to invade England.
1547 Death of Henry VIII and accession of Edward VI.
1553 Edward VI dies and is succeeded by Mary I.
1558 Death of Mary I and accession of Elizabeth I.
1588 The Spanish Armada.
1603 Death of Elizabeth I: the end of the Tudor monarchy.

The Tudor Dynasty and the Church

Such was the professionalism with which the Tudor dynasty forged an image of success and power for itself that today, five hundred years on, it is the image of Henry VIII and Elizabeth that dominate the popular conception of the English monarchy. The image of Queen Elizabeth has received intense scholarly scrutiny;[1] it is the purpose of this essay to provide an introduction to the evolving image of Elizabeth's father, Henry VIII.

An important part in the canonization of the Tudors was played by Shakespeare, who, by denigrating Richard III and extolling Henry Tudor and subsequently his son Henry VIII, set the eulogistic tone of historians for centuries to come. Shakespeare's history plays are the culmination of a concerted campaign by the Tudors to publicize the legitimacy and strength of their dynasty, a campaign which was started by Henry VII after his victory at Bosworth in 1485.

Henry VII had a pressing need to project himself as the legitimate king of England. Although undisputed king by right of his victory on the battlefield, his claim to the throne was scarcely better than that of his predecessor, Richard III (Fig. 9). Henry's few drops of royal blood came from his mother, Lady Margaret Beaufort, and his position as

2. Henry VII's Chapel in Westminster Abbey, built in 1503–12.
The chapel, with Henry VII's tomb in the centre, is perhaps the
epitome of Tudor architectural propaganda. Every feature is adorned
with badges and emblems relating to the Tudor dynasty.

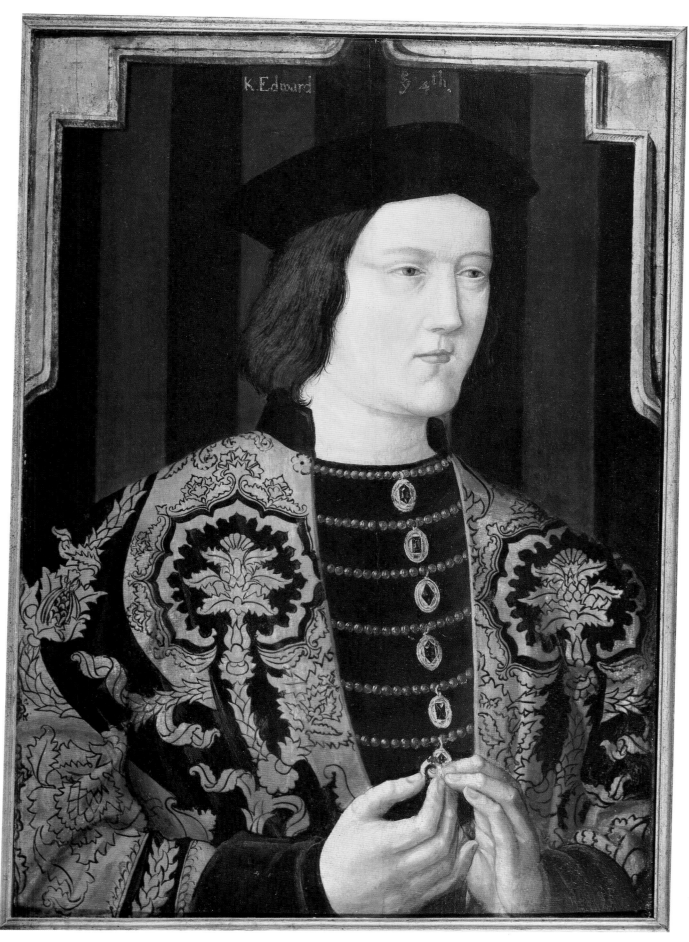

3. *Edward IV* by an unknown artist. *c*.1520. Panel, 67.9 x 47.9 cm. The Royal Collection

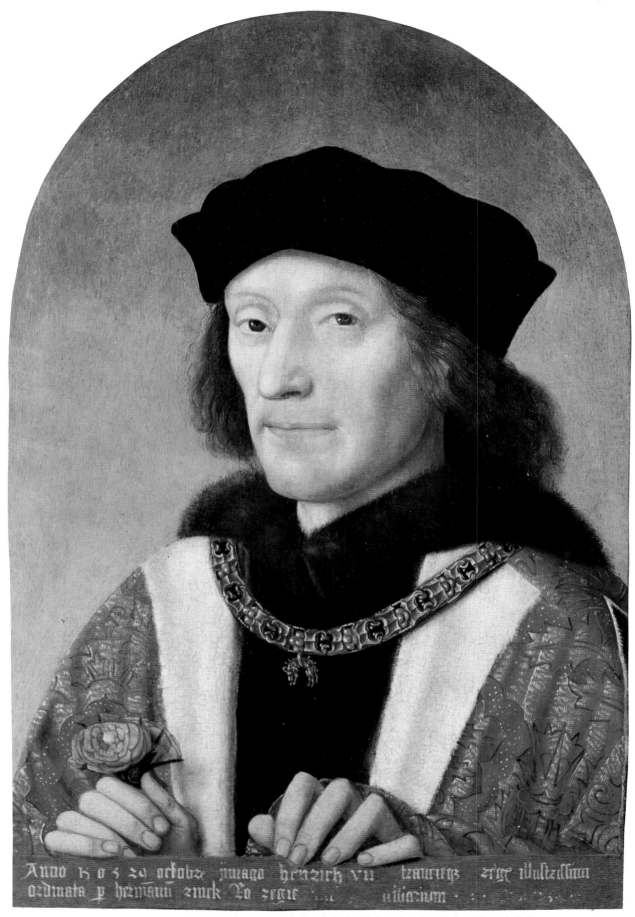

4. *Henry VII*, attributed to Michael Sittow. 1505. Panel, 42.5 x 30.5 cm. London, National Portrait Gallery

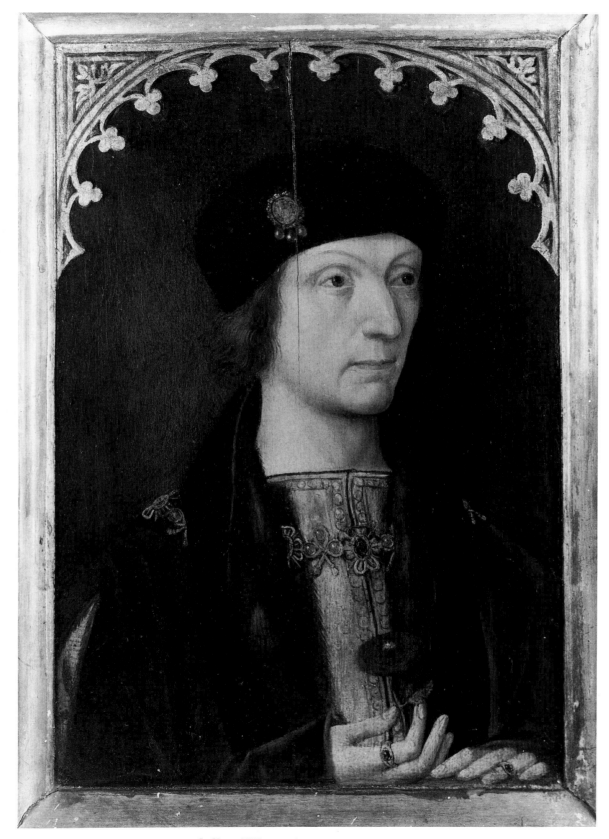

5. *Henry VII* by an unknown artist. *c*.1490–1500.
Panel. London, Society of Antiquaries

6. *Arthur, Prince of Wales* by an unknown artist. *c.*1500.
Panel, 39.1 x 28 cm. The Royal Collection.

7. *Elizabeth of York* by an unknown artist. *c.* 1502.
Panel, 38.7 x 27.9 cm. The Royal Collection

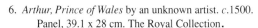

Lancastrian heir was fairly tenuous. Henry therefore needed to create a convincing image of kingship which stressed his legitimacy and his fitness for the task.

There were three elements in the image-making process undertaken by the first Tudor. First, there was a concerted attempt to legitimize his dynastic position in terms of his descent. Second, there was the process of legitimizing his position by achieving recognition by the Church. Finally, there was the projection of the king as a *magnificent* prince fit to rule his people. The machinery of royal image-making was in the hands of painters, stonemasons, illuminators, poets and historians; it was these men who had the initial task of forging what we would today call the Tudor corporate image.

HENRY VII AND HIS DYNASTY

In the last scene of Shakespeare's *Richard III* Henry Tudor proclaims, 'As we have ta'en the sacrament, we will unite the white rose and the red: smile, heaven, upon this fair conjunction.' Henry Tudor and Elizabeth of York, the heirs of the houses of Lancaster and York respectively, were to marry and thus unite the two warring houses which had 'made poor England weep in streams of blood'. Not only were the houses unified, so also were their symbols, the red and white roses, to produce the most enduring symbol of Tudor monarchy.

The Tudor rose became an image of Tudor kingship, and both Henry VII and Henry VIII employed it extensively. It was most visible architecturally, in badges, mottoes and heraldry which formed an outer crust of propaganda upon the shell of a building. Henry VII's Chapel at Westminster, for instance, leaves the visitor in no doubt as to the security and permanence of the Tudor dynasty (Fig. 2). King's College Chapel, Cambridge, likewise displays the Tudor badge in a totally unashamed attempt at dynastic glorification.

Nearer to the king's person, his palaces reverberated with the red and white rose. Fig. 8 shows badges made for Henry VIII in 1535 and used as an adornment on the ceiling of the Great Watching Chamber at Hampton Court. Elsewhere in the palace the Tudor badge appears in stained glass, tapestry,

stone and terracotta; it became, in effect, the logo of the Tudor dynasty. In portraiture the rose is equally prominent. The canopies in *The Family of Henry VII with St. George and the Dragon* (Fig. 11) are adorned with roses, and they appear in different combinations in the portraits of Henry VII, Elizabeth of York, and Arthur the Prince of Wales (Figs. 5–7).

The portraits of Henry and his family were, however, more than expressions of his dynastic position, they were also projections of his *magnificence*. The concept of *magnificence* is central to an understanding of the status of the king in early Tudor England. Sir John Fortescue (d. ?1476) in *The Governance of England* had set forth the rules of kingship, amongst which *magnificence* is the foremost:

> Item it shall need that the king have such treasure as he may make new buildings when he will for his pleasure and magnificence; and as he may buy him rich clothes, rich furs, rich stones and other jewels and ornaments convenient to his estate royal. And oftentimes he will buy rich hangings and other apparel for his houses... for if a king did not so, nor might do, he lived then not like his estate, but rather in misery, and in more subjection than doth a private person.[2]

According to Fortescue, then, *magnificence* was the art of giving lavish physical and public expression to status and power. One of Henry VI's failings had been an inability to create the necessary magnificence to give his kingship credibility. Henry VII, by contrast, clearly understood that the illusion of power, wealth and status was as important as the real thing. In his will he directed that his newly finished chapel at Westminster should be painted with 'our armes, badges, cognisants, and other convenient painting', not because 'such a work requireth' such embellishment, but, more importantly, because such lavish decoration 'to a king's work appertaineth'. In other words, Henry commanded that the chapel should be gilded and painted because it was a

royal building and, as such, it merited particularly magnificent treatment.[3]

The concept of *magnificence* as practised in late fifteenth- and early sixteenth-century England was introduced from the court and dominions of the Duke of Burgundy. After 1460, Edward IV had renamed the two principal departments of the royal household, following Burgundian practice. He called them the *House of Providence*, which was the kitchens and serving quarters, and the *House of Magnificence*, which was the part of the household inhabited by the king. It was the job of the House of Providence to facilitate the *magnificence* of the rest of the court.[4]

This was accomplished in the provision of enormous and lavish feasts, but also in the artistic outpourings of the king's craftsmen. Edward IV's deliberate construction of *magnificent* surroundings began a revival in the artistic life of the court. Suitably, many or most of the artists involved in this revival came from Flanders, and some from the court of Burgundy itself. Flemish tapestries and manuscripts were acquired by the king, and his palaces reflected the architectural tastes of the Burgundian court. An early, very possibly contemporary, portrait of Edward IV also displays a markedly Flemish handling (Fig. 3).[5] Edward's pose, well forward in the composition, his hands resting on a ledge, echoes portraits from the Burgundian court by artists such as Rogier van der Weyden .[6]

PORTRAITS OF HENRY VII

Henry VII's use of portraits differed little from that of his immediate predecessors. Fifteenth-century kings produced portraits to show foreign courts what they and their families looked like, and for the home market, to advertise themselves or commemorate their forebears. The exchange of portraits during international marriage negotiations was possibly their

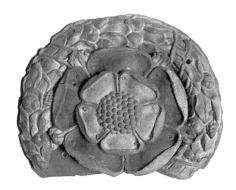

8. Roundels from the ceiling of the Great Watching Chamber, Hampton Court Palace. 1535. Leather maché, diameter 35.5 cm.
(Cat. No. 6)
The palaces of both Henry VII and Henry VIII were adorned with heraldic devices. In the case of Henry VIII these had to be altered at the advent of each new wife.

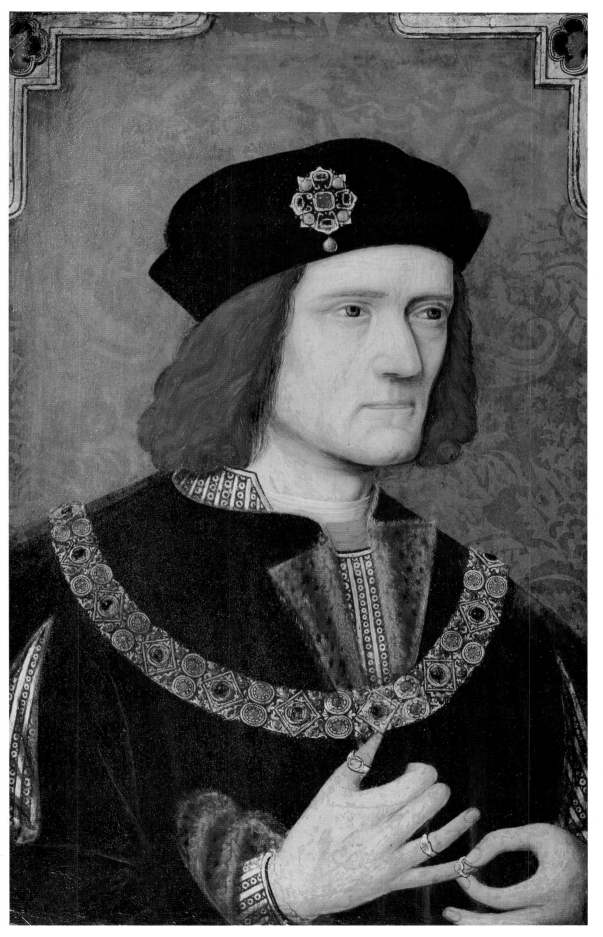

9. *Richard III* by an
unknown artist. *c*.1520.
Panel, 56.5 x 35.6 cm.
The Royal Collection.
(Cat. No. 2)
This portrait was altered
at an early date to give
the impression that
Richard III was
hunchbacked. It is an
example of the Tudors'
straightforward attitude
to dynastic propaganda.

most common use. In 1442, for example, Henry VI sent 'Hans the Painter' to the court of the Count of Armagnac to paint one of the count's daughters whom he was thinking of marrying.[7]

Most of the surviving portraits of Henry VII and his family are probably related, in one way or another, to diplomatic gifts.[8] The first record of such a gift in Henry's reign dates from 1496 during the visit of the Flemish ambassadors negotiating the treaty subsequently known as the *Magnus Intercursus*. It seems that the ambassadors brought with them portraits of the Duke and Duchess of Burgundy, as a gift for the king.[9] We know nothing of Henry's response to this gift or whether he had portraits of himself with which to reciprocate.

The first important artist of the Tudor court who certainly painted the king was Maynard Werwick. Maynard is first named in the royal chamber accounts in March 1505, when he is described as 'the king's painter'.[10] Yet it is certain that he was working for Henry VII long before then, for during marriage negotiations on behalf of the king's daughter Margaret in 1502 he was sent to James IV of Scotland with portraits of the king, his queen and Arthur, Prince of Wales.[11]

Unfortunately, no portrait of the king by Maynard survives, but two groups of near contemporary portraits, one in the Royal Collection and the other in the Society of Antiquaries, do depict Henry VII and his family (Figs. 5–7). The images preserved in these paintings almost certainly reflect the 'standard' royal portrait types produced by Maynard or his contemporaries.[12] In the painting of Henry VII, as in those of his wife and Prince Arthur, the formula of an earlier portrait of Edward IV (Fig. 3) has been followed. The king's hands rest on a ledge at the front of the composition and he looks out to one side. He is splendidly dressed, and in his hands he holds a red rose, while his wife holds a white rose and Prince Arthur wears a Garter chain of a new design on which the roses are conjoined.

One further dynastic portrait of Henry VII survives: the portrait usually attributed to Michael Sittow, which is now in the National Portrait Gallery (Fig. 4). It is interesting, not only for its high quality, but also because its purpose and date are fully recorded. After the death of Elizabeth of York in 1503, Henry began to search the international marriage market for a second wife. This search inevitably involved the exchange of portraits.

In 1504 Henry's interest turned to the Queen Dowager of Naples and led to the order for 'a picture of the said queen portraying her figure and the features of her face, painted on canvas'. This seems to have come to nothing, and the

following year Henry began negotiations for the hand of Margaret of Austria, daughter of the emperor Maximilian. The Spanish Ambassador reported in 1505 that the emperor had sent two pictures of Margaret to Henry. Maximilian's ambassador, and the carrier of the portraits, was a man named Hermann Rinck, and the 'Sittow' portrait of Henry is inscribed with a text stating that it was ordered by Rinck in October 1505. The obvious inference is that whilst he was in England Rinck had Henry painted for the emperor or the duchess as an exchange for the portraits he had brought.[13]

The image of Henry VII on the 'Sittow' portrait, being the product of a request by a foreign ruler, provides an international context for the standard English image of the king (Fig. 5). The surviving portrait types of Henry VII made mostly for the international marriage and diplomatic market adopted the standard image of a northern European ruler and offer a direct link with the Holbein portrait of Henry VIII discussed below (Fig. 69 and pp. 69–76).

HENRY VII AND THE CHURCH

All the portraits discussed so far were made for the limited purpose of furthering the king's dynastic and diplomatic position abroad. An important part of a king's standing in the national and international establishment was his acceptance by the Church. Traditionally, new rulers placed themselves and their dominions under papal protection, and beneath their crowns princes wore the cap of maintenance, a symbol of their fealty to the Pope. The Pope also presented the ruler with a sword as an indication that temporal power was given from above. Henry subscribed to these traditions, and two years after papal acceptance of Henry's title in 1486 the cap and sword of maintenance were presented to him.

Henry's position as a Catholic prince was expressed by portraying the king as a devout and faithful servant of the Church. This was achieved iconographically through the use of traditional medieval images such as those of Edward IV's daughters kneeling in the west window of the north transept of Canterbury Cathedral. In 1501–2 Henry gave a new east window to the Benedictine Priory at Great Malvern, Worcestershire. In it the king, queen and Prince of Wales were depicted kneeling at the foot of the window, which mainly contained scenes from the *Magnificat*. This devotional scene was duplicated in the window originally intended for Henry VII's Chapel in Westminster Abbey but now in St. Margaret's Church, Westminster (Fig. 10). The main lights contain a crucifixion scene, the panels either side containing the figures of the Prince of Wales and his wife Catherine of Aragon kneeling beneath patron saints.[14]

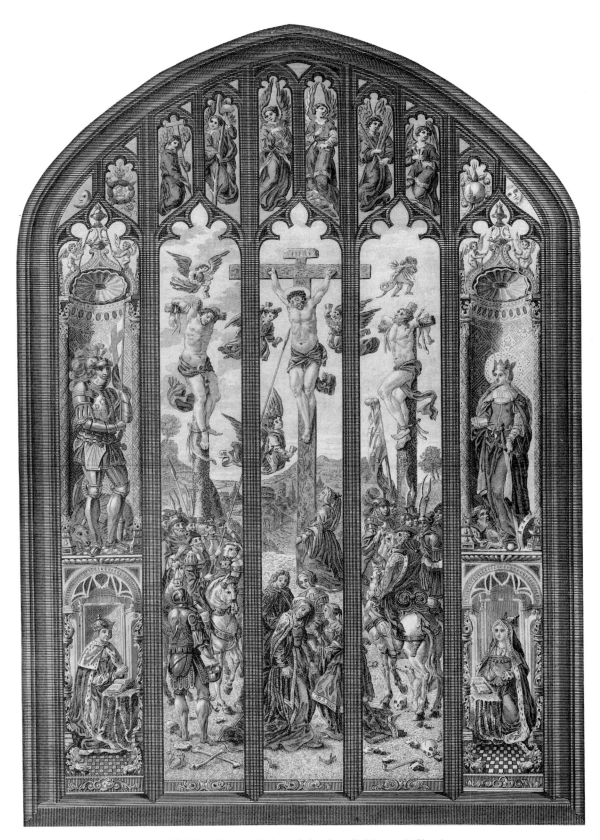

10. Print of a stained-glass window from St. Margaret's Church,
Westminster, originally made for Henry VII's Chapel,
Westminster Abbey.

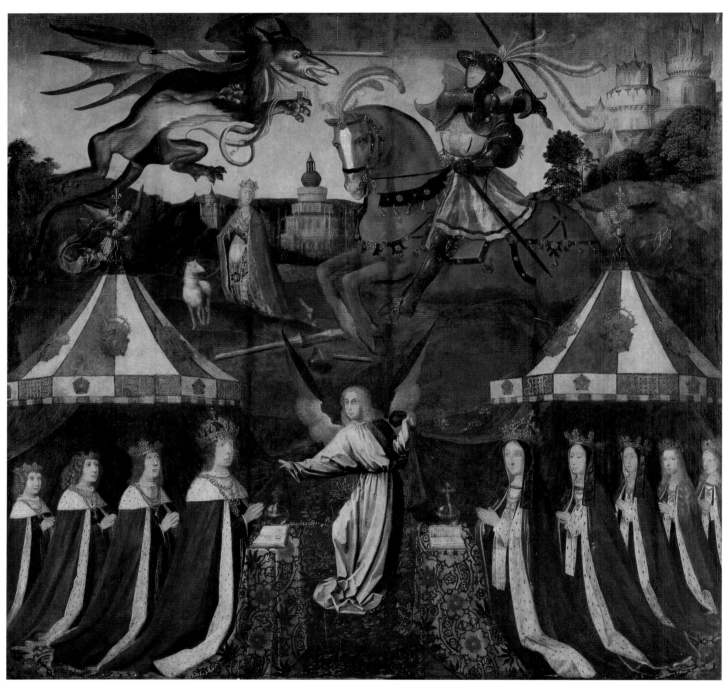

11. *The Family of Henry VII with St. George and the Dragon* by
an unknown artist of the Flemish school. *c*.1505–9.
Panel, 142.2 x 146.1 cm. The Royal Collection

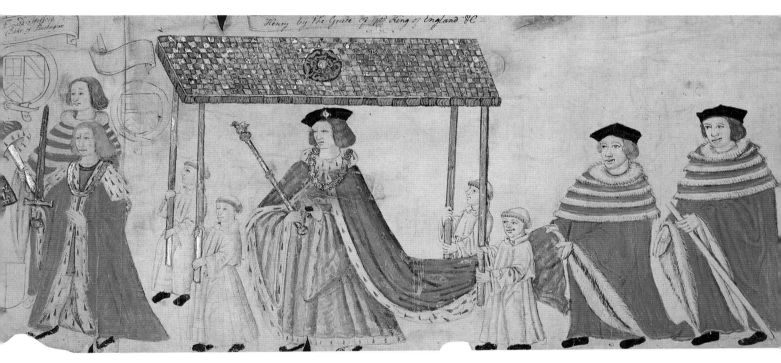

12. *The King Processing to Parliament*. 1512. Detail from a
parchment roll, height 27.4 cm. Cambridge, Trinity College
Beneath the canopy is Henry VIII. The Duke of Buckingham
carries the cap of maintenance and his son Lord Stafford carries
the sword. At the rear is the Earl of Oxford, carrying the staff of
the Lord Great Chamberlain.

In the field of painting, only one specifically religious portrait survives from Henry VII's reign, namely *The Family of Henry VII with St. George and the Dragon* (Fig. 11), now at the Palace of Holyroodhouse. It has been suggested that this painting was intended as an altarpiece connected with the palace or monastery at Richmond.[15] There are two points to be noted about the image of the king. First, is the extreme conventionality of the position of Henry and his family. It is entirely in the same tradition as the windows described above – votive figures kneel before their patron saint. There is little to distinguish their devotional posture from that adopted by Richard II in the famous Wilton Diptych in the National Gallery, London. Henry assumes the conventional role of the English king, a monarch under the protection of the saints and angels and, by inference, that of the Church.

Yet there is another aspect to the painting. Above the heads of the royal family rages a battle as unconventional in its composition as the lower part is predictable. Instead of St. George triumphing over a defeated dragon as in conventional iconography such as Raphael's *St. George and the Dragon* (Fig. 13) or the St. George in St. Margaret's Church, Westminster (Fig. 10), the dragon descends on the saint from the air, eyes flashing and claws extended. St. George, his lance broken, slashes at the dragon, visor up. The dynamism of the scene above contrasts sharply with the passive vision below, and this reinterpretation of the conflict itself reinterprets the position of the king. The established iconography of St. George is the triumph of holiness over evil, but in the Henry VII altarpiece the result, while not seriously in doubt, is still undecided. St. George, disadvantaged by the loss of his lance, faces the monster undaunted; it is an image of the knight facing adversity with equanimity. A purely religious image has been transformed into a chivalric one where the bravery of the knight is more important than his eventual victory.

The introduction of the ideal of knightly chivalry provides a direct link with the Order of St. George founded by Edward III and revived under Edward IV and Henry VII. The revival of the order in England was paralleled by the creation in Burgundy in 1430 of the chivalric Order of the Golden Fleece. This revival of interest in ancient chivalric orders was closely linked to the idea of *magnificence*. The *magnificent* prince was also a knight, with all the duties and responsibilities which that implied. The portrayal of St. George in *The Family of Henry VII* (Fig. 11) reinterprets both the significance of the saint and the position of the king. Although Henry's piety is stressed, the presence of the chivalric St. George provides a further link with the king's newly formed image of princely *magnificence*.[16]

In addition to the surviving religious images of the king there were those which adorned the ephemeral pageants which accompanied many of the great state occasions of the reign. No pictorial record survives of these pageants, which adopted a series of subtle interpretations of the king's position in relation to the Church, the saints and Old Testament figures. Most of the pageants were devised for the various civic entries made by Henry VII whilst on progress, but there were also those prepared for the reception of Catherine of Aragon in 1501. These are known to us from the surviving record of the verses used to explain each pageant. One of the verses prefigures in an uncanny way the position that Henry VIII was to adopt after the Reformation:

> And Right so as our Soverain lord the king
> May be resembled to the king Celestial
> As well as any prince erthley now living...
> As he whom it has pleased God to accept and call...
> Most Christian king and most steadfast in the faith

The verse compares the king of England and God, a theme to be developed in the following reign, but one which in 1502 had none of the anti-papal sentiments which it was to acquire. The reference alludes to Henry's championship of the Church, as evinced by his receipt of the sword and cap of maintenance. His God-like qualities are therefore derived from his protection of Christ's flock on earth and not, like Henry VIII's, from his direct relationship with God.[17]

Portraits of Henry VII therefore served three carefully defined purposes. First, single portraits were produced specially as gifts for foreign princes, to put a human face to diplomatic bargaining and to impress by their *magnificence*. Second, these portraits also served to proclaim the legitimacy of the Tudor dynasty by making connections with the past and stressing current dynastic ties. Finally, images of the king were employed in a religious setting, where the king's position was legitimized by his relationship to God and the Church.

This fairly limited use of royal iconography, widely paralleled throughout the Middle Ages across Europe,[18] was vastly expanded in the reign of Henry VIII, when religious, political and intellectual upheaval required the mobilization of all forms of imagery on the king's behalf.

HENRY VIII AND THE CHURCH

The reign of Henry VIII (1509–47) saw the first concerted effort by an English king to create a popular image of himself. After 1530 and the acts of the Reformation Parliament the whole idea of medieval kingship was overthrown, as the monarch's relationship with the Church, God and his people was reassessed. The political, intellectual and spiritual reassessment of the king's position required a

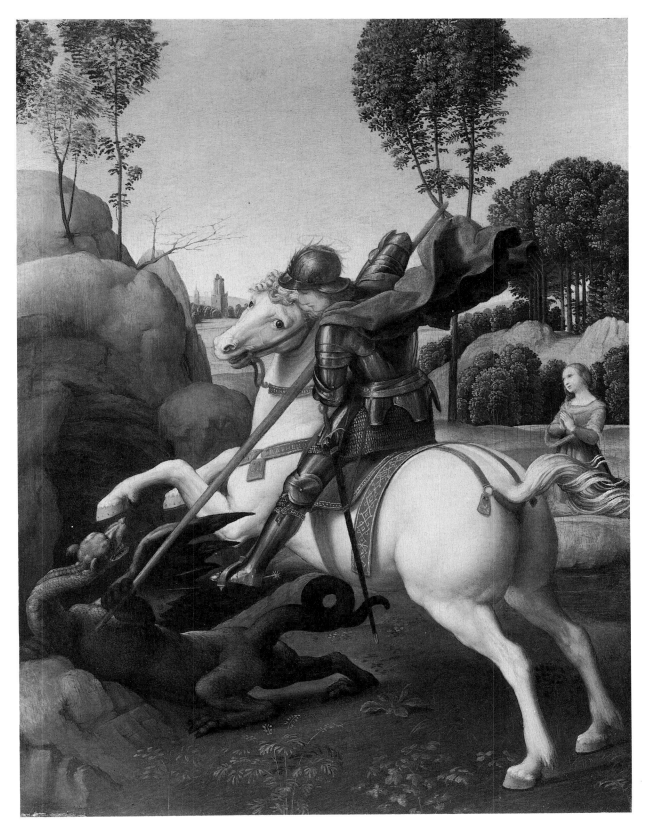

13. *St. George and the Dragon* by Raphael. *c*.1505.
Panel, 29 x 21 cm. Washington, D.C., National Gallery of Art

15 (above). *The Whitehall Mural (Henry VII, Elizabeth of York, Henry VIII and Jane Seymour)*, a copy by Remigius van Leemput after Hans Holbein the Younger. 1667.
Canvas, 88.9 x 98.7 cm. The Royal Collection. (Cat. No. 14)

14 (left). *Henry VII and Henry VIII*.
Fragment from the cartoon for
The Whitehall Mural by Hans Holbein the Younger. 1537.
Drawing mounted on canvas, 257.8 x 137.1 cm.
London, National Portrait Gallery

16. *The Coronation of Henry VIII* from Stephen Hawes,
*A Joyfull Medytacyon.... c.*1510.
Woodcut. Cambridge, University Library

new iconographical type to be produced. The production of a new iconography of kingship coincided with the arrival of influences from Renaissance Italy, which by the end of Henry's reign had combined to form an image of kingship which was to endure for at least a century.

It was not only the radical nature of the new iconography of kingship which was remarkable. Equally important was the adoption of such a wide range of media with which to express it. The newly fashioned image of Henry VIII was not confined to court circles, nor even to the wealthy and literate upper classes, but was diffused with unprecedented breadth throughout the country at large. This was made possible by the recently developed media of the printing press and the woodcut. For the first time both text and images could be quickly and cheaply produced on a large scale, a development which the Henrician propagandists were quick to exploit.

In the early part of Henry's reign, until about 1530, the themes which we have identified in the reign of Henry VII continued to dominate the king's image-making. Henry VIII's dynastic position was far more secure than that of his father. He had inherited the throne as Prince of Wales, almost out of his minority and in full health. There was no need to enlist artists and craftsmen to legitimize his position.

However, as we shall see, they were enlisted to legitimize the position of his son, the future Edward VI.

In his early years as king, Henry VIII's religious orthodoxy was the most notable feature of his attitude towards Rome. As his father had done before him, he claimed the cap and sword of maintenance and in addition was given a golden rose by the Pope. A roll of parchment illustrating the procession to Parliament in 1512 shows the Duke of Buckingham carrying the cap and his son Lord Stafford carrying the sword before the king (Fig. 12). An even clearer statement of Henry's relationship to the Church can be seen on a woodcut from Stephen Hawes's pamphlet *A Joyfull Medytacyon to all Englonde of the coronacyon of our moost naturall soverayne lorde kinge Henry the Eyght*, dating from about 1510 (Fig. 16). It shows the coronation of Henry and Catherine of Aragon, who are being crowned by two archbishops and are surrounded by clergy, stressing the fact that Henry's temporal authority stemmed from that which the Church had itself received from God. This image has countless medieval parallels, for instance, those of Figs. 17 and 29.

The king's enthusiasm for ecclesiastical recognition was further displayed by his quest for a papal title. The kings of France and Spain had been given the titles *Most Christian*

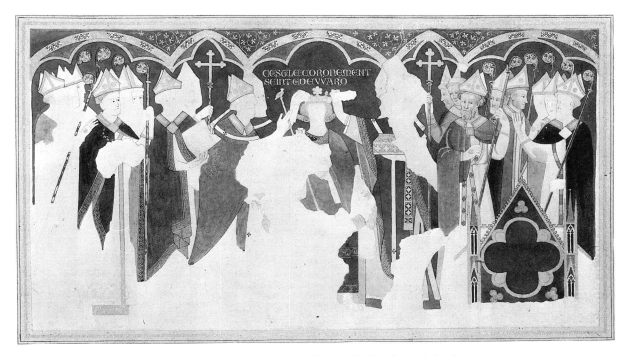

17. *The Coronation of St. Edward*, a copy by C.A. Stothard after the
mural in the Painted Chamber, Westminster Palace. 1819. Watercolour,
18.3 x 33 cm. London, Society of Antiquaries
King Edward the Confessor is crowned by the archbishops Aelfric of York
and Eadsige of Canterbury, who are surrounded by other ecclesiastics.

King and *Most Catholic Majesty* respectively, and it was Henry's earnest ambition to be likewise recognized. Henry's book, *Assertio septem Sacramentorum*, written with the encouragement and co-operation of Cardinal Wolsey, had by 1521 won the king the title of *Defender of the Faith*. This religious orthodoxy and enthusiasm were reflected in traditional iconographic modes. Two series of stained-glass windows, neither of which was strictly a royal commission, but both closely connected with the king and queen, show the continuity of the medieval tradition of royal piety: the chapel windows at the Vyne, Hampshire, and those at Hampton Court, made in Wolsey's time. Both show Henry and Catherine of Aragon kneeling at the foot of crucifixion scenes.[19]

The momentous parliamentary acts of 1529–39 radically altered the nature of kingship in England. Not only was the traditional relationship between the king and the Pope rejected but the nature of the king's civil powers was altered to accommodate and enforce his new spiritual position. The consolidation of this new position was achieved by a carefully orchestrated and skilfully executed image-making operation.

The Henrician legislation of the 1530s struck a series of blows against the medieval conception of the king. Between 1529 and 1531 the Reformation Parliament confined itself to dealing with the practical problems of abolishing abuses in the Church. This was followed in 1532 by the act known as *The Submission of the Clergy*, the first shift in the king's position, when the clergy were forced to recognize that their authority was at the king's pleasure. The second, more radical shift came the next year with the *Act in Restraint of Appeals*, which declared that England was a sovereign state and that its king owed no submission to any other human ruler. These two acts fundamentally altered the relationship of Church and State in England and from 1534 the king's chief minister, Thomas Cromwell, and his archbishop, Thomas Cranmer, began to build a new edifice upon the remains of the old Church-State relationship.

The rebuilding of the relationship between Henry and the English Church was even more radical than its demolition. Between 1534 and 1539 the king's powers were extended far beyond anything an English king had ever wielded. By the *Act of Supremacy* the king took on a spiritual function as head of the Church rather than merely the role of protector. The act transferred to the king full ecclesiastical jurisdiction over the Church in England. The final blows were delivered in 1539 when a series of measures drastically extended the power of king and council so that the king's proclamations acquired the same weight as an act of parliament. He was

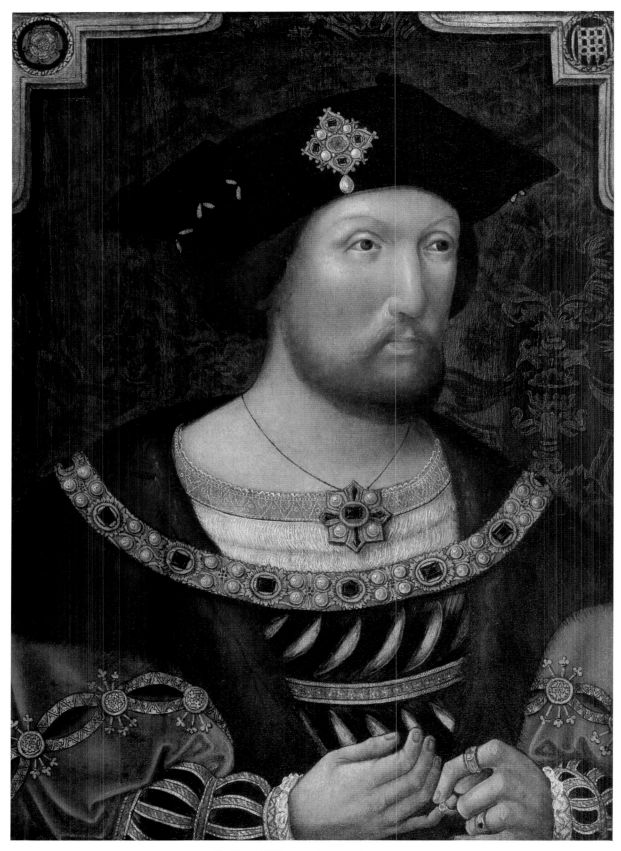

18. *Henry VIII* by an unknown artist. *c*.1520.
Panel, 50.8 x 38.1 cm.
London, National Portrait Gallery

19. *Solomon and the Queen of Sheba* by Hans Holbein the
Younger (enlarged). *c*.1535. Vellum, 22.7 x 18.3 cm.
Windsor Castle, The Royal Library

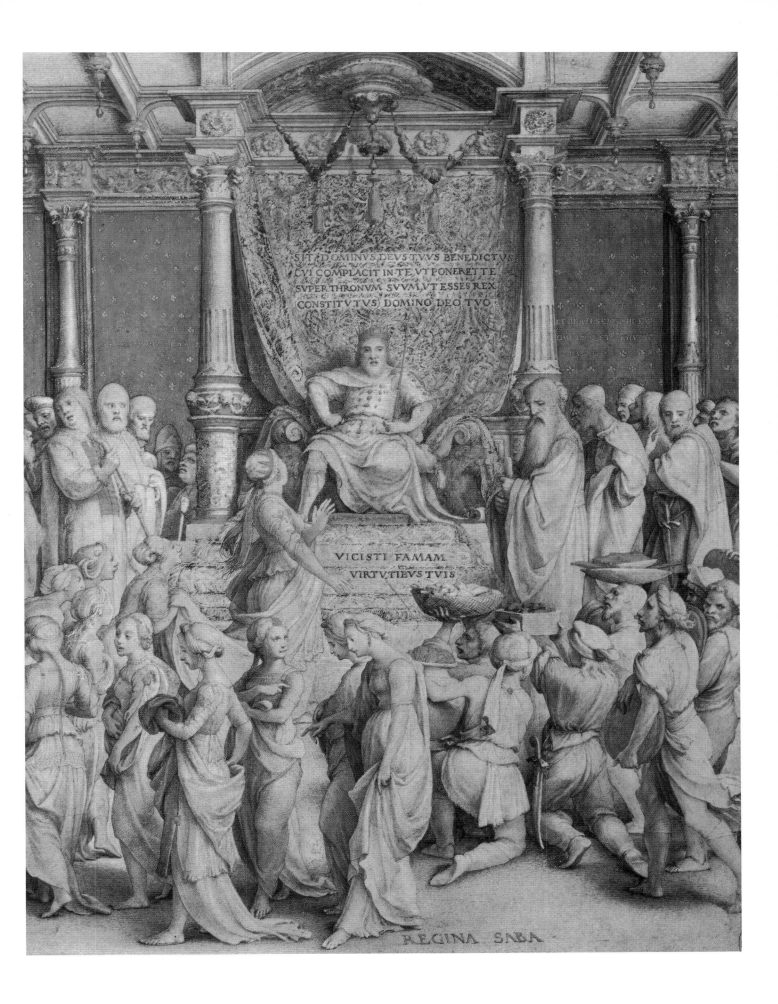

now empowered to create new bishoprics and to make doctrinal decrees.

Thus, by the end of the 1530s the king of England was not only supreme head of the Church, but had vastly increased spiritual and secular powers to enforce and maintain his position.[20] This political, religious and theoretical alteration in the nature of kingship caused an iconographical revolution. An entirely new image of the king was forged which left behind the images of Henry VII and those of the early part of Henry VIII's reign.

HOLBEIN'S IMAGE OF HENRY VIII

Portraits of Henry early in the reign followed the formula adopted by both Edward IV and Henry VII. The National Portrait Gallery painting of *c*.1520 (Fig. 18) shows the king looking outwards, sideways, his hands clasped in front nervously playing with a finger ring. The artist of this particular image is unknown, but from *c*.1525 an identifiable workshop was producing portraits of Henry and his family with great energy.

The Hornebolte family – the father, Gerard, his son Lucas and his daughter Susanna – arrived in England in about 1525, and in due course both father and son were directly employed by the king. Between 1525 and 1543 seventeen portrait miniatures of Henry and his family can be attributed to the Horneboltes, the majority of them being painted before 1535.[21] The purpose of the miniatures once more seems to have been to serve as diplomatic gifts, but they were also distributed to members of Henry's court.[22] The image of the king, especially on one of the miniatures in the Royal Collection (Fig. 99), is very similar to the National Portrait Gallery picture (Fig. 18). Together, the work of the Horneboltes represents the first important pre-Holbein series of portraits in the reign of Henry VIII.

Other than the miniatures (Figs. 98–9) no further pre-Reformation portraits survive of Henry, possibly by coincidence, but more likely because very few were painted. By contrast, from about 1532 there is a very large number of paintings of the king. This is almost certainly due to the fact that the revolutionary events of the Reformation generated a new image of Henry which was circulated to those who supported his position. Possession of a royal portrait indicated loyalty to the cause.

A critical figure in the production of the new image of the king was Hans Holbein the Younger. Holbein had first visited England from his native Germany in 1526, but he had not worked for the king. He returned to England in 1532, escaping from the violence of the continental Reformation and arriving in time to play an important part in the English one. In Holbein the king found someone more talented than the Horneboltes, someone who was capable of creating a new image of kingship for him. The images which Holbein produced were so powerful and successful that by the end of the reign they had penetrated all spheres of royal iconography.[23]

The only painting of Henry to survive which is certainly by Holbein is the portrait painted in about 1536, now in the Thyssen Collection (Fig. 69). In it the Henry of the National Portrait Gallery painting of *c*.1520 (Fig. 18) has been transformed. No longer is the king a nervous, round-shouldered young man avoiding the eye of the spectator. Holbein's Henry thrusts himself out of the picture towards the onlooker, his broad shoulders fill the frame and his hands hold a glove.

Henry's face, characterized by its squareness and flatness, was, as we shall see, transmitted to all subsequent images of the king, the most important of which, begun the following year, was the so-called *Whitehall Mural*.[24] The mural was painted at Henry's principal palace at Whitehall, and it involved the creation not only of a new facial image of the king, but of a full-length representation, in a pose which dominated royal portraiture for the next century.

The mural was destroyed when Whitehall Palace was burnt in 1698, but the composition is known through a copy made in the seventeenth century for Charles II by Remigius van Leemput (Fig. 15). Fortunately, the left section of Holbein's cartoon used for transferring the composition to the wall also survives (Fig. 14). These survivals enable a full discussion of this important work to be undertaken.

Holbein was forced to draw on several different sources to compose the mural. Three of the four figures depicted were dead and prototypes had to be found and Holbein probably used contemporary portraits of Henry VII and Elizabeth of York, such as those illustrated in Figs. 5–7, as models for the king's parents. He reinterpreted these portraits in the mural so that Henry VII looks at the spectator with the paternalism and wisdom of an elder statesman, while his wife Elizabeth, hands held modestly in front, looks towards her husband.

The other two figures are Jane Seymour and Henry himself. Jane Seymour died the year the mural was painted, but Holbein had drawn and painted her from life whilst she was queen (Fig. 70).[25] Like her mother-in-law in front of whom she stands, she looks towards her husband, with her hands clasped modestly in front.

Henry VIII is not positioned centrally nor on a higher level, yet he dominates the composition. This has been achieved

through a combination of the king's stance and a re-rendering of the face of the Thyssen portrait. His shoulders are almost unbelievably wide, emphasized by the position of his arms. Feet placed apart, the figure is resolute, immovable and all-powerful. The legend which appears on the central tablet explains the purpose of the picture:

> If you find pleasure in seeing fair pictures of heroes
> Look then at these! None greater was ever portrayed.
> Fierce is the struggle and hot the disputing; the question
> Does father, does son – or do both – the pre-eminence win?
> One ever withstood his foes and his country's destruction,
> Finally giving his people the blessing of peace;
> But, born to things greater, the son drove out of his councils
> His ministers worthless, and ever supported the just.
> And in truth, to this steadfastness Papal arrogance yielded
> When the sceptre of power was wielded by Henry the Eighth,
> Under whose reign the true faith was restored to the nation
> And the doctrines of God began to be reverenced with awe.[26]

Both in the portrayal of the king and in the text, the mural encapsulated the revolution of the 1530s.

The Whitehall Mural was very different from many of the images to be discussed below. The room in which it was painted was the king's privy chamber, a room to which access was heavily restricted by household ordinance. Only those members of the king's household who looked after his most personal needs were allowed access. In addition to these people, very favoured guests would sometimes be admitted. *The Whitehall Mural* was thus a very private work, only to be seen by an invited audience; it was not an image of mass propaganda.[27]

What, then, was the purpose of Holbein's masterpiece? First, it should be set in the context of previous royal murals. The most important of these was the mural painted in *c*.1267 for Henry III in the Painted Chamber at Westminster Palace. This famous painting, burnt in 1834 but fully documented by drawings before its destruction, is the only royal medieval wall painting of which we have any visual record (Fig. 17). There were several elements to the composition, but for our purposes the important part was the image of the king. Above the bed of Henry III was *The Coronation of St. Edward* (King Edward the Confessor), showing the saint being crowned by two archbishops and other ecclesiastics. Like *The Whitehall Mural*, this earlier mural was in a private rather than public location, yet likewise it was clearly intended to express Henry III's position.[28] Both murals served as private images of kingship.

The Whitehall Mural was principally a display of *magnificence*, painted to create an atmosphere of extreme richness and splendour and forming a backdrop to the king's physical presence in the privy chamber. Those who saw the mural reported that the figure of Henry left the spectators feeling 'abashed and annihilated'.[29] Like the tricks used by the Wizard of Oz, the mural expanded the real presence of the ruler into a supernatural one. An audience with Henry beneath the dominating mural in his privy chamber, the inner sanctum of the king and the most richly decorated room in the palace, would have been an experience never forgotton.[30] It is perhaps because of the power of the mural that in the 1540s there appears to have been a gradual opening up of the privy chamber at Whitehall. The room was increasingly used in preference to the presence chamber for important court occasions, and Henry began to adopt rooms in the privy gallery beyond as his private domain.[31]

THE DEIFICATION OF THE KING

Approximately contemporary with the Thyssen portrait is Holbein's *Solomon and the Queen of Sheba* (Fig. 19). This miniature is the third of Holbein's images of the king and shows Henry seated, in the guise of Solomon. Henry acquires a semi-divine status as he receives the homage of the Queen of Sheba, not an ecclesiastical figure but a lay princess. Above him are the words: 'Blessed be the Lord thy God which delighteth in thee to set thee on his throne, to be king for the Lord thy God.' Solomon's direct relationship with God, without the mediation of the Church, is suggested as a model for Henry's new kingship. The Queen of Sheba can be seen to represent either the Church or, more likely, secular powers paying homage to the king.[32]

Although Solomon was used as the model for Henry's kingship in this instance, more common was the use of the image of David. Indeed, Holbein's title-page border for the Coverdale Bible (Fig. 25, discussed below) introduces it for the first time. David was, of course, God's elect, his chosen and anointed one, and, as such, he was an ideal biblical type to be hijacked by the newly established supreme head of the Church. A series of private images of kingship which illustrate psalms in Henry's personal psalter of 1542 show the adoption of Davidic imagery.

In this psalter, Henry is four times deliberately portrayed as David. In the first image, 'the fool has said in his heart there is no God', Henry is seen playing the harp with his jester, Will Somers (Fig. 23). The second portrayal, 'his delight is in the law of the Lord; and in his law doth he meditate day and night', shows the king near his bed reading a book (night), with a garden in the background (day) (Fig. 20). The third is politically the most direct, showing the young David slaying Goliath. A marginal note in the hand of the illustrator widens

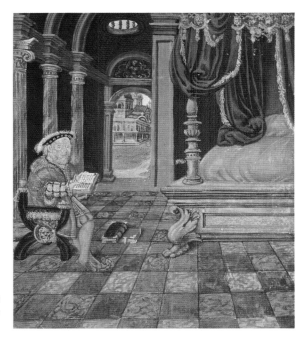

20. *Henry VIII Reading in his Bedchamber* from the
Psalter of Henry VIII. London, The British Library

Ominus illuminatio mea & sa-
lus mea: quem timebo:
ominus protector vitæ meæ a quo

21. *David and Goliath* from the Psalter of Henry VIII.
London, The British Library

22. *Henry VIII as the Penitent David* from the Psalter of Henry VIII. London, The British Library

Sed sperauit in multitudine diuitiaᵹ
suarum: & preualuit in vanitate sua.
Ego autem sicut oliua fructifera in
domo Dei speraui in misericordia Dei
in eternum, & in seculum seculi.
Confitebor tibi in seculum quia fecisti
& expectabo nomen tuum quoniam bonū est
in conspectu sanctorum tuorum Gloria
patri Sicut erat.

Dixit
insipies
in corde
suo nō
est Deꝰ
Cor=
rupti sūt

23. *Henry VIII Playing the Harp* from the Psalter of Henry VIII. London, The British Library

the significance of the image beyond David's triumph over the giant Goliath (i.e. the papacy) to Henry in the guise of Christ overcoming papal supremacy (Fig. 21). An image of the penitent David (Fig. 22) is likewise expanded by a marginal note to refer to Christ's Agony in the Garden.[33]

The imagery of the king's psalter was, of course, a private interpretation of the king's position. Yet, during the 1530s and 1540s the propagandists were writing publicly about the same semi-divine image of the king. For instance, Bishop Gardiner in *De Vera Obedientia* wrote that the king represented 'as it were the image of God upon earth' and that he excelled, in God's sight, 'among all other human creatures'. This was one tract in an enormous flood attacking the old order and extolling the king's new position. This campaign was not solely the work of the Crown, but it was a government-sponsored operation undertaken in alliance with sympathetic elements of the population.[34]

THE HENRICIAN BIBLES

Holbein's role in the creation of the king's new God-like image was extended by his work on the title-page for a new Bible. It was undoubtedly the influence of Thomas Cromwell and Thomas Cranmer which eventually persuaded a reluctant Henry to overcome his objections to a Bible in the vernacular tongue. Such a Bible was published in Basle in 1535 by its translator, Miles Coverdale, and it was subsequently published in England, with a new title-page and an unofficial dedication to the king.[35]

The title-page of the Coverdale Bible is usually accepted as being by Holbein (Fig. 25), and it personifies the new idea of kingship. At the top, on either side of the symbol of God the Father, are depictions of the risen Christ and original sin. Below these images of the Godhead and Christ's redemption is a series of Old and New Testament models for sacred kingship: Moses receiving the Law, Esdras reading the Law to the Jews, Christ sending the Apostles into the world, and Peter preaching to the Jews after Pentecost. At the foot of the page, by implication in direct descent from the biblical models, sits Henry VIII. He is enthroned above both the churchmen and the secular lords and holds the sword, the sign of his secular power, and a book, the sign of his spiritual leadership.

The iconography of the title-page of the Coverdale Bible was revolutionary, turning the traditional iconographical relationship of Church and State on its head. The medieval conception of the source of the king's right to rule can be illustrated by a miniature from a fourteenth-century coronation *ordo* (Fig. 29). The enthroned king receives his crown, sceptre, orb and the paraphernalia of kingship from the bishops who surround him (cf. Fig. 17). The image is of a king who receives his temporal authority from God's representatives. Images from early in Henry VIII's reign, such as his coronation woodcut (Fig. 16), show the same relationship.

Whereas the Coverdale Bible emphasizes the spiritual hierarchy by which Henry occupied his position as head of the Church, the Great Bible, first published in 1539, emphasizes as much the social and political hierarchy by which Henry ruled.[36] The title-page of the Great Bible (Fig. 26) continues where the Coverdale title-page left off. Henry sits at the top of the page, God squeezed in above him, with the *verbum dei*, the Word of God, in each hand. He gives a copy to Cranmer, representing the Church, and to Cromwell, representing the secular powers. In the Coverdale borders sacred kingship is passed down through history to Henry. In the Great Bible Henry passes the word of God down through the social orders. Right at the very bottom of the page are the common people; too ill-educated to cry 'Vivat Rex', they cry 'God Save the King'.

The difference in emphasis between the two Bibles can be explained in terms of the changing pace of the Reformation and the development of the king's position. In 1535, although the old relationship between the king and the Roman Church had been destroyed, the new edifice of the national Church governed by a semi-divine king had not been fully worked out. The important change was freedom from the legitimizing power of the Church. In the Coverdale title-page Henry's kingship had been legitimized directly by the example of biblical models. By 1539 a different element of the revolution was being stressed. The Great Bible was to be distributed throughout every church in the land, with Henry's relationship to God summarized at the top of the title-page. The main business of the illustration was to stress the hierarchical nature of government and the king's position as the fount of religious and secular power and justice.

Thomas Cromwell had initiated the Great Bible by an order of 1538, and the Bibles were printed and distributed to parish churches throughout England by the early summer of 1539. By 1541 it had run to its sixth edition. In this way the new image of the king was transmitted to every corner of the country. It was the first time a consciously planned act of mass propaganda, directed at forging the image of a ruler, had been so widely disseminated in England.

HENRY VIII AND THE COINAGE

In about 1504 Henry VII had issued, for the first time, coins with a realistic portrait of himself on the obverse (Fig. 24b). Before then the image of the monarch on his coinage was a

stereotypical crowned royal head, seen full-face (Fig. 24a). To forge this new image Henry employed a German die-striker, Alexander Bruchsal, whose results were so successful that Henry VIII subsequently retained the image of his father on his coins for the first sixteen years of his reign (Fig. 24c).

Henry VIII's second coinage, issued in 1526 under the supervision of Wolsey, featured for the first time a profile portrait of himself, but it was only in the coins of the third issue that the image of Henry acquired the totally recognizable features now familiar to us from the works discussed above. The king's third issue of 1544 was an attempt to raise revenue by debasing the currency. The proclamation which accompanied the issue specifically mentioned a change in the king's portrait on the coins. It was now to be a facing bust showing the king's square bearded face above a mantle with a fur collar (Fig. 24d).

The final development in the image of the king on coinage was the seated figure on the gold sovereign. Henry VII had introduced the sovereign in 1489 in direct imitation of Burgundian practice. The obverse showed a king sitting on a very ornamental Gothic high-backed throne, flanked by a greyhound and dragon on the side pillars. The sovereign of Henry VIII's final issues shows the full face of the bearded king, who is seated on a Renaissance throne and is holding a sceptre and orb. At his feet there is a Tudor rose (Fig. 24e). His bearing, slightly askew, with knees apart and flowing

robes, is that of the post-Reformation king. Realism combines with aggressive posturing to express the king's newly assumed political and religious position.[37]

THE PLEA ROLL IMAGE

The diffusion of the new image of the king extended to all spheres of royal activity. The transformation from the traditional medieval conception of the monarch to the new all-embracing monarchy can be seen particularly well in two of the instruments of government. First, is the example of the Plea Roll image of the king.[38] The proceedings of the Court of King's Bench were recorded on a series of parchment Plea Rolls, each of which began with the formula *Placita c oram domino rege* (Pleas before the Lord King). The capital P at the start of this phrase was embellished by the clerks who engrossed the roll, and who thus produced a series of colour portraits of Henry which, beginning in 1514, in due course showed the adoption of the king's new image.

The portrait of the king found at the top of the roll for the Trinity term of the legal year 1517 shows the young king seated on a narrow-backed medieval throne and holding a sceptre and orb (Fig. 30). It is the standard medieval image of a king and is paralleled in many other art forms (Figs. 17, 27, 29). The facial features of the king are clearly not taken from life but represent a standardized 'kingly' face. A

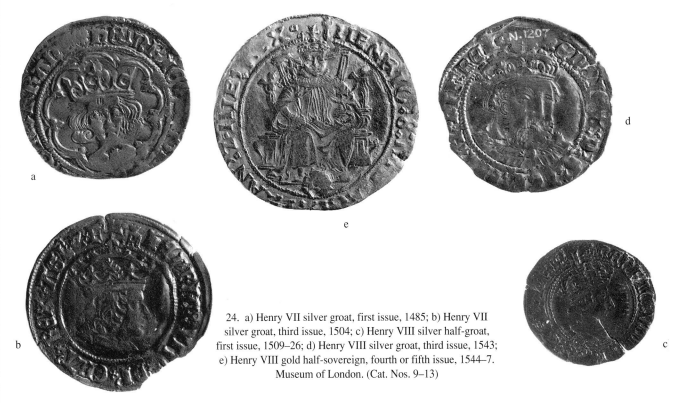

24. a) Henry VII silver groat, first issue, 1485; b) Henry VII silver groat, third issue, 1504; c) Henry VIII silver half-groat, first issue, 1509–26; d) Henry VIII silver groat, third issue, 1543; e) Henry VIII gold half-sovereign, fourth or fifth issue, 1544–7. Museum of London. (Cat. Nos. 9–13)

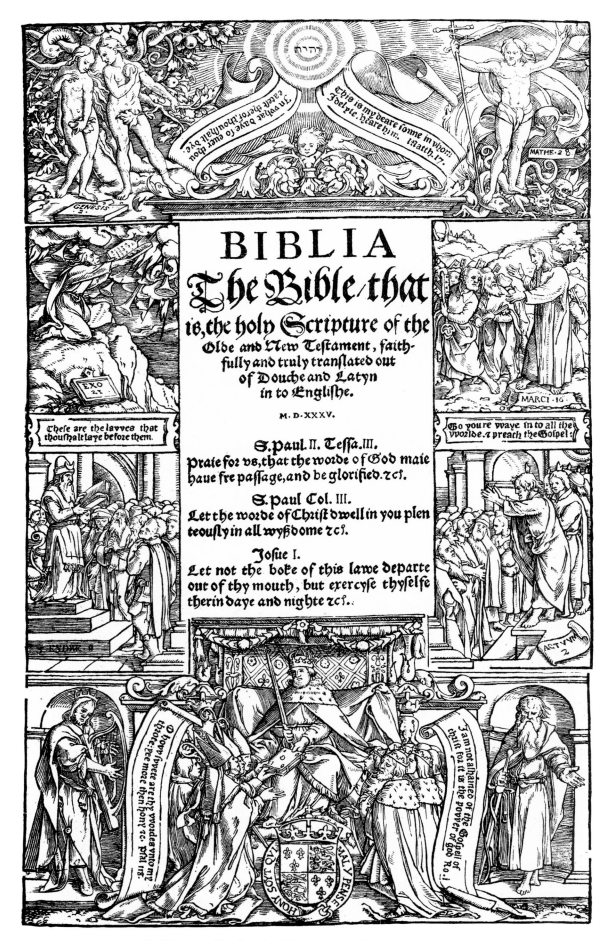

25. Title-page of the Coverdale Bible, by Hans Holbein the Younger. 1535.
Folio 27.4 x 16.7 cm. London, Sion College Library. (Cat. No. 17)

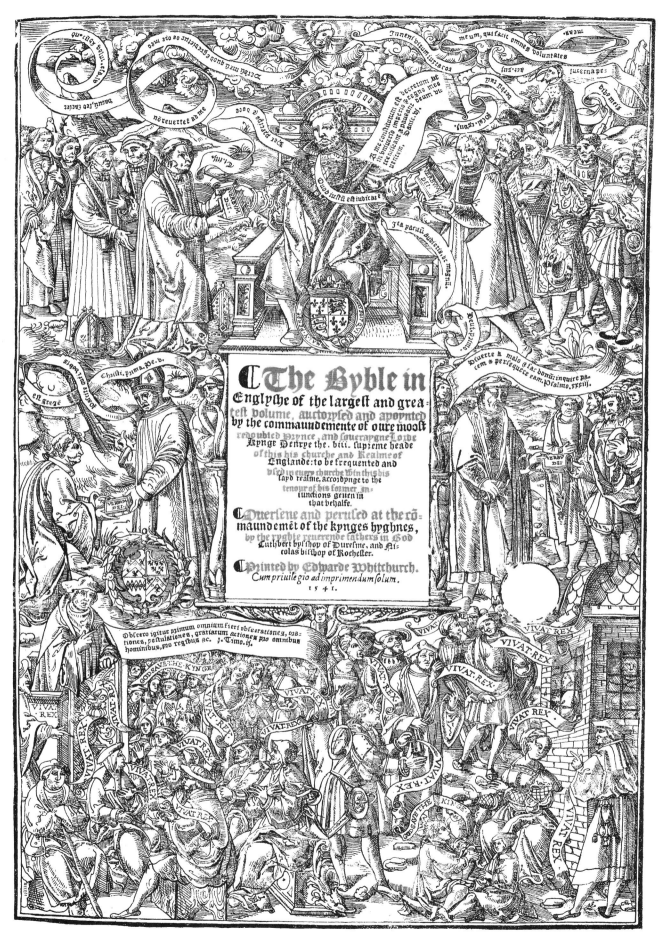

26. Title-page of the Great Bible. First published 1539. 35.5 x 24 cm.
Windsor Castle, The Royal Library. (Cat. No. 18)

contrasting image is found on the roll for Hilary term 1543–4 (Fig. 31). Here, Henry is totally recognizable; the square, bearded face first introduced by Holbein identifies the sitter immediately. In addition, the figure has much greater presence; he is broader and his throne fills the available space in the manner of Holbein's image. In short, the Plea Roll Henry of the 1540s is the figure of the new Tudor kingship.

THE IMAGE ON THE GREAT SEAL

More directly connected with the mechanics of central government is the image of the king as it appears on the Great Seal of England.[39] The Great Seal, kept by the Lord Chancellor and administered through the office of the Chancery, was an essential tool in the administration of grants (gifts from the Crown) and in authenticating writs (actions at law). From the early Middle Ages it had been a two-sided wax seal attached to the bottom of documents, one side showing the king seated, the other the king mounted. The seal of Henry VII (Fig. 27), like those of fifteenth-century kings before him, showed a stereotypical king sitting on a narrow throne and clasping a sceptre and orb. The image was very similar to the standardized Plea Roll portrait discussed above (Fig. 30).

Henry VIII's first Great Seal (in use 1509–32) followed this pattern closely. A second seal in use from 1532 differed in some minor respects, the flanking shields being, for the first time, surrounded by a garter. Yet the image of the king on the second seal was fundamentally that of the first.

Henry's third seal (Fig. 28), however, was revolutionary. Probably made to accommodate the king's change of title to Defender of the Faith during the 1530s, the seal was first used in 1542 and it continued in use until his death.[40] Once again, the square-faced Henry is unmistakable. His vast bulk sits astride a broad throne. The relief of the figure is such that the king appears to be bulging out of the impression. There is a particularly close parallel with Holbein's *Solomon and the Queen of Sheba* (Fig. 19). In both images the king sits with one leg thrust out at an angle, hands on hips. This aggressive posture contrasts sharply with the passivity of the image of Henry VII (Fig. 27) and can be paralleled with the image of Henry VIII on his later coins (Fig. 24e).

The legend around the seal chronicles the change, for while Henry VII was *King of England and France and Lord of Ireland*, Henry VIII was, in addition, *Defender of the Faith, Supreme Head of the English Church and of Irish Churches*. As in the Plea Roll image, the Great Seal shows how successfully Holbein's portrayal of the self-confident and self-sufficient king transferred directly into the political sphere.

PARLIAMENTARY SEATING PLANS

The elevation of the king's position was not merely a theoretical and iconographical development. Two parliamentary seating plans, one dated 1523 and the other 1553, show the translation of the king's new position into reality.[41] The plan for 1523 (Fig. 32) shows the king seated at his throne and flanked by lords spiritual and temporal. He is the greatest of the great lords of the land, his power deriving from, and shared with, the spiritual and secular lords on either side of him. The second plan dates from the second parliament of Edward VI in 1553 (Fig. 33). In it the king sits isolated, the benches to his left and right empty. The Lord Chancellor and Treasurer stand behind the bench, bareheaded in the presence of the king.

The development that had taken place can be directly related to the wording of an act of parliament of 1539, which states:

> No person or persons, of what estate, degree or condition soever...except only the king's children, shall at any time hereafter attempt or presume to sit or have place at any side of the cloth of estate [the throne canopy] in the parliament chamber...whether the king's majesty be there personally present or absent.

This was the final step in the evolution of the nature of kingship. The gradual deification of the monarch as illustrated by the images of the king discussed above is here transformed into an institution. The king is physically raised above even the greatest peers of the realm, to such an extent that even in his absence his throne is sacrosanct.

LATER IMAGES OF HENRY VIII

Holbein died of the plague in 1543, depriving Henry's court of its greatest artistic genius. A group of later paintings, the most important of which, by an unknown artist, is known as *The Family of Henry VIII* (Figs. 1, 35), developed the work of Holbein in the last years of Henry's reign. The background of *The Family of Henry VIII* shows a view from Whitehall Palace northwards. It was certainly painted for Henry VIII and was probably designed to hang at Whitehall. This creates a direct link with the Holbein mural painted for the privy chamber about seven years earlier (Fig. 15). The differences between the two paintings are striking.

In terms of the characters portrayed, *The Whitehall Mural* was, as we have seen, as much a statement of the nature of Henry's kingship as of his dynastic position. He is shown with his father, mother and favourite wife. Edward, his heir, a small baby at the time, does not appear. The central attraction is Henry himself, glorying in his newly achieved position. It is a painting of past and present and not of the future.

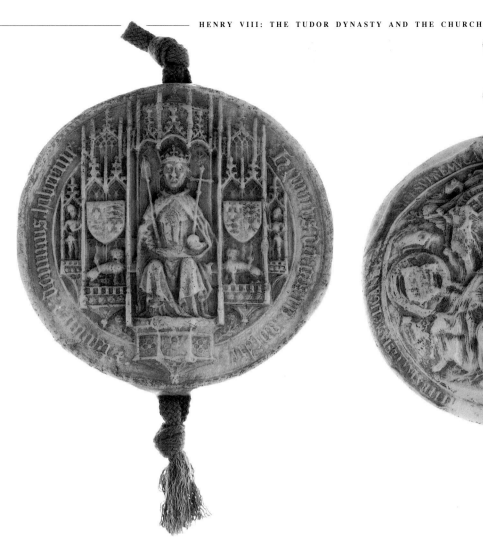

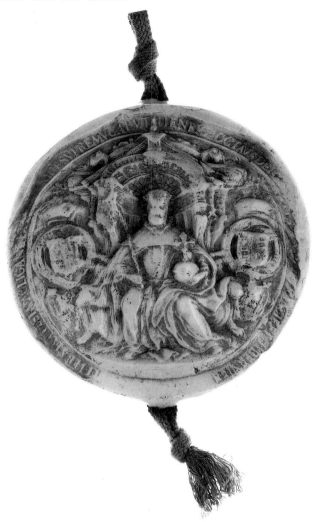

27. Great Seal of Henry VII. Modern wax impression, diameter 11.2 cm. London, Public Record Office. (Cat. No. 7)

28. Third Great Seal of Henry VIII. Modern wax impression, diameter 12.2 cm. London, Public Record Office. (Cat. No. 8)

In *The Family of Henry VIII* the Holbeinesque, massive, square-faced Henry dominates the composition. He is flanked, once again, by the mother of his heir, Jane Seymour, and by their son, the future Edward VI. His two daughters stand in the wings in reserve. It is an image of the ageing king. The super confidence of the mural has been replaced by the image of the elder statesman with his dynasty secured before him, and, unlike the mural, it is a picture of the future as well as of the present.

The Family of Henry VIII was painted on canvas and was therefore a movable item, although its vast size implies that it was probably painted for a particular location. It is known that in 1586–7 the painting hung in the presence chamber at Whitehall, and it may be that it was always intended for that room.[42] If this is so, it served a different purpose from that of *The Whitehall Mural*, which had only a limited audience.

This dominant painting proclaimed in rich and magnificent colour the success of Henry's dynasty and its secure continuation.

If *The Family of Henry VIII* is an image of the ageing king, the painting known as *Edward VI and the Pope* (probably *c.*1548) may be termed the image of the dying king (Fig. 36).[43] In it Henry lies on his death-bed pointing towards his son, who sits enthroned above an image of the Pope being crushed. To Edward's right stands the Protector Somerset and through a window iconoclasts can be seen destroying religious images. Of all the paintings discussed so far this has the most overt message, nothing is left to the imagination. Across the Pope's chest is written 'all fleshe is grasse', and he is crushed by the Word of the Lord, which appears to have been dropped on him by father and son above.

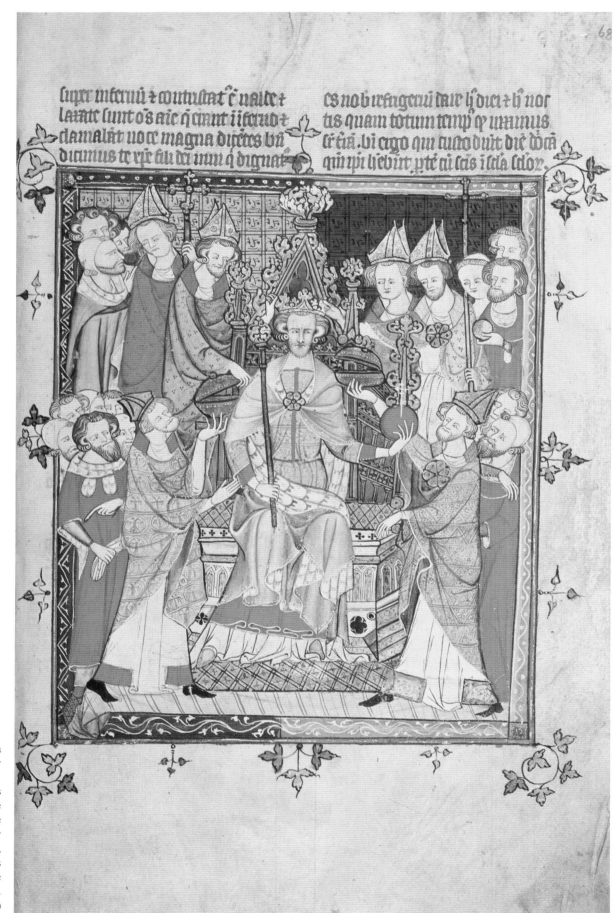

29. Illumination from a
fourteenth-century
coronation *ordo*.
Cambridge, Corpus
Christi College
In the Middle Ages the
king was crowned by
ministers of the Church,
and he derived his
temporal power from the
coronation ceremony.
(Compare Fig. 17)

30. Detail from a Plea Roll. Trinity, 1517. 13.7 x 9.7 cm.
London, Public Record Office

31. Detail from a Plea Roll. Hilary, 1543/4. 14.9 x 10 cm.
London, Public Record Office

The figures of Henry and Edward in the painting are both directly related to images initially created by Holbein. Holbein had produced an image of Edward as early as January 1539, when he gave Henry a portrait of his two-year-old son as a New Year's present (Fig. 52). This portrait can be linked to *The Whitehall Mural* through the verses written upon the tablet on which the boy leans:

> Little one! imitate your father, and be the heir of his virtue, the world contains nothing greater – heaven and nature could scarcely give a son whose glory should surpass that of such a father. You only equal the acts of your parent, the wishes of men cannot go beyond this. Surpass him, and you have surpassed all the kings the world ever worshipped, none will ever surpass you.[44]

These verses continue the theme of the mural, and the connection must have been made by contemporaries familiar with the Whitehall privy chamber. Although the text on Holbein's painting linked the images of father and son, the artist died before Edward was old enough for Holbein to portray him in the style of the full-length image that he had created for Henry. This task was left to Holbein's followers, who created the standard full-length portrait of Edward (Fig. 51) from which the figure in *Edward VI and the Pope* ultimately derives. In it Edward stands in the same pose (but reversed) as Henry in *The Whitehall Mural*: a more direct transmission of a ready-made image of royalty could hardly be imagined.

Edward VI and the Pope (Fig. 36) is one of a group of sixteenth-century anti-papal paintings, the earliest of which Henry VIII himself owned. At least three are listed in Henry's collection at his death.[45] One remains in the Royal Collection today. *The Four Evangelists Stoning the Pope* by Girolamo da Treviso (Fig. 54) is perhaps one of the most terrifying paintings to survive from this period. In it four men viciously stone the sprawling figure of a pope, who is accompanied by personifications of Hypocrisy and Avarice.

The final painting in the sequence of post-Holbein royal images is much later, but can be related directly both to *The Family of Henry VIII* and to *Edward VI and the Pope*. The *Allegory of the Tudor Dynasty* was painted in *c*.1572 and is attributed to Lucas de Heere (Fig. 55). Much had passed since *The Family of Henry VIII* was painted in the mid-1540s. Edward VI, who kneels on Henry's left, had reigned and died; so had Mary I, who stands with her Spanish husband, Philip II, on Henry's right. Elizabeth I remains, and she enters the composition hand in hand with Peace, who tramples the weapons of discord beneath her feet, followed by Plenty with her cornucopia of fruit. The Catholic monarchs on the other side of the composition are attended by Mars, the god of war, referring to former unhappy times.

Although the figure of Elizabeth I is enlarged to emphasize her position as the reigning Tudor monarch, Henry still dominates the composition. The image of Henry can be traced backwards through *The Family of Henry VIII*, Holbein's *Solomon and the Queen of Sheba*, his *Whitehall Mural* and the Thyssen Collection *Henry VIII* to the iconographical revolution of the 1530s. The *Allegory of the Tudor Dynasty* embodies all the dynastic and religious themes discussed above and epitomizes the success with which Henry, and his painter Hans Holbein, were able to hand down to posterity a carefully fabricated image of Tudor kingship: an image which endures today.

as Soldier Diplomat

 There can be few greater contrasts in English history than the change in foreign policy after the death of Henry VII in 1509. As has been demonstrated in the previous chapter, the dynastic problems that faced the king in 1485 absorbed all his attention at the outset. He did not ignore foreign affairs, but they were always subordinate to dynastic and domestic policies. The priorities in his foreign policy were to establish a role for his country in European affairs, to elevate his own dynasty in Europe, and to safeguard mercantile interests. In all of these matters Henry VII achieved a considerable success, and certain aspects of his relationship with foreign powers, such as his interest in the exploration of America and Asia, were far sighted. A leading historian of his reign asserts that Henry VII 'largely cast the role that England was to play in European affairs far into the modern period'.[1] This is true, but the change that occurred after his death ensued from the fact that his son chose to place a different emphasis on foreign policy. Henry VIII searched for martial glory where his father had carefully avoided it; he decided to spend vast sums of money on campaigns where his father had preferred not to; and he pursued ideals where his father had been forced to act as a realist.

Such a volte-face was partly due to personality. Henry VIII acceded to the throne at the age of seventeen and his outlook was to a very large extent dictated by his superb physique and his abilities as a sportsman, about which his contemporaries, particularly foreign ambassadors, commented endlessly. The chronicler Edward Hall recorded that on the first royal progress of Henry VIII's reign in 1510 the king spent his time:

> ...exercising himself daily in shooting, singing, dancing, wrestling, casting of the bar, playing at the recorder, flute, virginals, and in setting of songs, making of ballets, and did set two goodly masses, every one of them five parts, which were sung oftentimes in his chapel, and afterwards in divers other places. And when he came to Okng [Woking], there were kept both jousts and tournaments: the rest of this progress was spent in hunting, hawking and shooting.[2]

Henry's energy and prodigious skill at physical activities needed to be channelled in a positive direction. He decided to embrace the code of chivalry, yet he also chose to revive the tradition of Edward III and Henry V by reawakening memories of the Hundred Years War in an aggressive campaign against France during the second decade of the sixteenth century. As the passage quoted from Hall suggests, Henry VIII was a paradoxical figure: a man of peace and a man of action. 'If Henry ever felt the pull of the ideal Christian prince, the man of peace and justice, he felt, too, the call of the chivalrous and spectacular.'[3] Indeed, his reign is embedded in paradox. As Scarisbrick concludes:

> He began his reign as a warrior, therefore, bent on the splendid and heroic. Later he would take on other parts, of peacemaker, theologian, Supreme Head of the Church. But when he had dealt with what some may have regarded as but an interlude in his career (and which we take as its centre-piece), namely, the matters ecclesiastical of the 1530s, he was able to resume what had been for him the principal business of his reign and end his life as he had begun it, at war.[4]

Henry VIII was not alone in his policy of aggrandizement. Like-minded personalities can easily be found in European politics at this time – all were seeking military success as part of policies of expansion, all became embroiled in complicated diplomatic alliances, and all were keen patrons of the arts. In addition, they had youth in common, and the chief personalities that were to dominate European politics during the first half of the sixteenth century soon declared themselves. In 1515, Francis I of France (Fig. 50), aged twenty-one, succeeded Louis XII and revived the ambitions of Charles VIII (d. 1498) by invading Italy and immediately winning a decisive victory at Marignano near Milan, which was subsequently avenged at the Battle of Pavia in 1525 (Fig. 96). On that occasion Francis I's main opponent was the imperial army of Charles V, formerly the Duke of Burgundy, who, in 1519 at the age of nineteen, had succeeded his grandfather Maximilian I as Holy Roman Emperor, thereby uniting Spain with the Empire. The imperial army subsequently marched south and sacked Rome in 1527. The wars of the 1520s, which Wolsey so desperately tried to avoid, were essentially a power struggle for the domination of Europe between Valois France and the Habsburg Empire, centred for the most part on the Italian peninsular. England could lend support to either side. 'Her alliance would bestow dominance, while her neutrality could, in theory, guarantee peace.'[5] Henry VIII clearly enjoyed this kind of superpower politics and invested a great deal of time and money in diplomatic negotiations, but in the final analysis he was ineffectual. Then other events such as his divorce from Catherine of Aragon and the break with the papacy intervened. However, the king reverted to war during the 1540s, the last decade of his reign.

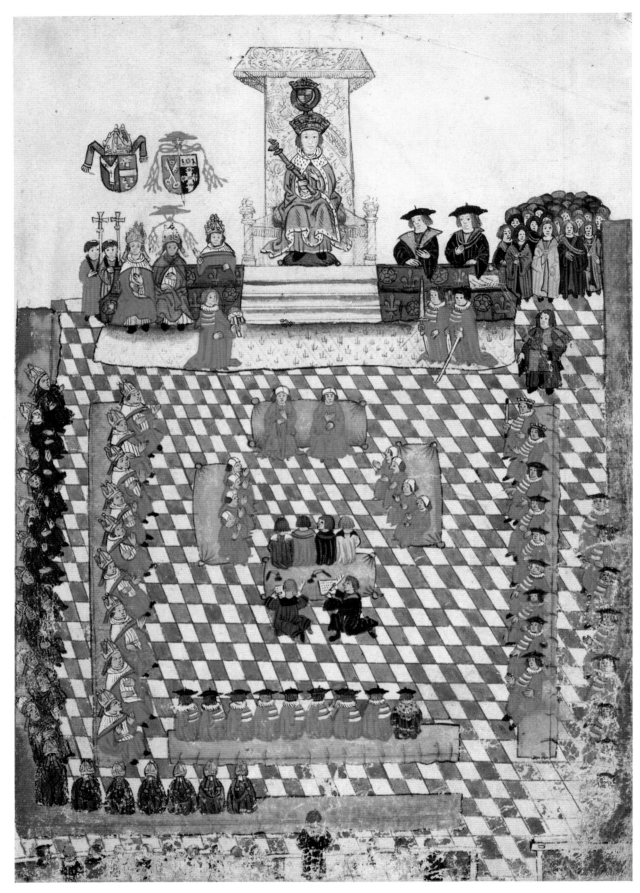

32. *Henry VIII in Parliament* from
The Wriothesley Garter Book. 1523. Vellum, 30.8 x 22.2 cm.
Windsor Castle, The Royal Library

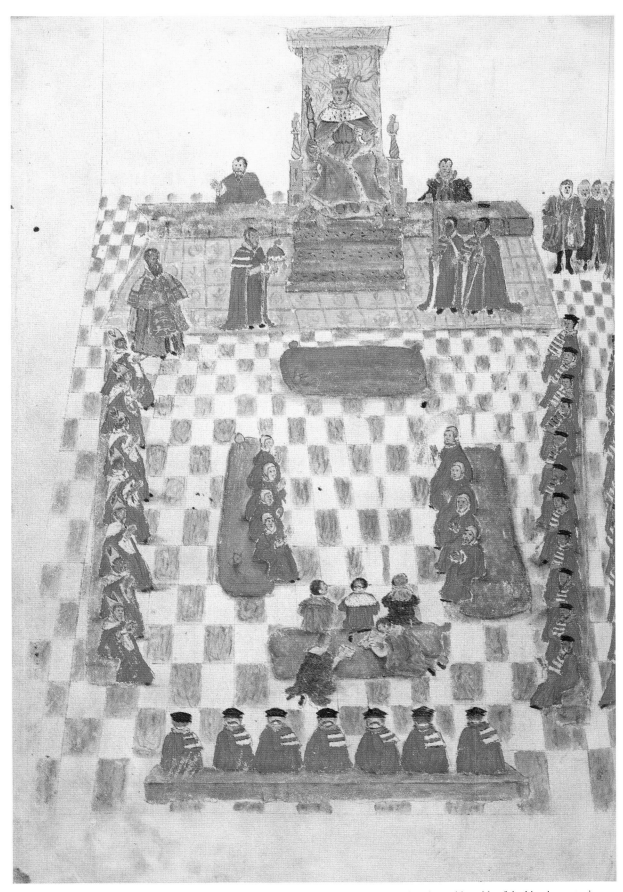

33. *Edward VI in Parliament* from
The Dethick Register of the Order of the Garter. 1551–88.
Vellum, 27.9 x 20 cm. Windsor Castle, The Royal Library
The second, and last, opening of Parliament under Edward VI

(March 1553). The bench on either side of the king is empty, in
accordance with the statute of 1539. The Chancellor and Lord
Treasurer stand bareheaded behind it.

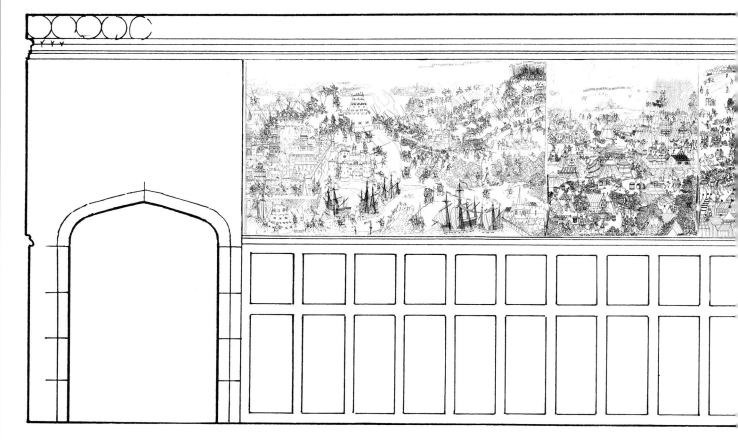

Both Henry's continental wars, that of 1513 and those of the 1540s, were commemorated by series of paintings. There had been a long tradition of painting a record of the most significant events of a monarch's reign. As early as the reign of Henry III crusader subjects had decorated the walls of the Antioch Chamber at Clarendon Palace, including the duel between Richard I and Saladin.[6] There is no record of Henry VII's activity in this sphere, despite the fact that in the Battle of Bosworth he clearly had a major subject for depiction. The early part of Henry VIII's reign, however, saw the completion of several historical murals. The most important of these historical works was that painted on the walls of the Low Gallery at Whitehall Palace, where painters were paid for 'drawing and settyng owte wyth colours the coronacion of our seide soverigne lorde with the circumstance of the same as also certayne other works upon the walles'.[7]

At Windsor Castle a room next to the King's Bedchamber was named the Siege of Rhodes Chamber after a series of murals which depicted the two sieges of Rhodes of 1480 and 1522. The Knights Hospitallers were favoured by both Henry VII and Henry VIII, and this subject, illustrating their finest hour in the defence of the last Christian outpost against the Infidel, was clearly an important one.[8]

No record survives of either of these murals, but two series do survive of history paintings depicting Henry VIII's military and diplomatic achievements. First, in the Royal Collection are four large-scale paintings showing incidents from Henry's first campaign against France in 1513 and the subsequent diplomatic negotiations of the 1520s. Second, there survive copies in the form of prints of a great wall mural which decorated the Dining Parlour at Cowdray House, Sussex, showing scenes from Henry's later campaigns. Together these paintings illustrate Henry's entire military career on the Continent.

The four paintings in the Royal Collection are *The Meeting of Henry VIII and the Emperor Maximilian I* (Fig. 38), *The Battle of the Spurs* (Fig. 40), *The Embarkation of Henry VIII at Dover* (title-page) and *The Field of the Cloth of Gold* (Fig. 48). Only one of these (*The Meeting*) is recorded in royal inventories during Henry's reign. *The Embarkation* is first recorded in 1586–7, *The Field of the Cloth of Gold* in 1600, and *The Battle of the Spurs* in 1613.[9] Despite this, it seems certain that they were painted for Henry VIII during his lifetime; the scenes depicted would have had no meaning for either Edward VI or Elizabeth I. One explanation for their non-appearance in early inventories is that the paintings

44

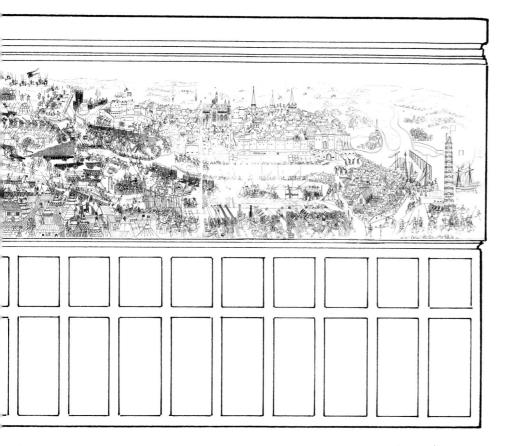

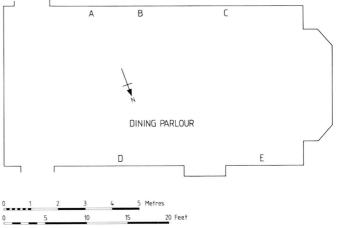

34. Plan and elevation of the Dining Parlour, Cowdray House. This modern reconstruction by David Honour of English Heritage shows the north wall of the Dining Parlour as it would have been in the mid-sixteenth century. The reconstruction is based on the surviving ruins of Cowdray House and on eighteenth-century descriptions and copies of the murals (see Figs. 37, 39, 59, 60, 62).

might have been incorporated into the architecture of Whitehall Palace, for instance as a frieze.[10]

A number of artists, not necessarily even of the same nationality, seem to have been involved. *The Embarkation of Henry VIII at Dover* and *The Field of the Cloth of Gold* form a pair, although they are not by a single hand throughout. *The Meeting of Henry VIII and the Emperor Maximilian I* and *The Battle of the Spurs* form a chronological sequence but are not a pair and are clearly unrelated in style to one another or to the other two history paintings. Essentially, the skills shown in all the paintings are *retardataire*, both as regards the compositions and the execution. The variety of styles is typical of the hybrid cultural climate of the Tudor court.[11]

The internal evidence for dating the paintings all points to their having been executed at the very end of Henry's reign. In *The Field* and *The Embarkation*, events of the 1520s, the image of Henry is unmistakably a post-Holbein image of the 1530s or 1540s (Figs. 43, 65). The clothes of the supporting figures in both paintings date from the late 1540s and the architectural style of the castle and forts in *The Embarkation* denote a date before the late 1530s. Yet, despite this time lapse, both paintings show a remarkable degree of faithfulness to the actual events as recorded in contemporary documents.

The detail in *The Field* is particularly impressive considering that the picture was painted twenty-five years after the event.[12]

The Meeting of Henry VIII and the Emperor Maximilian I (Fig. 38) and *The Battle of the Spurs* (Fig. 40) both pertain to the king's first campaign against France in 1513 when Louis XII was still on the throne. In order to pursue his ambitions in France, Henry VIII entered into an alliance with Ferdinand II

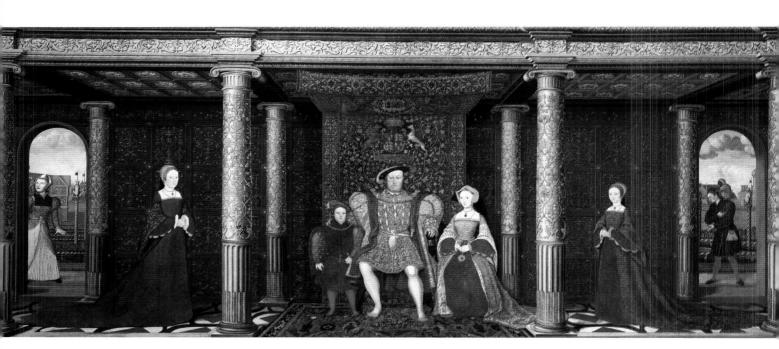

35. *The Family of Henry VIII* by an unknown artist. *c*.1545.
Canvas, 169 x 357 cm. The Royal Collection. (Cat. No. 3)

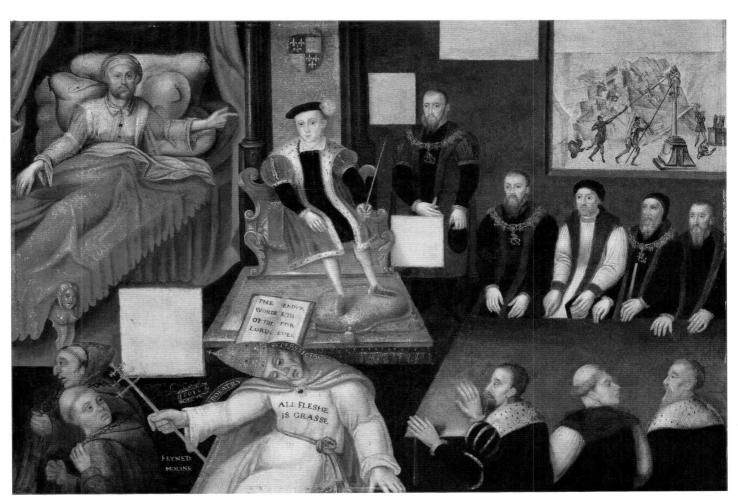

36. *Edward VI and the Pope* by an unknown artist. *c*.1548–9.
Canvas, 62.2 x 90.8 cm. London, National Portrait Gallery

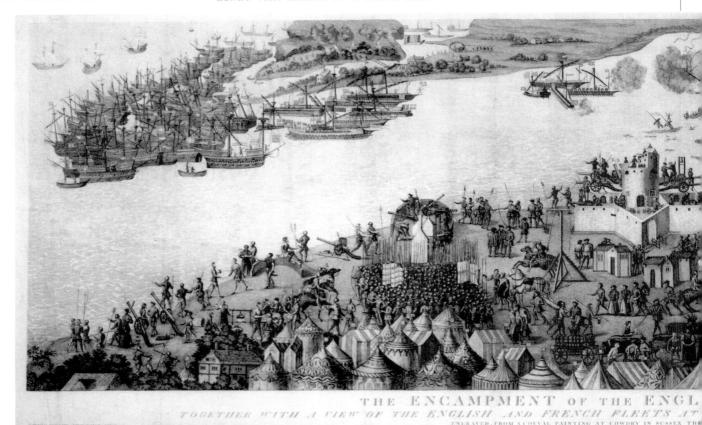

37. *The Encampment of Henry VIII at Portsmouth* by James Basire. 1788.
Engraving, 58.9 x 188 cm. Windsor Castle, The Royal Library. (Cat. No. 27)

of Aragon and the Holy Roman Emperor, Maximilian I, to which the Pope, Julius II, also secretly adhered. The plan was for Spain to attack France through Aquitaine, while the papacy would advance through Provence and the Dauphiné, and Henry would make his assault through Flanders. Maximilian was to have an itinerant role. Spain to all intents and purposes immediately withdrew from the alliance, and the Pope proved dilatory. Thus, the thrust of the onslaught fell to Henry and Maximilian. Henry landed at Calais (then an English possession) on the last day of June, amidst a large task force and a huge personal entourage. By early August he was advancing towards Thérouanne, which he then besieged. At that point (12 August) the emperor arrived and flatteringly put himself under Henry's command. The siege continued, during the course of which the Battle of the Spurs took place (16 August). The engagement was provoked by a French cavalry force coming to the assistance of the town, but in doing so they failed to take account of the disposition of the allied army. The French were first repelled by artillery and then chased by English and Burgundian cavalry across the fields of Guingates (today Enguingattes) to the east of

Thérouanne. It was not a spectacular victory, but six standards were captured and several prisoners, including the Chevalier Bayard, who was soon to become one of the legends of French history.[13] The town of Thérouanne surrendered on 24 August and Maximilian then proceeded to raze it to the ground, while Henry went on to Tournai, which surrendered (21 September) after an eight-day siege – a far more important prize than Thérouanne. Henry VIII declared his opening campaign against France a success, although in strict military terms the gains were somewhat nebulous.

The Meeting of Henry VIII and the Emperor Maximilian I is a conflation of the main events in the campaign. The composition comprises a series of horizontal bands. The emperor and the king, both on horseback, meet in the centre foreground. They are shown again in the middle distance, again on horseback, between divisions of infantry and artillery. The emperor's coat-of-arms is shown on the tent to the left and the king's on the tent to the right. Just above the centre the Battle of the Spurs is taking place, while in the background the towns of Thérouanne (left) and Tournai

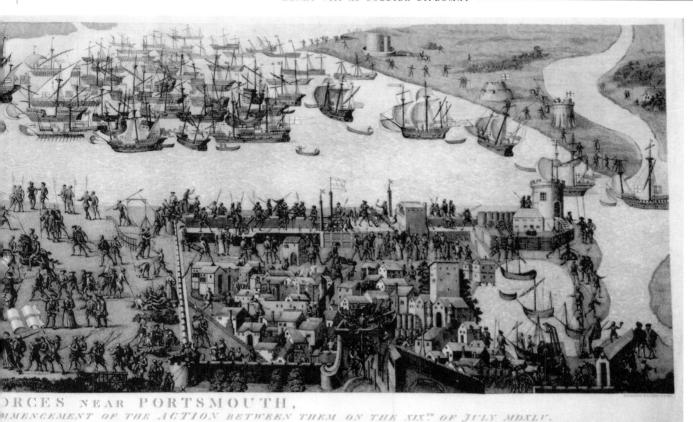

RCES NEAR PORTSMOUTH,
MMENCEMENT OF THE ACTION BETWEEN THEM ON THE XIX™ OF JULY MDXLV.
IGHT HONOURABLE ANTHONY BROWNE LORD VISCOUNT MONTAGUE

This is one of only two of the drawings of the Cowdray mural that were fully engraved
(the other is Fig. 39). The scenes were from the part of the mural that occupied the
southern wall, with the fireplace.

(right) are under siege. *The Battle of the Spurs* (Fig. 40) depicts a single action outside the town of Thérouanne. The king is shown in the centre of the composition receiving the surrender of an opponent, possibly the Chevalier Bayard. The emperor, who was also present at the action, cannot be identified, but he may be the figure on a white horse seen in the left foreground. The vigour with which the action has been painted has not deterred the artist from attending to a considerable amount of detail. The trumpets, tents, personal armour and horse armour are all decorated with the appropriate emblems.

After this military flourish at the start of his reign, Henry VIII under the influence of Cardinal Wolsey began to play the role of peacemaker. An Anglo-French alliance approved by all the great European powers as well as more than twenty lesser powers was ratified in the Treaty of London signed on 2 October 1518. 'What had begun as a plan for a five-year truce under papal auspices, to be followed by a crusade, had ended as a multilateral treaty of universal peace organised by a cardinal and concluded in London, with peace in

Christendom as its objective.'[14] At a time when diplomatic initiatives were difficult to bring to fruition Wolsey's achievement was truly remarkable. The fact that the agreement lasted for hardly more than a year should not detract from the attempt or nullify Henry VIII's or Wolsey's determination to gain peace in Europe. In many ways it was the king's outstanding contribution to European politics and it is hardly surprising that he chose to celebrate it in style in a public meeting with Francis I at the Field of the Cloth of Gold.

The Embarkation of Henry VIII at Dover (title-page, Figs. 43, 44) and *The Field of the Cloth of Gold* (Figs. 48, 65, 66) attest the organizational powers of the early Tudor administration if nothing else. The king was accompanied by Catherine of Aragon, and their entourage numbered over five thousand people, with full equipage for living and feasting. The main protagonists embarked at Dover on 31 May 1520. *The Embarkation* shows the castle at Dover in the upper left corner, while in the foreground formal salutes are fired from two forts, the Archcliff and the Black Bulwarks (Fig. 44).

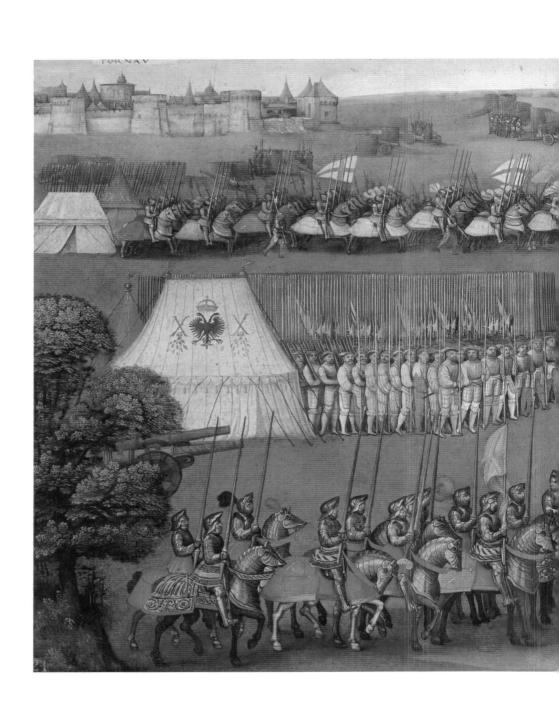

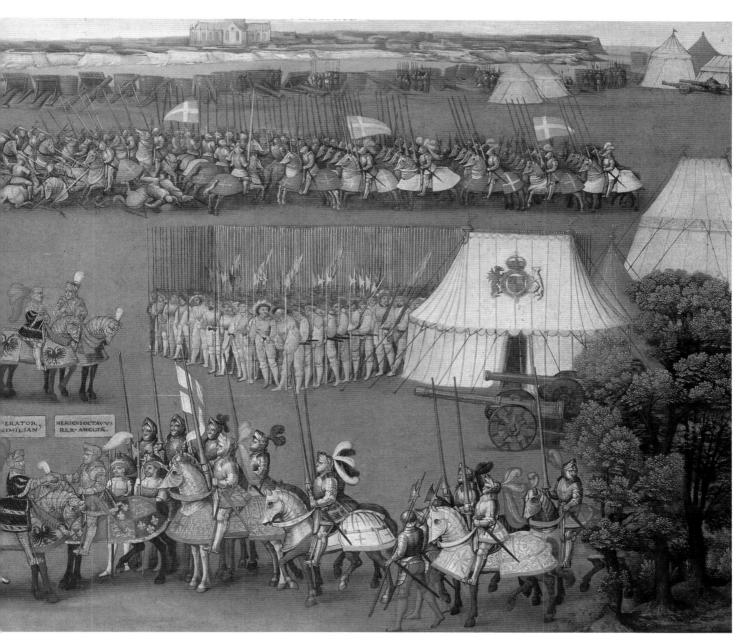

38. *The Meeting of Henry VIII and the Emperor Maximilian I*
by an unknown artist. *c*.1545. Panel, 99.1 x 205.7 cm.
The Royal Collection. (Cat. No. 20)

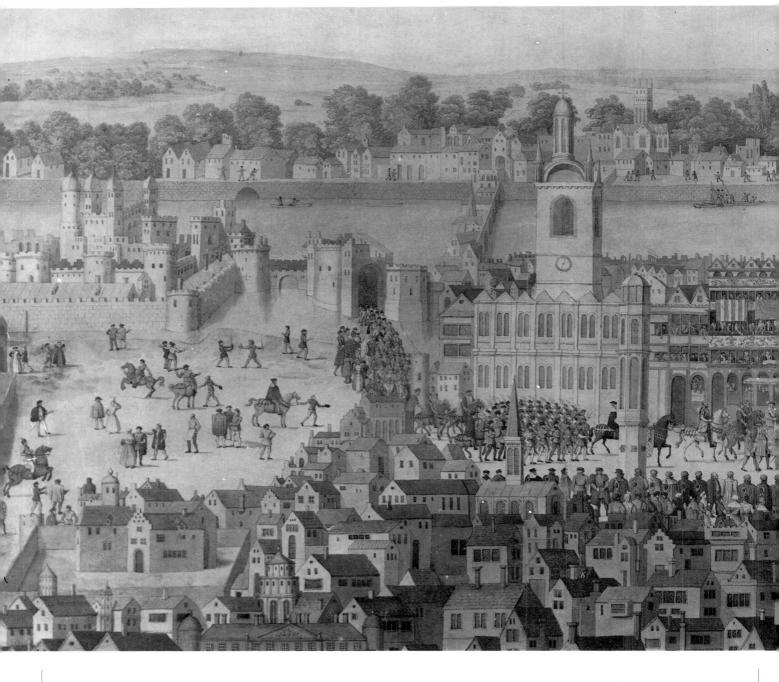

The fleet comprises five principal vessels, with others in the background. They sail towards France, the coast of which can be seen in the far distance on the right. The vessels fly streamers displaying the Cross of St. George and are decorated with similarly emblazoned shields and other Tudor livery colours (green and white). The large ship in the centre foreground is decorated with royal coats-of-arms. The names of the vessels are not recorded in the written sources and so a certain artistic licence may have been used.[15] The king and his suite can be seen on the deck of the vessel to the right of centre in the middle distance: this is most probably the *Henri Grace-de-Dieu*, the largest vessel in the Tudor navy, and is equipped with golden sails. Gold was to be the leitmotif of the whole expedition.

The meeting between Henry VIII and Francis I known as the Field of the Cloth of Gold took place on 7–24 June 1520 in a valley subsequently called the Val d'Or, near Guisnes to the south of Calais (Fig. 48).[16] The English party was based at the town of Guisnes, seen in the left half of the painting. The king entered the town on 5 June accompanied by Catherine of Aragon, who appears not to be represented in the procession. However, several members of the king's suite on horseback can be identified (Fig. 65): Sir Thomas

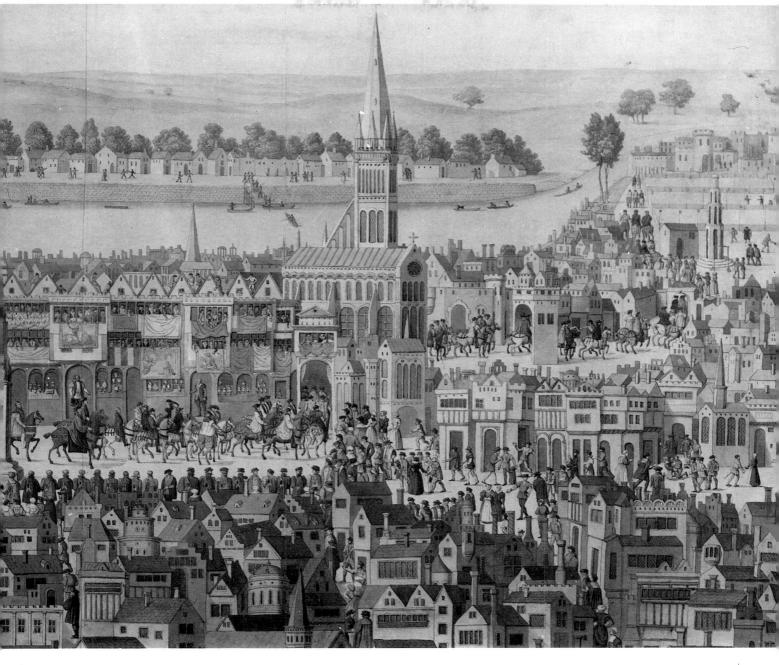

39. Copy by Samuel Hieronymous Grimm after *The Coronation Procession of Edward VI* by an
unknown artist (from the Cowdray House mural). 1785. Drawing, 75.4 x 152.2 cm.
London, Society of Antiquaries. (Cat. No. 41)

Wriothesley, Garter King of Arms, and Thomas Grey,
Marquess of Dorset, who carries the Sword of State, precede
the king. Cardinal Wolsey is alongside, with his cross-bearer
riding ahead. Of the few horsemen behind the king only the
one on the far left, Charles Brandon, Duke of Suffolk, can be
identified. The queen may be the female figure dining in the
tent at the extreme right or she may be in the litter behind that
tent, accompanied by ladies-in-waiting. The foreground of
the right half of the composition is dominated by a palace
erected specially for the occasion by six thousand men from
England and Flanders sent ahead of the royal party in March
to make preparations (Fig. 66). The palace was set on

brickwork foundations, but the walls and roof were made
solely of canvas painted illusionistically to suggest more
solid materials. The framework was of timber specially
imported from the Netherlands and in such quantity that it
had to be floated to Calais because no ship could transport
such a heavy load. The windows were made of real glass and
the facade was adorned with sculpture. This temporary palace
was where Henry VIII and Catherine of Aragon and their
households were domiciled, in the style to which they were
accustomed, and it was here that the main celebrations were
held. In front of the palace were two fountains, each flowing
with wine. Immediately behind the palace was the king's

golden dining tent, with its own facilities for cooking and serving nearby.

In the centre of the composition, at the top, is the meeting of Henry VIII and Francis I in front of another golden pavilion. The event, comprising several formal meetings between the monarchs, was marked by numerous jousts and tournaments (much affected by rain and wind). One such can be seen in the upper right of the painting, being watched by Henry VIII and Francis I with their respective wives. Such a quantity of armour and weapons was required that the steel mill at Greenwich was dismantled and set up at Guisnes temporarily with four forges in full operation. The dragon flying overhead on the left is probably a reference to an elaborately designed firework or rocket that featured in one of the displays that accompanied the numerous masques and banquets, probably that on the Eve of the Nativity of St. John the Baptist, 23 June (for which occasion fireworks are still used today in Florence). The event was stage managed and the strictest formalities of chivalrous etiquette were observed so that one side did not seem to outdo the other. For example, the valley where the kings met was altered so that its natural features would not permit either party to take advantage over the other. The French were based at the town of Ardres (seen in the distance beyond the jousting), which was transformed in a similar way to Guisnes. In the upper left corner of the composition can be seen the castle of Hammes surrounded by water, while Calais lies in the far distance.

The meeting at the Field of the Cloth of Gold derived its name from the sumptuousness of the materials used for the tents, pavilions and other furnishings. It was a spectacle of the greatest magnificence, anticipating Louis XIV or, in a lighter vein, Hollywood in the 1920s. On the basis of contemporary accounts, it is apparent that the artist of *The Field of the Cloth of Gold* has provided a fairly accurate visual summary of the occasion: only the topography of Guisnes (on the left) and the lists (upper right) do not stand comparison with the written sources.

> The whole affair —with its romantic palaces and pavilions, its costly tournaments, and sumptuous banquets —seems a late flowering of the most extravagant medieval chivalry. In the course of the interview, and the preparations for it, every chivalric cliché was encountered... The practice, corresponding to the much vaunted theory of Universal Peace, should have been an attempt to establish friendly relations between nations by using the international language of chivalry. But the reality was far removed from this. The ideal of a united Christendom crumbled upon its foundation of nationalistic prejudice.[17]

Until its gutting by fire in 1793, Cowdray House in Sussex contained a highly important collection of paintings. An inventory of 1777 lists ten works painted on board which depict major diplomatic and military events of Henry VIII's reign.[18]

In addition to these panel paintings, there was in the Dining Parlour a mural divided into five sections, showing four scenes from the French Wars of the 1540s and one depiction of Edward VI's coronation. Unlike the panel paintings, this mural was recorded in engravings (Figs. 37, 39, 59, 60, 62) before its destruction and so it is possible to reconstruct its appearance. The Dining Parlour was a ground-floor room behind the great hall. It had been extensively altered since the mural was painted, principally by the addition of two great windows, but the overall layout of the room can be deduced (Fig. 34).

Moving round the room to the left of the door, *The Departure of Henry VIII from Calais* (Fig. 59) was the first scene, followed by *The Encampment of Henry VIII at Marquison* (Fig. 60) and *The Siege of Boulogne* (Fig. 62). These three sections, divided from each other by vertical lances, took up the entire 38 ft (11.6 m) length of the south wall (Fig. 34: A, B and C). On the opposite wall (Fig. 34: D and E) were painted *The Encampment of Henry VIII at Portsmouth* (Fig. 37) and *The Coronation of Edward VI* (Fig. 39).

Cowdray House was begun by Sir David Owen in 1492. Owen sold the property to Sir William Fitzwilliam, who took up residence in the house in 1535. Fitzwilliam died in 1542 and the house passed to his half-brother, Sir Anthony Browne, who continued to live there until his death in 1548.[19] Both Fitzwilliam and Browne were very close to the king. Fitzwilliam was made Lord High Admiral of England in 1536 and Earl of Southampton the following year. In 1539 he was made Lord Privy Seal, the same year that Browne was made Master of Horse. Browne was later given the important, newly formed post of Lieutenant of the Gentlemen Pensioners. Both men were principal participants in the diplomatic and military events of Henry's later years in France and Scotland.

It is highly significant that of the ten panel paintings Southampton appears as a major figure in five, and in the mural, other than the king, Sir Anthony Browne is clearly the principal figure. Browne was a key participant in the events of 1547 at the time of Henry VIII's death. He was named in Henry's will as one of Edward's guardians and rode to Hertford to inform the prince of the king's death. It was

40 (above right). *The Battle of the Spurs* by an unknown artist. *c.*1545. Canvas, 131.4 x 263.5 cm. The Royal Collection. (Cat. No. 21)

41 (right). *The Battle of the Spurs* by Cornelis Anthoniszoon. 1553. Woodcut, 54.2 x 71.5 cm. Amsterdam, Rijksmuseum (Prentenkabinet)

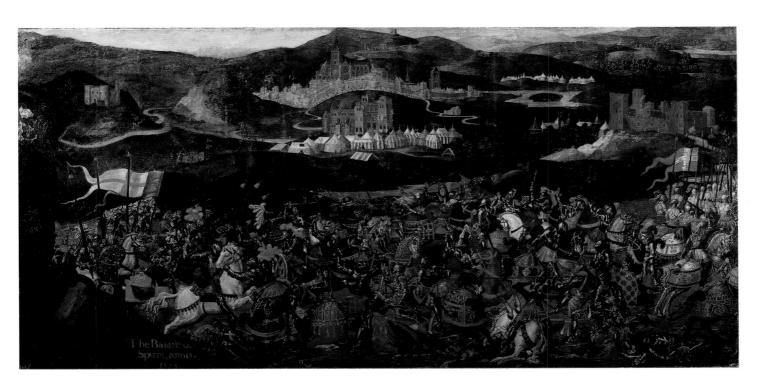

The Batalle of
Spurs, anno
15..

Browne who rode at Edward's side when he made his public entry into London; indeed it was his efficiency which, more than anything, ensured the peaceful accession of Edward VI.[20]

Browne's leading role in all the events portrayed in the Cowdray mural make it certain that the work was commissioned by him. The inclusion of the coronation of Edward VI enables the paintings to be closely dated. Edward was crowned in January 1547 and Browne died in May 1548. The mural must, therefore, have been painted between those dates.

Nothing is known of the paintings on board lost in the 1793 fire, but some observations can be made about the mural. First, in style it is very close to two paintings in the Royal Collection. *The Field of the Cloth of Gold* (Fig. 48) and *The Embarkation of Henry VIII at Dover* (title-page) contain buildings and figures which may be by the same hand as the Cowdray House painting. The nature of the compositions is also very similar, a series of scenes from one overall event are telescoped in time and place and shown together in a series of banded interludes across the picture.

It is suggested here that the same hands were possibly responsible both for these two royal paintings and for the Cowdray mural. Furthermore, amongst the paintings on board at Cowdray House there were also two pictures which must have been very similar to the royal versions of the Field of the Cloth of Gold and the meeting of Henry and Maximilian (Fig. 38), a description of the latter sounding particularly close.[21] This correspondence of paintings and artists is a striking example of an expression of loyalty to the Crown by a particular subject. It is also an unusual example of royal craftsmen working on commissions from a courtier.

The great mural at Cowdray House illustrated Henry's final campaign against the French in the last years of his reign. In illustrations of the earlier campaigns Henry had been a young, handsome warrior (Fig. 18), but he was now advanced in age, corpulent, difficult, and ill (Fig. 45). He had no Cromwell or Wolsey to advise him and he personally led his armies against the old enemy – France.

The English army, led by the Dukes of Suffolk and Norfolk, crossed the Channel in early June 1544 and landed at Calais. The king arrived on 14 July and set out with the Duke of Suffolk (Fig. 59) a week later to besiege Boulogne, while the Duke of Norfolk laid siege to Montreuil. The king camped at Marquison (today known as Marquise), half-way between Calais and Boulogne (Fig. 60). Boulogne put up a stout resistance, not surrendering until 14 September (Fig. 62). Henry entered the town four days later. This victory was a considerable boost for the ageing monarch, and he returned to England on 30 September. Yet, the campaign had not been an overall success and in military terms it 'was a muddle even by the generous standards of the time'.[22] The one gain, namely Boulogne, was suddenly and ineptly abandoned by Suffolk and Norfolk, who returned to Calais and soon afterwards to England, leaving the French to reclaim the town.

The whole expedition had been immensely costly (some £650,000) and Henry was now forced onto the defensive. During the summer of 1545 England faced the threat of invasion from Francis I, who had mustered a fleet of over two hundred ships. The danger to Henry was no less than that later faced by Elizabeth I from the Spanish Armada in 1588. The French fleet sailed into the Solent on 19 July and landed troops on the Isle of Wight and at Seaford on the south coast, only to withdraw almost immediately.

The English fleet set sail from Portsmouth on 9 August to engage the French (Fig. 37). A combination of bad weather and a preliminary skirmish caused the French fleet to withdraw and the immediate danger passed. However, the skirmish was a huge humiliation for the English forces, for during manoeuvres the *Mary Rose* capsized, as can be seen in the middle distance of Fig. 37, where the vessel is shown with only its masts above the water. Built in 1509 and refitted in 1536, the *Mary Rose* was Henry VIII's flagship, upon which the king had dined only hours before its loss. According to contemporary accounts, the vessel keeled over suddenly and, being heavily armed, took in water through its gun ports and sank rapidly. On board was Henry's vice-admiral, Sir George Carew, who, together with most of the crew, lost his life. All this took place in full view of the king, who is shown in the engraving, on horseback, observing the scene.[23]

Henry gained 'little more than "ungracious dogholes" and ephemeral international prestige'[24] from his wars on the continent of Europe. His campaigns starkly revealed the shortcomings of a policy based on that of forebears such as Edward III and Henry V and conducted in a style governed by an outmoded form of chivalry. Most of all, his various sorties had led to near bankruptcy, despite the huge release of wealth gained from the Dissolution of the Monasteries. Instead of forming a sound foundation for future Crown finances this wealth was swallowed up in one gulp by the king's last French war.

and Princely Magnificence

Few English monarchs have been so concerned as Henry VIII about their image and few have been so successful in imposing it upon posterity. As one historian of the Tudor period has expressed it, 'No king of England is more familiar to his countrymen; indeed, he is the only one whose portrait the vast majority would recognise on sight.'[1] The reason for this lies in the happy conjunction of a supremely egotistical monarch with an outstandingly talented artist. Henry VIII's reign resulted in the transformation of the English court, which could now stand comparison with those created in the Renaissance style by the rulers of France, Spain, Italy and the Holy Roman Empire.

The introduction of Renaissance court art in England was due as much to Henry VII's achievements as to his son's personality. As has been seen, Henry VII had of necessity diligently concerned himself with the security of his dynasty at home and abroad, the growth of wealth, the working of law and order, and the exertion of his influence in European affairs. It is easy to argue that these policies were pursued to the exclusion of everything else, but this was not the case. He spent lavishly on architectural projects such as the Savoy Hospital (now lost), various ecclesiastical foundations, and the royal palaces at Richmond and Greenwich. His most important memorial, however, is the Chapel of Henry VII (Fig. 2) at the east end of Westminster Abbey. This contains the posthumous (c.1511/12) effigies of the king, his wife Elizabeth of York, and his mother Lady Margaret Beaufort, sculpted by the Florentine sculptor Pietro Torrigiano (1472–1520), to designs approved by the young Henry VIII. Torrigiano also sculpted a bust of Henry VII (c.1510), now thought to be based on a death-mask (London, Victoria and Albert Museum).[2] Henry VII himself had also had close contact with Italian courts. The administration of the Savoy Hospital, for example, was based upon the hospital of S. Maria Nuova in Florence.[3] When Henry honoured Guidobaldo da Montefeltro, Duke of Urbino, with the Order of the Garter, the event was celebrated in a painting by Raphael of *St. George and the Dragon* (Fig. 13), which may have been presented to the king to mark the occasion.[4] Furthermore, there is in the Royal Collection a terracotta head of a young boy identifiable as the young Henry VIII that is certainly Italian in conception if not in execution (Fig. 42).[5] As Polydore Vergil wrote in c.1512–13, Henry VII 'was not devoid of scholarship'.[6] It is not unlikely, therefore, that

Henry VIII should have felt these influences during his upbringing, and in 1499, when Erasmus in the company of Sir Thomas More saw the royal children at Eltham, Prince Henry's precocity was already evident.[7] Of greater significance, however, was the change of circumstances between the reigns of Henry VII and Henry VIII. The latter 'ascended to a throne which his father had made remarkably secure, he inherited a fortune which probably no English king had ever bequeathed, he came to a kingdom which was the best governed and most obedient in Christendom'.[8] The burgeoning dominance of Henry VIII's personality, combined with this legacy, ushered in a period of profound political and religious change, as well as a turning-point in the history of art in Britain.

Ambassadorial reports herald this note of change. In 1515, six years after Henry VIII acceded to the throne, the Venetian ambassador recorded:

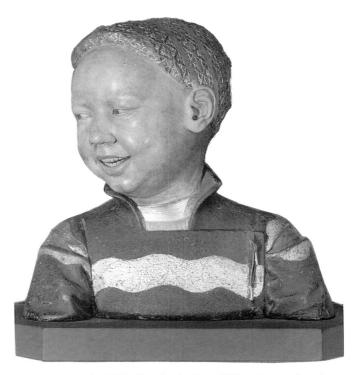

42. Bust of a child believed to be Henry VIII as a boy, attributed to Guido Mazzoni. c.1500. Terracotta, height 31.8 cm. The Royal Collection

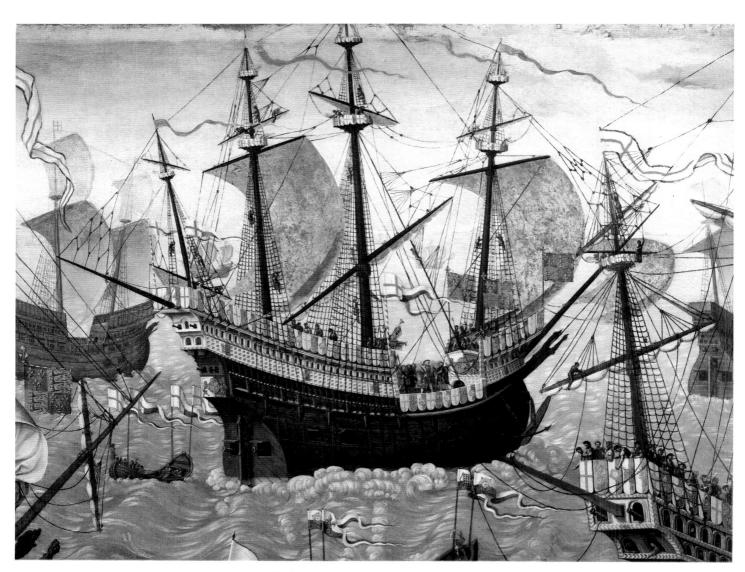

43. *Henry VIII on board 'Henri Grace-de-Dieu'*.
Detail of *The Embarkation* (see title-page)

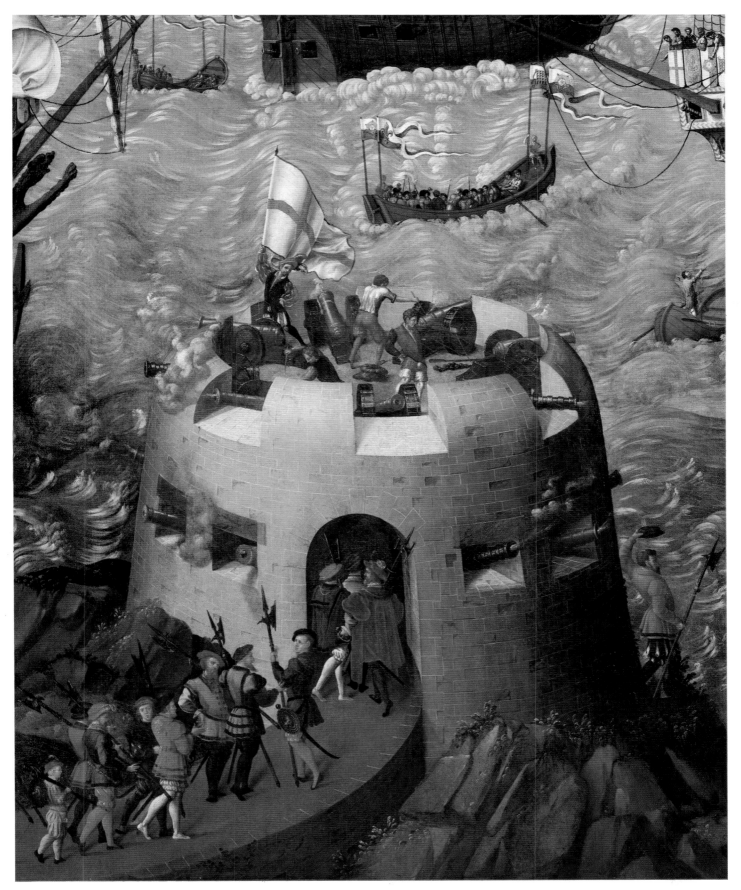

44. *A Fort in Dover Harbour*. Detail of *The Embarkation* (see title-page)

This most serene king is not only very expert in arms, and of great valour, and most excellent in his personal endowments, but is likewise so gifted and adorned with mental accomplishments of every sort that we believe him to have few equals in the world. He speaks English, French and Latin; understands Italian well; plays almost on every instrument; sings and composes fairly; is prudent and sage, and free from every vice.[9]

Something of this mental and physical vitality can be discerned in the early likenesses of Henry VIII made in miniature by Lucas Hornebolte (Figs. 98–9).

Another Italian, Francesco Chieregato, wrote to the influential Isabella d'Este at the court of Mantua, reporting on the English court in equally favourable terms:

In short, the wealth and civilisation of the world are here; and those who call the English barbarians appear to me to render themselves such. Here I perceive very elegant manners, extreme decorum, and very great politeness, and amongst other things there is this most invincible king, whose acquirements and qualities are so many and excellent that I consider him to excel all who ever wore a crown; and blessed and happy may this country call itself in having as its lord so worthy and eminent a sovereign, whose sway is more blessed and gentle than the greatest liberty under any other.[10]

At the outset, therefore, Henry VIII appeared as a *stupor mundi*.

For the first part of his reign ambassadors continued to extol Henry VIII's personal abilities and physical advantages, but the course of events and the workings of time soon eroded the promise of the early years, even if they did not quench the king's indomitable will or sense of opportunism. The engraving by Cornelis Matsys illustrates the physical change that was wrought in the king during the course of time (Fig. 45). In the words of the historian G.R. Elton, 'Unquestionably his physical grossness, suspicious arrogance and political dexterity all grew more marked as self-indulgence and the effects of adulation worked on one of the most purely egotistical temperaments known to history.'[11]

Art, however, provided a consistency to the reign of Henry VIII that was lacking in other respects. The king chose his servants spectacularly well, as evidenced by the complementary strengths of Wolsey and Cromwell. Yet, he himself remained a determined opportunist throughout his reign. Even if he did not devise his own policies in detail, it was the king's personality that lay behind their direction. 'No person was ever more monarchical, no monarchy more personal in this sense, than Henry VIII's.'[12] It is this duality to which Holbein gave the most perfect expression.

Hans Holbein the Younger had been born into a family of

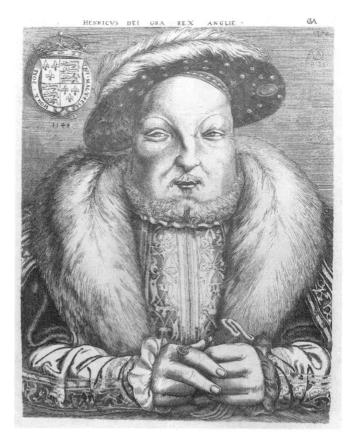

45. *Henry VIII* by Cornelis Matsys. Engraving, 17.6 x 13.3 cm. Windsor Castle, The Royal Library

artists in the imperial city of Augsburg in 1497/8. Like his father, he began as an able painter of large-scale altarpieces and as a designer of stained-glass windows for churches, working in a late Gothic or nascent Renaissance style. Later he painted only a few independent and highly unusual religious works – *Noli me Tangere* (Royal Collection, Hampton Court), *The Body of the Dead Christ in the Tomb* (Basle, Kunstmuseum) and *The Old and the New Law* (Edinburgh, National Gallery of Scotland). Although his youth was spent in Augsburg, Holbein had two extended periods of activity in Basle (1515–26 and 1528–31/2). He seems to have visited France in *c*.1524 and first came to England in 1526 for a stay of two years, when he painted *The Family of Sir Thomas More* (now only known through a copy). He was also employed intermittently at the court by Sir Henry Guildford, the Comptroller of the Royal Household, acting in his capacity as Master of the Revels. On this first visit, Holbein was able to establish a reputation for himself in England as a portraitist of distinction, so that he was in considerable demand when he returned to the country finally in 1532. It seems that on this second visit Holbein was

46. Armour of Henry VIII. *c*.1540. Overall height 183 cm.
The Royal Collection

47. Design for a gold cup for Jane Seymour, by
Hans Holbein the Younger. 1536.
Drawing, 37.6 x 15.5 cm (irregular). Oxford, Ashmolean Museum

taken up by the merchants of the Hanseatic League and also by Anne Boleyn, the king's second wife.[13] He was now, therefore, moving in reformist circles and during these years he designed the illustrations for the Coverdale Bible (Fig. 25) and made the miniature of *Solomon and the Queen of Sheba* (Fig. 19). It is not known exactly when Holbein entered royal service officially as 'the King's Painter', but it must have

been during the mid-1530s, by 1536 if not slightly before. He earned a salary of £30 per annum, paid on a quarterly basis.[14] Holbein was undoubtedly the most outstanding artist to that date ever to have been appointed to the post of the King's Painter and his impact was considerable. Not only were his abilities as a portrait painter put to full use, but he was also expected to design jewellery, and decorations for weapons,

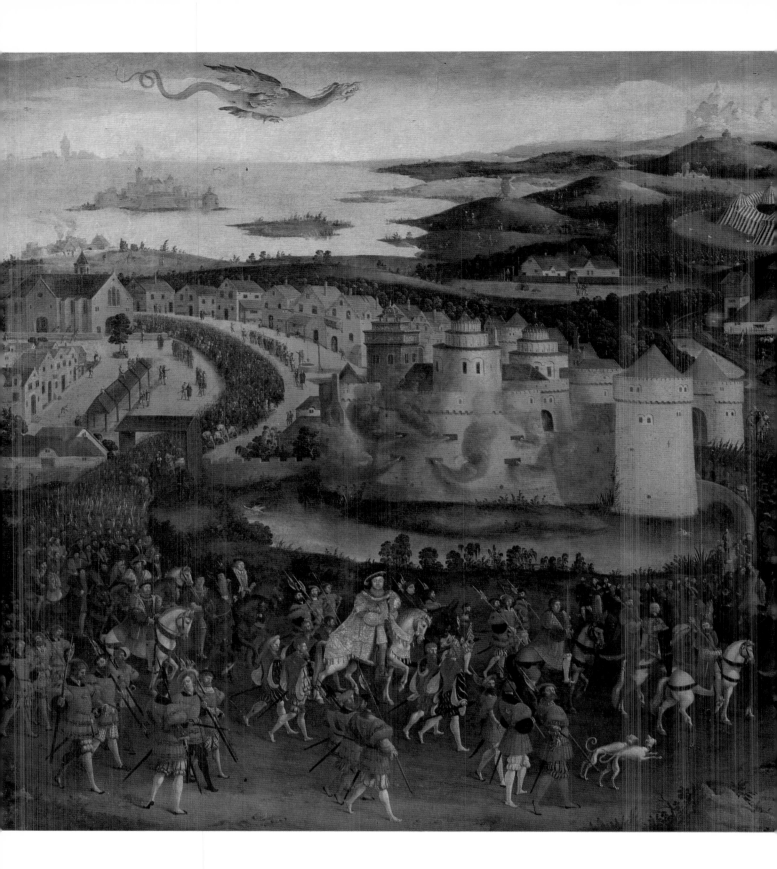

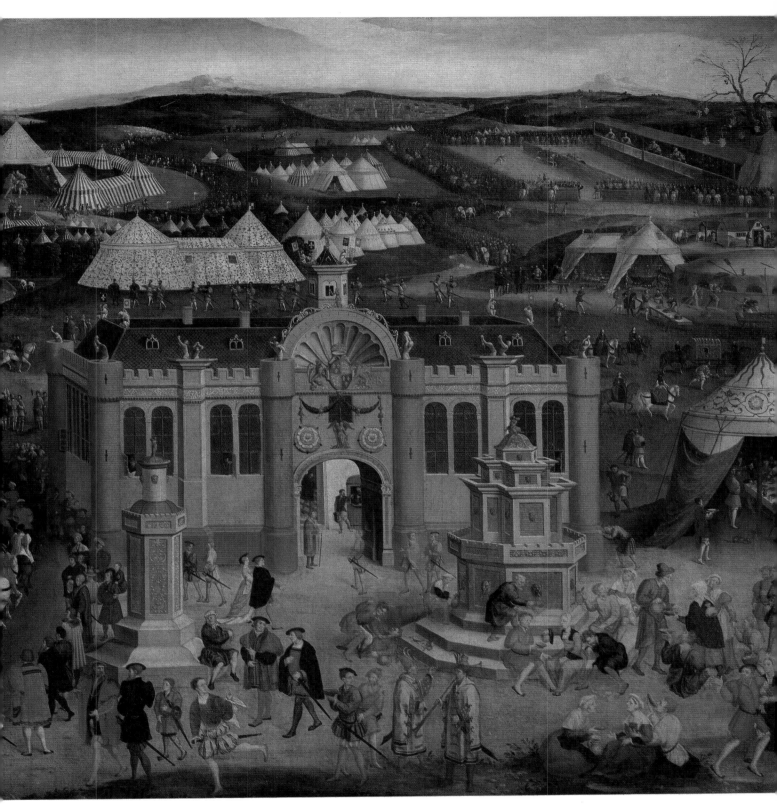

48. *The Field of the Cloth of Gold* by an unknown artist. *c.*1545.
Canvas, 168.9 x 347.3 cm. The Royal Collection. (Cat. No. 23)

Le feu Roy francois premier

49. *Francis I* by Jean Clouet. *c.*1525. Drawing, 26.5 x 19 cm.
Chantilly, Musée Condé

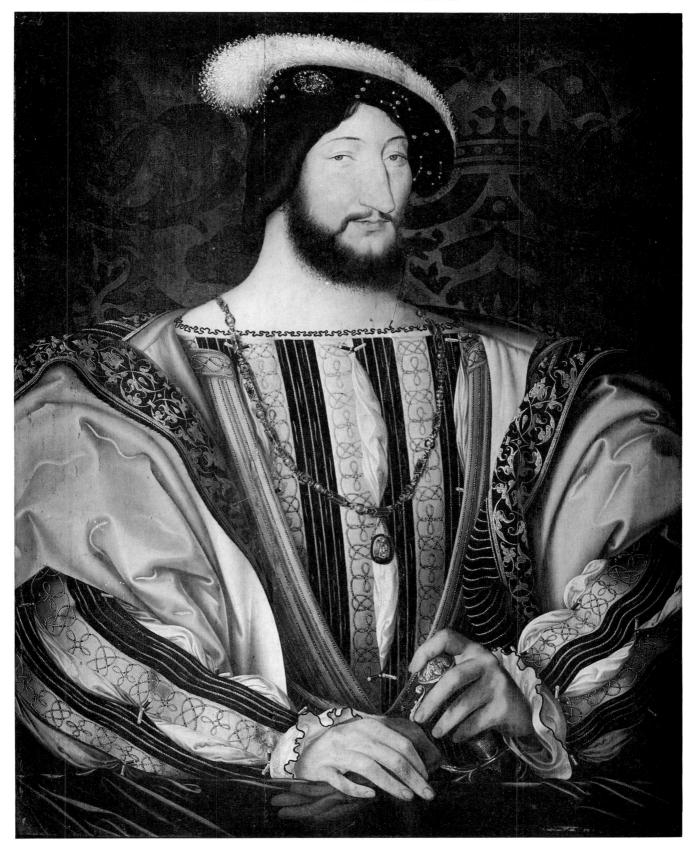

50. *Francis I* by Jean Clouet. *c.*1525. Panel, 96 x 74 cm.
Paris, Musée du Louvre

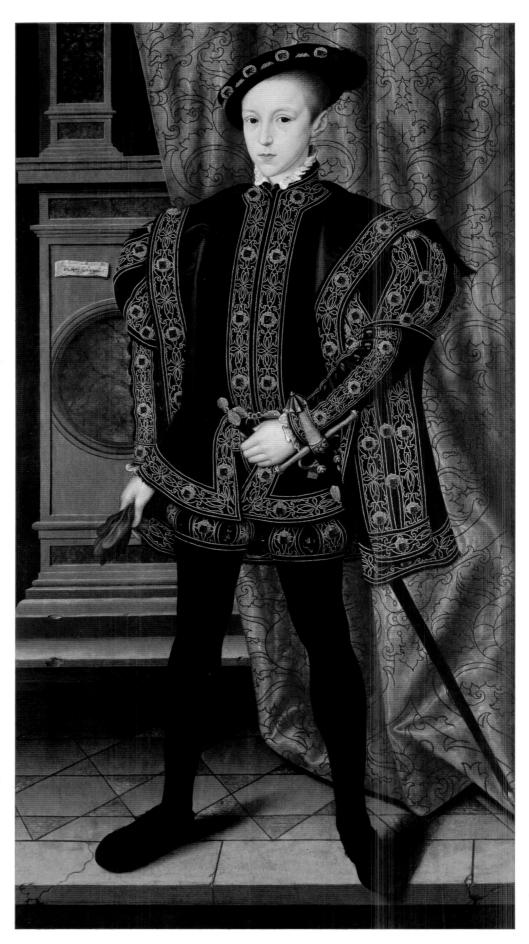

51. *Edward VI*, attributed to
William Stretes. *c*.1550.
Panel, 167 x 90.8 cm.
The Royal Collection.
(Cat. No. 4)

52 (right). *The Young Edward VI* by
Hans Holbein the Younger. *c*.1539.
Canvas, 57 x 44 cm.
Washington, D.C.,
National Gallery of Art

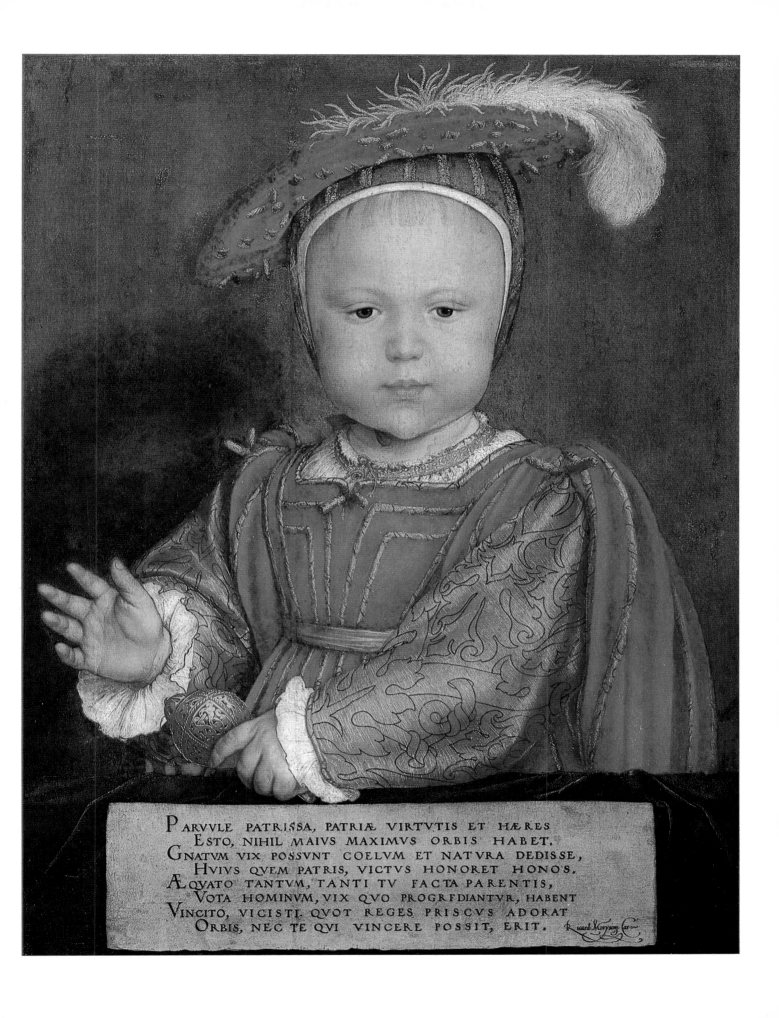

PARVVLE PATRISSA, PATRIÆ VIRTVTIS ET HÆRES
ESTO, NIHIL MAIVS MAXIMVS ORBIS HABET.
GNATVM VIX POSSVNT COELVM ET NATVRA DEDISSE,
HVIVS QVEM PATRIS, VICTVS HONORET HONOS.
ÆQVATO TANTVM, TANTI TV FACTA PARENTIS,
VOTA HOMINVM, VIX QVO PROGREDIANTVR, HABENT
VINCITO, VICISTI. QVOT REGES PRISCVS ADORAT
ORBIS, NEC TE QVI VINCERE POSSIT, ERIT.

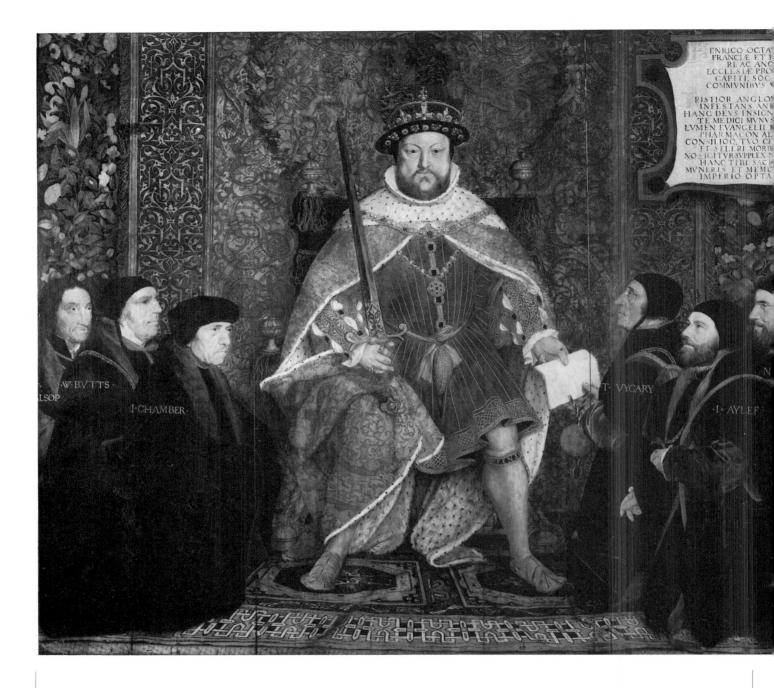

53. *Henry VIII and the Barber-Surgeons* by Hans Holbein the Younger. 1540. Panel, 108.3 x 312.4 cm. London, Barber-Surgeons Hall

The painting was probably commissioned in 1540 to commemorate the union of the Company of Barbers with the Guild of Surgeons. The cartouche reads:

'To Henry the eigth the best and greatest King of England. . . Defender of the Faith, and next to Christ, supreme Head of the Church of England and Ireland. . .'

gold and silverware (Fig. 47), as well as items of a more ephemeral character for entertainments, jousts, tournaments, and processions. Holbein's skill in designing ornaments and his expertise in devising intricate decorative patterns is apparent in the details that characterize so many of his portraits.

Holbein's first major commission from Henry VIII was for a

mural to adorn the wall of one of the rooms in Whitehall Palace (see Figs. 14, 15). This was painted in 1537, but was burnt in the fire of January 1698. As has been shown, the significance of *The Whitehall Mural* is underlined by the fact that Henry VIII's pose became the definitive image of the king. This is characterized by the legs placed firmly astride, the arms at the sides bent in such a way as to stress the corpulence of the figure, and the gaze directed straight out at

the viewer. In art-historical terms, the pose has several features in common with the *St. George* sculpted (*c.*1415) by Donatello for Or San Michele in Florence and it can also be found in the work of Andrea del Castagno, Antonio Pollaiuolo and Pietro Perugino.[15] It has been pointed out that on comparing this image with the suit of armour (Fig. 46) made for Henry VIII in *c.*1540 at the Greenwich Armouries, it can be seen that Holbein has falsified the proportions of the

lower part of his figure so that the legs seem much longer.[16]

Several important whole-length and half-length versions of this figure from the mural were made by studio assistants and followers, which testifies to the potency of the image. The pose no doubt proved so effective because at the time it must have seemed strikingly novel. Although Richard II is shown full-face in the portrait in Westminster Abbey and although there may be some connection with royal representations on seals for charters (Fig. 27), there is nothing stereotyped about Holbein's image. The angle of the shoulders, the position of the feet, the slant of the cap and the hang of the arms create an internal rhythm that evoke the feeling of a powerful physical presence looming out of the picture space. The pose had been anticipated to some extent by Holbein in the *Portrait of Charles de Solier, Sire de Morette* (Dresden, Gemäldegalerie) dating from *c.*1534, just as the whole composition is in some respects comparable with the so-called *The Ambassadors* (London, National Gallery), painted in 1533. The measure of Holbein's achievement in depicting Henry VIII can be gauged by comparing the earlier historical portraits in the Royal Collection (Figs. 3, 5–7, 89), the style of which is based on the art of the medal or coins (Fig. 24). It is highly significant that the pose originated by Holbein was later used for depictions of the king's son, Edward VI (albeit in reverse in this particular instance, Fig. 51), who acceded to the throne at the age of ten. The strength and resolve of the father was thus seen to have been inherited by the son, a situation that was not in fact upheld by events.

One important discrepancy between the cartoon for *The Whitehall Mural* and the final composition may be observed. The position of the head has been changed from the three-quarter profile favoured in the cartoon (Fig. 14) to the full-face chosen for the mural itself. The position of the head in the cartoon coincides, as it happens, with the portrait of the king as shown in the Thyssen portrait (Fig. 69), which was almost certainly painted a year before the mural. This alteration indicates a late change of mind and the king might have had to pose again for the artist.

The Thyssen portrait is the only surviving image of Henry VIII painted entirely by Holbein himself. Half-length and set against a plain blue background the portrait in many ways resembles an icon. The plain background is a stylistic feature common to several of Holbein's later portraits and serves to silhouette the outline of the figure and to offset the detailed rendering of the clothes. The status of the king is unmistakable. What may be termed the propagandist elements of the portrait are emphasized by Holbein's realistic and wholly convincing depiction of the facial features and the richly embroidered, bejewelled garments highlighted with

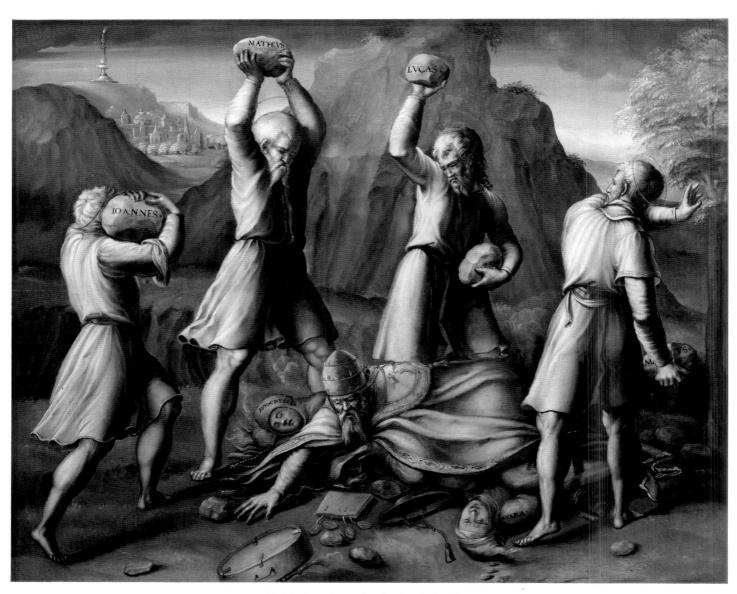

54. *The Four Evangelists Stoning the Pope* by
Girolamo da Treviso the Younger. *c.*1540. Panel, 68 x 84.4 cm.
The Royal Collection. (Cat. No. 15)

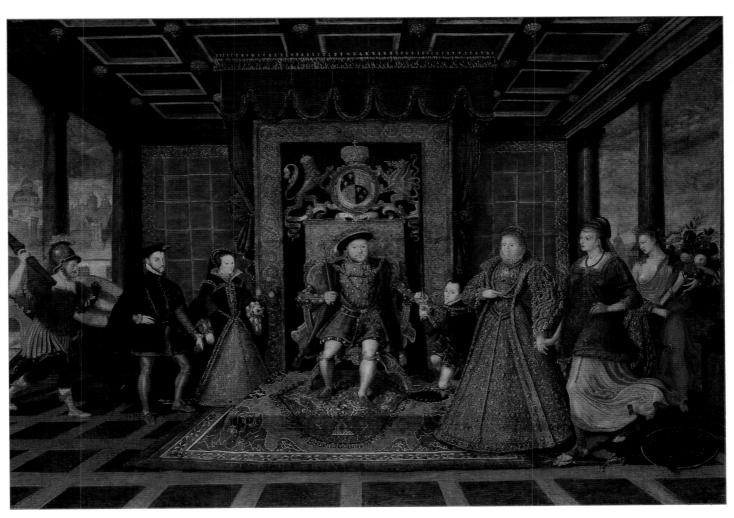

55. *Allegory of the Tudor Dynasty* attributed to
Lucas de Heere. *c*.1572. Panel, 129.5 x 180.3 cm.
Sudeley Castle, The Lady Ashcombe

56. *Elizabeth I when Princess*, attributed to William Stretes.
c.1547. Panel, 108.9 x 81.6 cm. The Royal Collection

gold (particularly the collar of the undershirt). There is a marked contrast between the openness of the smoothly modelled, carefully structured face and the intricate rendering of the clothes, but the emphasis on line throughout is one of the main hallmarks of Holbein's style. The overall effect is one of monumentality, which is exaggerated by the small dimensions of the panel. The sheer bulk of the king is only just contained within the picture space and the arms and hands are undeniably cramped. The viewer is initially aware of the outline and presence of the figure, and only then does

one become absorbed by the precise observation of the fur, the precious stones, the pendant, the silver and gold. The image is not necessarily a flattering one: it is intended to exude a sense of supreme self-confidence and overweening power. All the facets of Holbein's skill as a portraitist are concentrated in this work in the sense that it is a perfect fusion between the monumental and the miniature.

The portrait was in all probability painted by Holbein in 1536 either at the time of Henry VIII's marriage to his third wife,

57. *Unknown Woman in a Masque Costume*, attributed to
Marcus Gheeraedts the Younger. *c*.1590–1600.
Canvas, 217 x 135.3 cm. The Royal Collection. (Cat. No. 33)

58. *Virgo Persica* from J.J. Boissard,
Habitus variarum orbis gentium. . .
1581. Woodcut

Jane Seymour, or shortly after. Anne Boleyn was beheaded on 19 May 1536 and the marriage took place on 30 May. Jane Seymour, who had been a lady-in-waiting to Catherine of Aragon and Anne Boleyn, died a year later, two days after giving birth to a male heir, the future Edward VI. The Thyssen portrait appears never to have been recorded in the Royal Collection and it is not listed in either of the inventories made in 1542 and 1547. Possibly, the portrait never entered the king's possession or, if it did, he may have given it away fairly promptly. It next appeared in the collection of Robert Spencer, second Earl of Sunderland (1641–1702), who was an important seventeenth-century politician, diplomat and collector.[17] The portrait then passed by descent through the Spencer family at Althorp House until it was sold in 1934. A portrait of this surprisingly small size is essentially a cabinet picture and may have formed the left wing of a diptych, with a matching image on the right, such as a portrait of Jane Seymour. A diptych or double portrait of this sort is recorded in the royal inventories of 1542 and 1547 but without an attribution.[18] However, the constituent

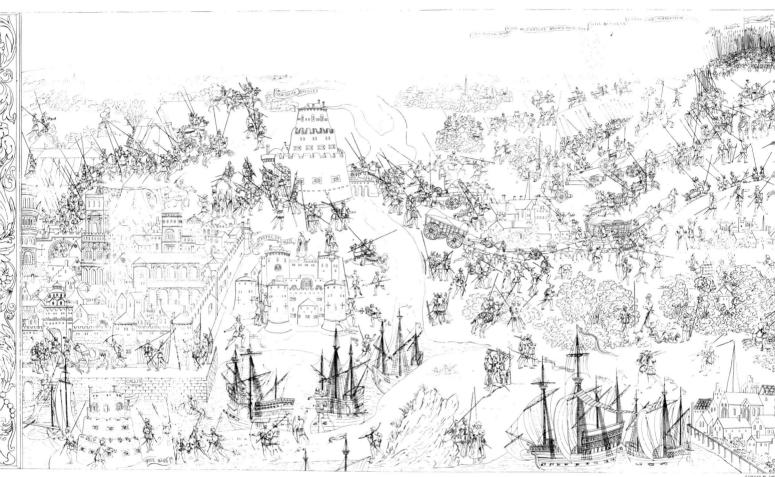

THE DEPARTURE OF KING HENRY VIII FROM CALAIS, JULY XXV MDXLIV.

ENGRAVED FROM A COEVAL PAINTING AT COWDRAY IN SUSSEX, THE SEAT OF LORD VISCOUNT MONTAGUE

59. *The Departure of King Henry VIII from Calais*
by James Basire (from the Cowdray House mural).
1788. Engraving, 59 x 90.5 cm.
Windsor Castle, The Royal Library. (Cat. No. 24)

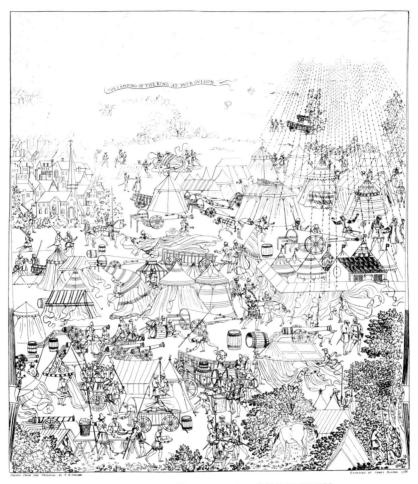

THE CAMPING OF THE KING AT MORQVISON

Drawn from the Original, by S. H. Grimm. Engraved by James Basire, 1788.

THE ENCAMPMENT OF KING HENRY VIII. AT MARQUISON, JULY MDXLIV.

ENGRAVED FROM A COEVAL PAINTING, AT COWDRAY IN SUSSEX, THE SEAT OF LORD VISCOUNT MONTAGUE.

60. *The Encampment of King Henry VIII at Marquison*
by James Basire (from the Cowdray House mural).
1788. Engraving, 59.5 x 46.5 cm.
Windsor Castle, The Royal Library.
(Cat. No. 25)

elements of this listed diptych do not seem to have survived. Furthermore, neither of the two known images of Jane Seymour (Vienna, Kunsthistorisches Museum, and The Hague, Mauritshuis) makes a suitable pair with the Thyssen portrait as regards composition, size or quality (Fig. 70). The Thyssen portrait is therefore likely to have been made as a diplomatic gift. Although it differs in form from the *Portrait of Henry VII* usually attributed to Michael Sittow (Fig. 4), the function is comparable.

The degree to which Holbein was working in accordance with Renaissance principles while at the English court is apparent by comparison with the portraits of Francis I and his wife Eleanora of Austria in the Royal Collection (Figs. 76–7). The Flemish artist Joos van Cleve (who also painted Henry VIII, Fig. 95) worked for Francis I at the French court probably between 1529 and 1534. The French king was one of the major patrons of the arts during the Renaissance. He attracted Leonardo da Vinci to Amboise, and he commissioned a memorable decorative scheme from Primaticcio, Rosso Fiorentino and Niccolò dell'Abate for the principal gallery in his palace at Fontainebleau (the Galerie François I). Just as Henry VIII later employed Holbein, in 1516 Francis I employed the services of a talented portraitist, Jean Clouet, who, like Joos van Cleve, was probably from the Netherlands.[19] Clouet's masterpiece is the portrait of Francis I in the Musée du Louvre (Fig. 50), but he is perhaps more famous for the numerous coloured-chalk drawings of heads that he made as the starting-point for his portraits (Fig. 49). These drawings are now at the Musée Condé in Chantilly and in the Bibliothèque Nationale in Paris.

Although no portrait drawings by Joos van Cleve are known, it may be that he used similar preparatory processes. In his portraits of Francis I and Eleanora of Austria the heads are attached to the bodies somewhat arbitrarily, which perhaps signifies a certain reliance on drawings (not necessarily even his own). A certain Italian influence (notably of Leonardo da Vinci and his Lombard followers) in his work is here detectable in the emphasis on the hands that enlivens these two pictures. In the case of the king's portrait the gesture made with his right hand pushes out of the picture space into the viewer's space. By contrast, in the Thyssen portrait Holbein's treatment of the hands is more schematized, or, at best, more restrained. The effect of these portraits, whatever the differences in handling or whatever the countries of origin, is the same. The images are direct and their purpose is unmistakable. They all partake of the *realpolitik* of the European Renaissance, where the appearance and the achievements of individual rulers personified the character of their governments. By contrast, the group portrait of *Henry VIII and the Barber-Surgeons*, begun by Holbein for that city company in 1540 (Fig. 53), serves a similar purpose, but conveys its meaning in a more traditional way.[20]

If Henry VIII encouraged this type of portraiture at the English court, his daughter Elizabeth I both perpetuated and extended it. The half-length portrait of the queen holding a feather fan (Fig. 80) operates within the same constraints that Holbein used in the Thyssen portrait of Henry VIII. This portrait dates from the 1580s and is somewhat removed both in concept and characterization from the far more famous image of *Elizabeth I when Princess* in the Royal Collection (Fig. 56). Yet, in contrast to such straightforward image-making, the queen also encouraged the representation of herself in an emblematic or allegorical mode, as in the famous Ditchley Portrait in the National Portrait Gallery (Fig. 81), or the 'Sieve' Portrait, the 'Ermine' Portrait and the 'Rainbow' Portrait, all known in several versions.[21] Until the second half of the nineteenth century it was claimed that the *Unknown Woman in a Masque Costume* (Fig. 57), which is close in date to the Ditchley Portrait and related in style to Marcus Gheeraedts the Younger, was a portrait of Queen Elizabeth I. The sitter is in fact unknown, but she is depicted in Persian dress, possibly worn at a court masque. The costume, particularly the headdress, is derived from an engraving (entitled *Virgo Persica*) in J.J. Boissard's *Habitus variarum orbis gentium* published in 1581 (Fig. 58). The imagery, involving a stag and a tree, may be interpreted in combination with the verses in the cartouche in the lower right corner to conjure up the meaning of the portrait:

> With pensive thoughtes my
> weeping Stagg I crowne
> whose Melancholy teares my cares
> Expresse
> her Teares in sylance, and my
> signes unknowne
> are all the physicke that my
> harmes redresse.

This, like similar portraits of the Elizabethan period, belongs to a cerebral, somewhat rarefied world. It would obviously have been more accessible to contemporary viewers than it is for us today, but, none the less, even in the sixteenth century the distinction between Holbein's *Henry VIII* and this type of allegorical portrait would have been clear-cut.

and the Antiquarian Tradition

It has already been seen to what extent the early Tudors were dependent upon the role of historical interpretation for the establishment of their dynasty. This development in historical consciousness was an important factor in the emergence of a school of historical writing in England.[1] Significantly, the first historian to emerge during the reign of Henry VII was an Italian, Polydore Vergil (?1470–?1555), who was born in Urbino and came to England in 1502 as the result of a papal appointment, remaining there for most of the rest of his life. He was a friend of Erasmus and had an established reputation as a writer, although he wrote in Latin and so his work had to be translated into English. His history of England from the beginning to his own time was written at the behest of Henry VII. It was printed in 1534 and was added to subsequently. As a humanist, Polydore Vergil aspired to the tradition of Livy or Tacitus, but at the same time he transcended these role-models by exercising his critical faculties in the search for impartiality and for motives. For Polydore Vergil, the working of history is governed by cause and effect, which is by no means related to an all-embracing system, but is simply the result of ordinary decisions governed by human nature. In addition to chronicling events, the historian has to take into account moral considerations.

The *Chronicle* of Edward Hall (d. 1547) is of considerable consequence. Ostensibly, Hall's history of England extends from the reign of Henry IV to that of Henry VIII, but in fact nearly half of the book is devoted to the latter. Hall was educated at Eton and King's College, Cambridge, from where he went to Gray's Inn and became a professional lawyer and major legal official of the City of London. With these credentials he was perfectly situated to observe events. The emphasis of the *Chronicle* is more than ever before on the moral dimension of history – the exercising of good or evil by powerful men who play influential roles in the tide of

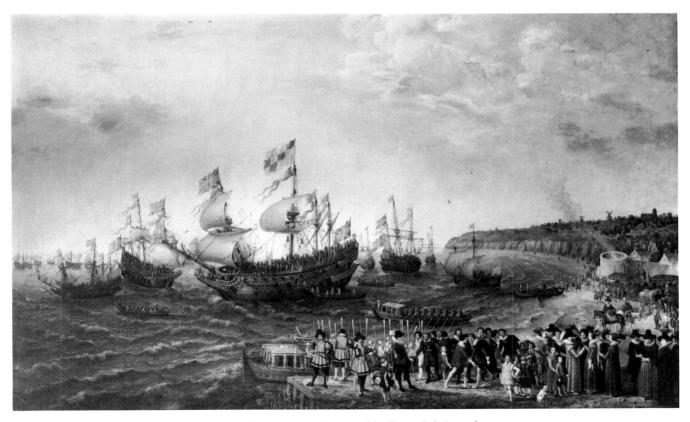

61. *The Embarkation at Margate of the Elector Palatine and Princess Elizabeth* by Adam Willaerts. 1623.
Canvas, 121.9 x 196.9 cm. The Royal Collection

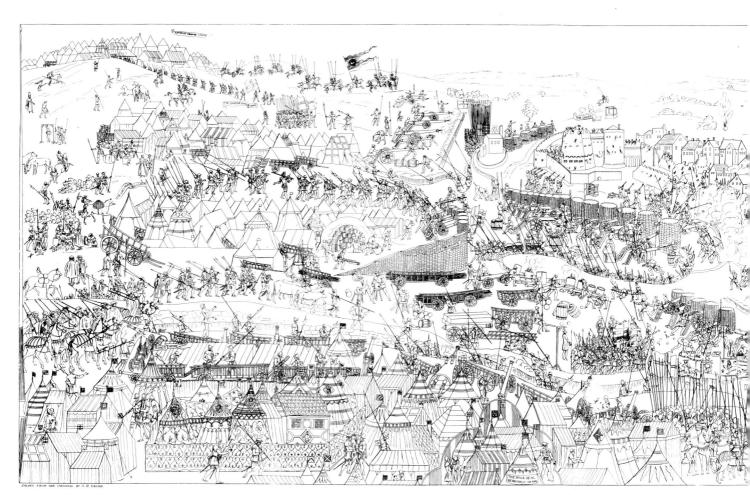

THE SIEGE OF BOULOG

DRAWN FROM THE ORIGINAL BY S. H. GRIMM.

SUMPTIBUS SOCIETATIS ANTIQUARIORUM LONDINI.

ENGRAVED FROM A COEVAL PAINTING, AT C

KING HENRY VIII MDXLIV.

SUX, THE SEAT OF LORD VISCOUNT MONTAGUE.

62. *The Siege of Boulogne* by James Basire
(from the Cowdray House mural). 1788.
Engraving, 65.7 x 169.3 cm.
Windsor Castle, The Royal Library.
(Cat. No. 26)

63. *Sarah Siddons as Catherine of Aragon*, a detail from the painting by G.H. Harlow, *The Kemble Family in the Trial Scene from Henry VIII*. 1817. Engraving, 23.5 x 15.3 cm.
Oxford, Ashmolean Museum (Hope Collection)

events. Hall's approach is hinted at in the titles to his chapters: 'The unquiet time of King Henry the Fourth', 'The victorious acts of King Henry the Fifth', 'The troublous season of King Henry the Sixth', leading in the eighth chapter to 'The triumphant reign of King Henry the Eighth'. Hall appreciated the drama of history and his style matched his sense of purpose. His *Chronicle*, which was dedicated to Edward VI and prohibited by Mary I, is a primary source for the reign of Henry VIII, and his accounts of the principal events are detailed and enthralling. Hall was also a great believer in the Tudor myth extolling the virtues of the Reformation and the new autocracy established by the dynasty, and he thus saw Henry VIII's reign as being the summation of the policy initiated by the king's father.

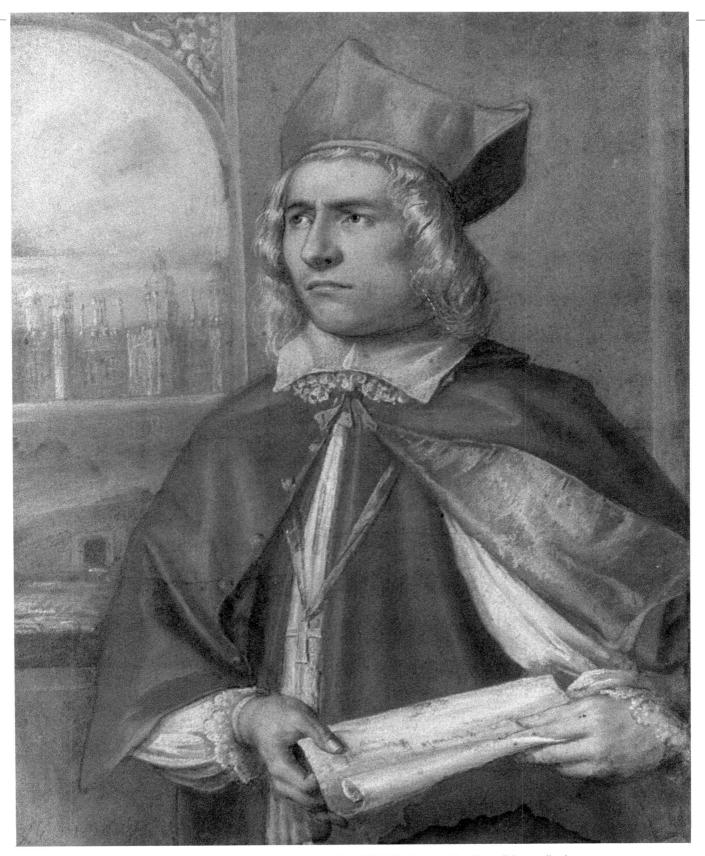

64. *Henry Harris as Cardinal Wolsey* by John Greenhill. 1664. Drawing, 41 x 31 cm. Private collection
One of the earliest known representations of an English actor in costume.
Henry Harris had a long theatrical career from 1661 until 1699.

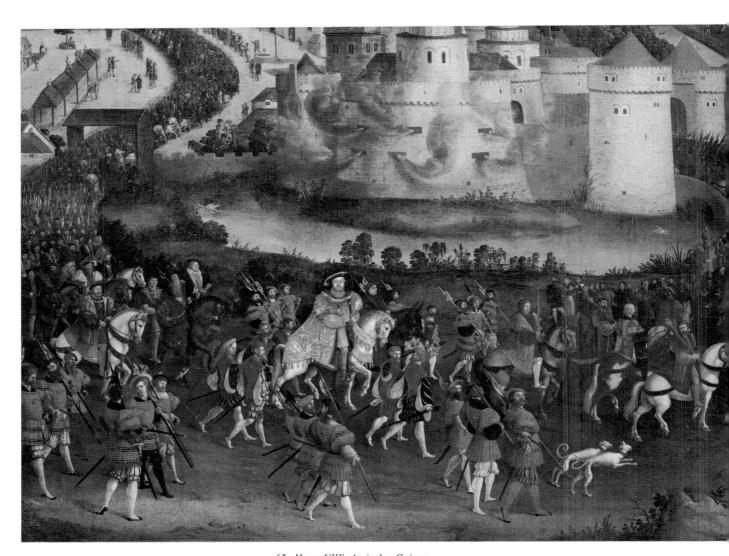

65. *Henry VIII's Arrival at Guisnes.*
Detail of Fig. 48

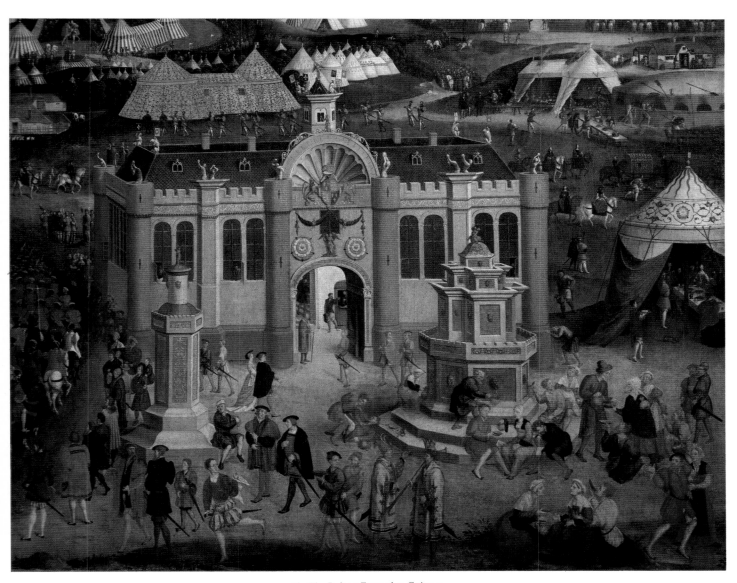

66. *The Palace Erected at Guisnes.*
Detail of Fig. 48

67. *Catherine of Aragon and her Maid* by Charles Robert Leslie.
1826. Canvas, 57.1 x 49.5 cm. London, Royal Academy of Arts

68. *Henry VIII, Act I, Scene IV* by Isaac Taylor after a painting by T. Stothard, from *Boydell's Graphic Illustrations of the Dramatic Works of Shakespeare*, London, 1802. Aquatint and etching, 16.5 x 23 cm. Oxford, Ashmolean Museum

The new tradition of historical writing was continued into the time of Elizabeth I by Raphael Holinshed (d. ?1580), the second edition of whose *Chronicles* was published in 1587. He draws on both his predecessors, but on the whole his style is pedestrian and he offers no more than a compilation that is somewhat old-fashioned in so far as he begins his narrative with Noah. Yet, it is a novel element of this work that it includes the history of Scotland and Ireland.

To these general works should be added two historical biographies of distinction: Sir Thomas More, *The Life of Richard III* (begun in 1513 but unfinished), and George Cavendish, *Life of Wolsey* (written in the 1550s but not published until 1641). Cavendish was a member of Wolsey's

Privy Chamber, and he wrote retrospectively on the basis of personal experience and from the point of view of an apologist. More's biography is one of the landmarks in the genre. Not only did it establish the official line on the last Yorkist king, Richard III, by indulging in a character assassination of him, but it did so in a narrative style spiced with humour.

Perhaps the most famous literary treatment of the reign of Henry VIII is the play by Shakespeare.[2] *Henry VIII* is a late play and it is possible, as several authorities have argued, that the text is not wholly by Shakespeare, but in part by John Fletcher. Whatever the merits of such arguments, the play still holds an important position in Shakespeare's canon, not

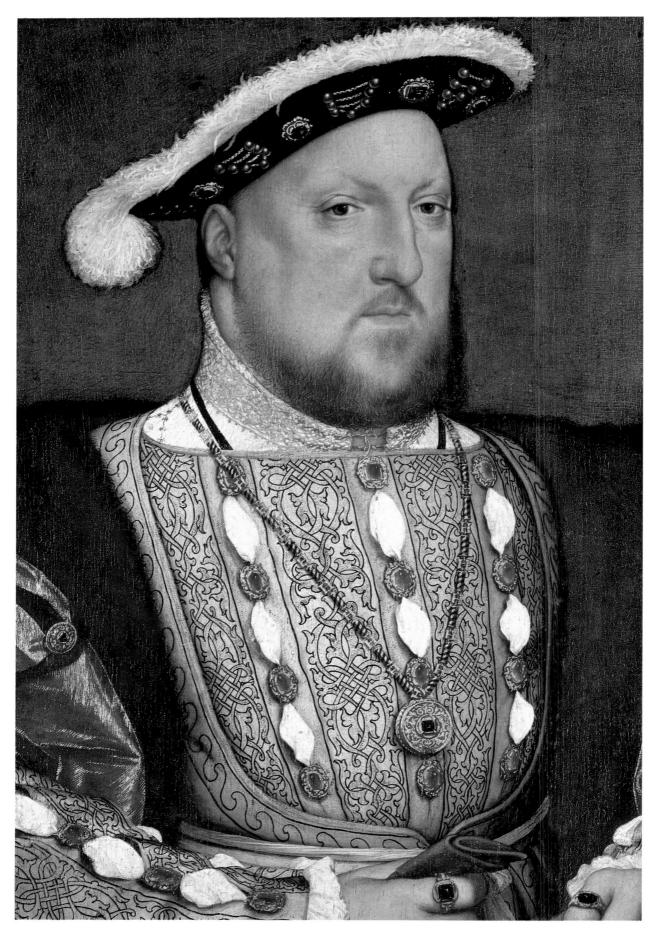

69. *Henry VIII* by Hans Holbein the Younger. *c.*1536.
Panel, 28 x 20 cm. Lugano, Thyssen-Bornemisza Collection. (Cat. No. 29)

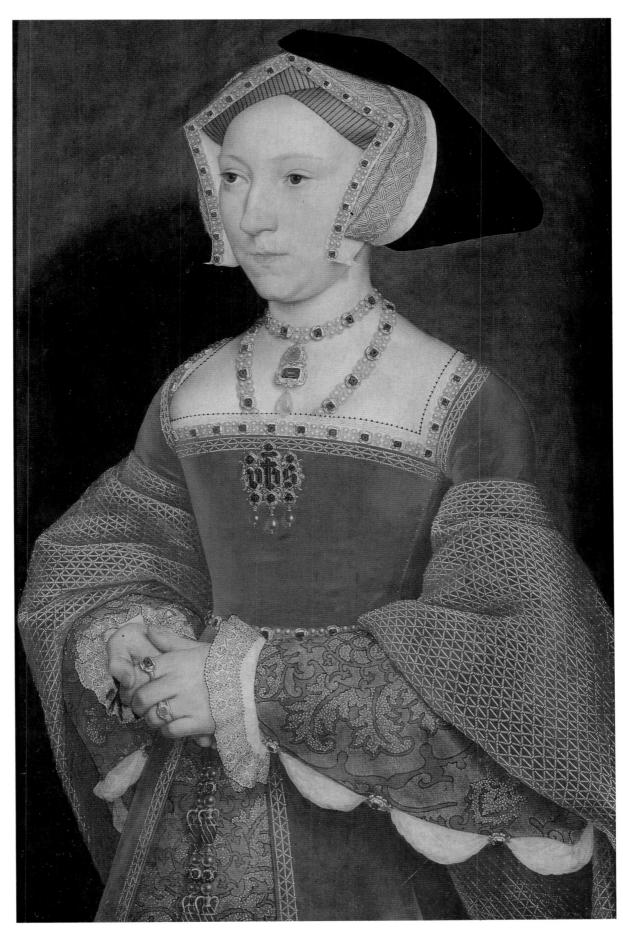

70. *Jane Seymour* by Hans Holbein the Younger. *c.*1536.
Panel, 65 x 40.5 cm. Vienna, Kunsthistorisches Museum

71. *The Disgrace of Cardinal Wolsey* by John Pettie.
Canvas, 102 x 157.5 cm. Sheffield City Art Galleries

least because in it he returns to a historical theme after a gap of several years. It is likely, therefore, that the play was written to mark a special occasion, such as the marriage of James I's daughter Elizabeth (the Winter Queen) to Frederick of Bohemia, the Elector Palatine, which took place in London on 14 February 1613 (Fig. 61). Not only was this a marriage in the Protestant interest, but it also encouraged a revival of the expression of enthusiasm for Elizabeth I, whose name the bride shared. It is perhaps unfortunate that the play of *Henry VIII* is associated with the fire that burned down the first Globe Theatre on the night of 29 June 1613. The fire was caused when cannon were fired (stage direction for Act I, scene IV, line 50) to mark the entrance of the king at York Place (later Whitehall Palace) where Wolsey lived in London. The success of the play and its subsequent revival to mark state occasions (for example, the coronations of George II in 1727 and of Elizabeth II in 1953) derives in part from the ceremonial allowed for in the plot, especially the procession following the coronation of Anne Boleyn (Act IV, scene I) and the closing scene of the christening of the future Elizabeth I (Act V, scene IV). Matching these scenes of pageantry are the more introspective moments in the play,

such as the fall of Buckingham, the plight of Catherine of Aragon, and the eclipse of Wolsey.

Seen in the context of Shakespeare's other late plays such as *The Winter's Tale, Cymbeline, Pericles* or *The Tempest, Henry VIII* explores the themes of resolution and self-knowledge achieved through the exercise of patience in the face of adversity. Where it differs from the other late plays is in the specificity of the historical context. This is not an ancient setting or a mythological world full of symbolism, but early Tudor England of half a century ago, known to Shakespeare through the chronicles of Polydore Vergil, Hall and Holinshed and through publications like J. Foxe's *Actes and Monuments of Martyrs* (Fig. 85).[3] Because of its subject-matter, the tendency has been to compare *Henry VIII* with the earlier Shakespeare histories which concentrate on a single heroic figure. In fact, the importance of *Henry VIII* as a play is that Shakespeare is attempting a history play in his final manner, where the style of the writing, the characterization, the structure of the drama, and the themes are all different.

The king is the principal character around whom events and personalities circulate, but he does not dominate the play in

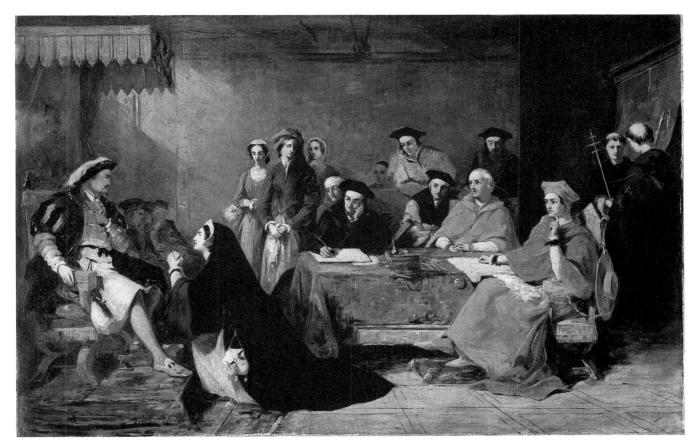

72. *The Trial of Catherine of Aragon* by Henry Nelson O'Neil.
1848. Canvas, 42.5 x 64.8 cm. Birmingham, City Museum and
Art Gallery

any other way. Buckingham, Wolsey, Catherine of Aragon, and Cranmer are all equally significant, if not more so, when it comes to analysing the aspects of human nature that Shakespeare explores within the play. The effect is therefore of an ensemble, but within it there are various contrasts, especially of mood and speech: the rise and fall of powerful men such as Buckingham and particularly Wolsey; the scenes of public celebration contrasting with ones of private reflection; the conflict of interest between the secular and the spiritual, epitomized by Wolsey's utterance:

> Had I but serv'd my God with half the zeal
> I serv'd my King, he would not in mine age
> Have left me naked to mine enemies.
>
> (Act III, scene II, lines 455–7)

There are also the changing fortunes of innocent victims caught up in events, such as Catherine of Aragon's death balanced by Anne Boleyn's rise in Henry's favour. The structure of the play is dependent upon set pieces, not just of ceremonial but also of dramatic action, as in the trial scenes of Buckingham, Catherine of Aragon, Wolsey, and Cranmer. For Shakespeare, however, it is not the outcome of the trials or the course of justice that is significant, but the way in which the individuals react to the outcome. Each of the main characters whose actions are questioned benefits in some way from the ordeal, and so the overall theme of the play becomes one of reconciliation both public and private. Wolsey, for instance, declares about his own downfall:

> I know myself now, and I feel within me
> A peace above all earthly dignities,
> A still and quiet conscience. The king has cur'd me,
> I humbly thank his grace; and from these shoulders,
> These ruin'd pillars, out of pity taken
> A load would sink a navy, too much honour.
>
> (Act III, scene II, lines 380–8)

Wolsey is humbled and suffers adversity, but in doing so becomes a better human being as he prepares for death.

These contrasts in theme and treatment of character are mirrored by the language of *Henry VIII*. Moments of tension are expressed in terse sentences, often with complex syntax, whereas in the soliloquies marking scenes of downfall and death the lines are melodic and full of rich similes. Again,

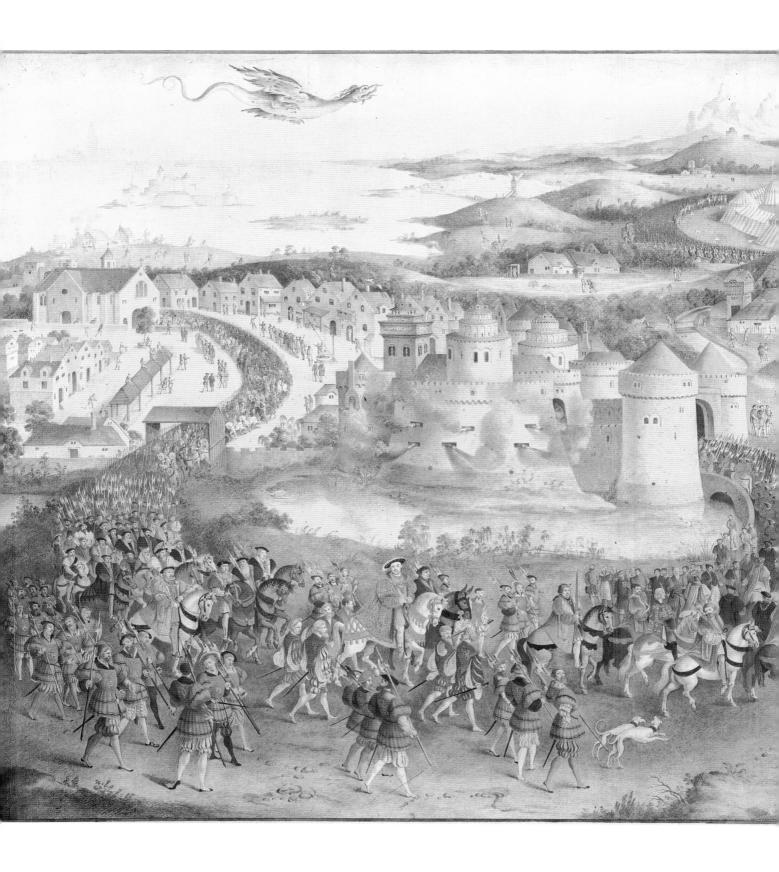

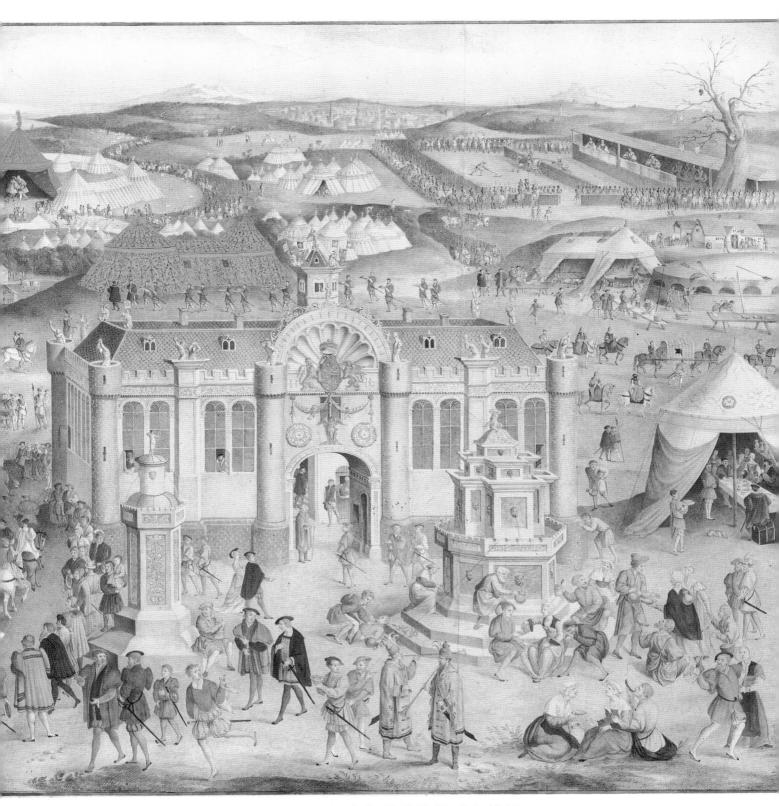

73. Copy by Edward Edwards after *The Field of the Cloth of Gold* by an
unknown artist (see Fig. 48). 1771. Drawing, 60 x 119.5 cm. Windsor Castle, The
Royal Library. (Cat. No. 39)

74. *Cardinal Wolsey at the Gate of Leicester Abbey* by
Charles West Cope. 1847. Canvas, 233.7 x 294.6 cm.
The Royal Collection

Wolsey's speeches provide the best examples. His speech of farewell (Act III, scene II, lines 350–72) is justly famous, but there are several other notable moments in the same scene:

> I have touch'd the highest point of all my greatness,
> And from the full meridian of my glory
> I haste now to my setting. I shall fall
> Like a bright exhalation in the evening
> And no man see me more.
>
> (Act III, scene II, lines 223–7)

For all the characters in Henry VIII, therefore, 'The general progress is an optimistic one; forgiveness and reconciliation expiate past misdeeds, and the future, in the hands of the young and the good, offers a golden prospect.'[4] Not only is this true in the context of the play, it is, on Shakespeare's part, a perfectly acceptable historical interpretation of Henry VIII's reign.

Performances of *Henry VIII* demanded a large company for the ceremonial scenes, but the roles that attracted leading actors were those of Wolsey and Catherine of Aragon, although the part of the king was usually of necessity also strongly cast. The play proved to have an enduring popularity in the seventeenth (Fig. 64) and eighteenth centuries and it was also performed frequently during the nineteenth century, with great emphasis placed on the spectacle to the extent that on occasions the text seemed to be of little consequence. John Philip Kemble, William Macready and Henry Irving all achieved great critical successes in the role of Wolsey, as did Mrs Sarah Siddons (née Kemble) (Fig. 63) and Ellen Terry in the part of Catherine of Aragon. The most lavish productions

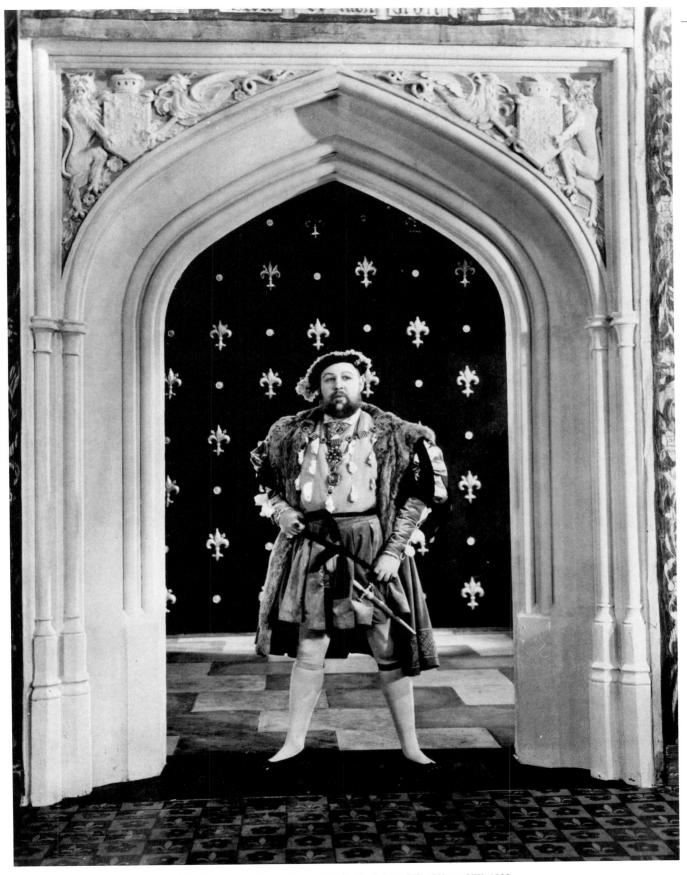

75. Charles Laughton as Henry VIII in *The Private Life of Henry VIII*, 1933

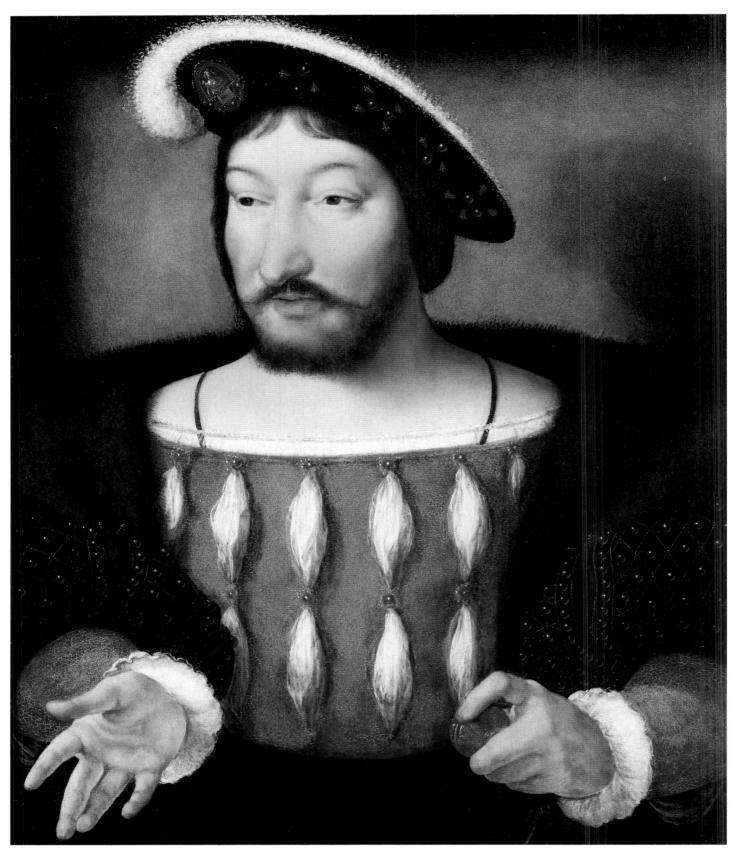

76. *Francis I* by Joos van Cleve. *c.*1530–4. Panel, 37.5 x 31.7 cm.
The Royal Collection. (Cat. No. 30)

77. *Eleanora of Austria* by Joos van Cleve. *c*.1530–4. Panel, 71.4 x 58.7 cm.
The Royal Collection. (Cat. No. 31)

78 (above). *George Vertue*
by Thomas Gibson. 1723.
Canvas, 73.5 x 50.8 cm.
London,
Society of Antiquaries

79 (right). *The Banquet*
by James Stephanoff. 1832.
Drawing, 56 x 71 cm.
Windsor Castle,
The Royal Library. (Cat. No. 42)

of the play, involving panoramas, pageants and tableaux, were those staged by Charles Kean in 1855, Irving in 1892 and Beerbohm Tree in 1901, but such extravaganzas have rarely been emulated in the twentieth century. In fact, *Henry VIII* has proved to be less popular during this century, although it is closely associated with Tyrone Guthrie, who produced it three times – in 1933 at the Old Vic (with Charles Laughton as Henry, Flora Robson as Catherine of Aragon and Robert Farquharson as Wolsey); in 1949 at Stratford-upon-Avon (with Anthony Quayle as Henry, Diana Wynyard as Catherine of Aragon and Harry Andrews as Wolsey); and in 1953 at the Old Vic/Sadlers Wells (with Paul Rogers as Henry, Gwen Ffrangçon-Davies as Catherine of Aragon and Alexander Knox as Wolsey). Recently, there has been a revival of interest in the play, with two productions by the Royal Shakespeare Company (1969/70 with Donald Sinden as Henry, Dame Peggy Ashcroft as Catherine of Aragon and Brewster Mason as Wolsey; and 1983 with Richard Griffiths as Henry, Gemma Jones as Catherine of Aragon and John Thaw as Wolsey), and a production on television as part of a BBC-TV Shakespeare series.

The popularity of *Henry VIII* on stage during the eighteenth and nineteenth centuries was emulated by the popularity of several of its scenes as subjects for artists. Two artists in particular – Charles Robert Leslie (Fig. 67) and Sir John Gilbert – returned to the play frequently during the first decades of the nineteenth century. During the previous century this had also been the play most frequently (eight times) painted for the Shakespeare Gallery founded by John Boydell in 1789 (Fig. 68).[5] Unlike the depictions of other plays by Shakespeare, artists tended to place great emphasis on certain scenes in *Henry VIII* – the trial of Catherine of Aragon (Act II, scene IV) (Fig. 72), the judgement of Catherine of Aragon by Wolsey and Campeius (Act III, scene I), the descriptions of the deaths of Wolsey and of Catherine of Aragon (Act IV, scene II), the dispute between Wolsey and Buckingham (Act I, scene II), and Wolsey's disgrace (Act III, scene II) (Fig. 71).[6] The painting of the death of Wolsey at Leicester Abbey by Charles West Cope, in the Royal Collection (Osborne House), is a typical example. It was acquired from the artist by Prince Albert in 1848 (Fig. 74). Queen Victoria liked the picture and, indeed, very much enjoyed Kean's 1855 production of the play, which ran for one hundred consecutive nights – a record-breaking run for the time.[7]

A more recent expression of the Henrician myth can be traced in the cinema and in modern drama. Film producers, for example, found Henry VIII a sympathetic figure: brave,

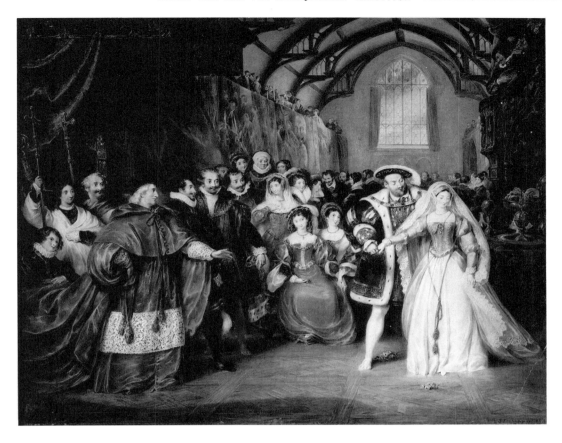

swashbuckling, talented in love, with occasional intellectual outbursts. Of all the British monarchs portrayed in the cinema, only Elizabeth I has occupied the attentions of Hollywood producers to the same extent as her father. However, perhaps the finest treatment of Henry VIII on film was not achieved in Hollywood but in Britain by the director Alexander Korda, with Charles Laughton (Fig. 75) playing the king in *The Private Life of Henry VIII* (1933). This film was a landmark in British cinema – a fledgeling at that date compared with Hollywood – and Laughton won an Oscar for a performance that ranks with his later portrayals of Captain Bligh and Quasimodo.[8] Yet, the shadow of Hollywood assuredly falls across the series of television dramas entitled *The Six Wives of Henry VIII*, made in 1972 for BBC-TV. In certain other films of varying banality the king appears in a supporting role: for instance, *Anne of the Thousand Days* (1970 with Richard Burton), *The Sword and the Rose* (1953 with James Robertson Justice), *The Prince and the Pauper* (1962 with Paul Rogers and 1977 with Charlton Heston) and, of course, *Carry on Henry* (1971 with Sidney James).[9] On the other hand, *A Man for All Seasons* by Robert Bolt, first produced on stage in 1960, was a work of a different order exploring the conscience of Sir Thomas More, set against the background of the king's divorce of Catherine of Aragon. It was made as a film in 1969.

This treatment of the myth of Henry VIII is summary and no doubt the examples could be multiplied or extended into other fields such as the historical novel, of which *The Fifth Queen* (1906–8) by Ford Madox Ford is a notable example. Yet, however diverse, the one aspect that unites these renderings in purely visual terms is Holbein's image of the king that lurks behind them all.

Such portrayals should not be too hastily dismissed, because, perhaps rather surprisingly, they are in one sense an extension of the antiquarian tradition. The development of historical writing and the importance attached to history painting in Britain during the eighteenth century gave rise to a new attitude to the past. It was argued that the past was of relevance to the present and that the study of history could therefore be beneficial in its own right. The past was no longer considered to be just the classical past, although Athens and Rome continued to be supremely important, but also the Middle Ages. To discover the art of the medieval past became the purpose of antiquarians such as George Vertue (1683–1756), an engraver and a leading member of the Society of Antiquaries, for whom he acted as official Draughtsman and Sub-Director (Fig. 78). Vertue was an inveterate note-taker and his notebooks formed the basis of Horace Walpole's *Anecdotes of Painting in England*

80. *Elizabeth I with a Feather Fan* by an unknown artist. *c*.1580–5.
Panel, 57.2 x 43.8 cm. The Royal Collection. (Cat. No. 32)

81. *Elizabeth I* (The Ditchley Portrait) by an unknown artist. *c*.1592.
Panel, 241.3 x 152.4 cm. London , National Portrait Gallery

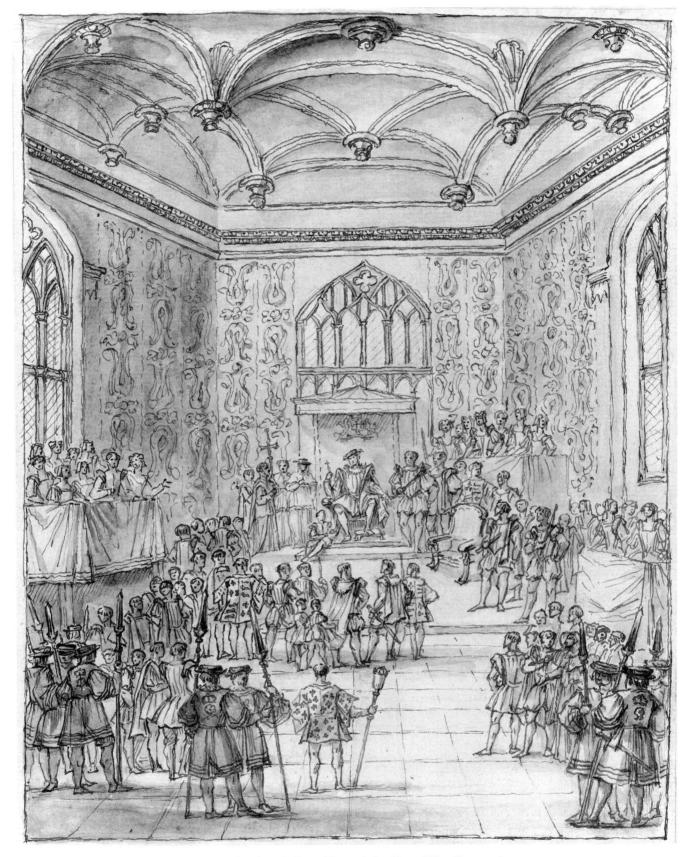

82. *Ambassadors from the King of France before Henry VIII at Hampton Court*
by William Kent. Drawing. London, British Museum

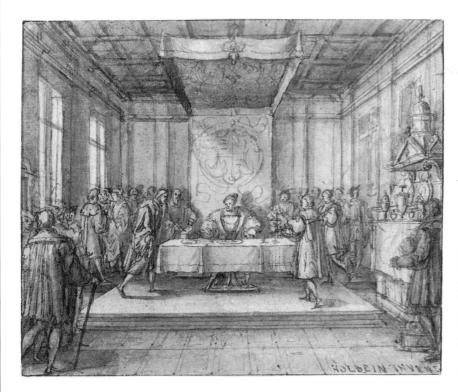

83. *Henry VIII in his Presence Chamber* by an unknown artist of the North German school. Drawing, 9.5 x 11.1 cm. London, British Museum This sketch, probably dating from the early seventeenth century, shows Henry dining alone beneath a canopy and being served by members of his Privy Chamber. Its purpose and source are unknown, but it should be noted that it is reversed, possibly for engraving.

(1762–71). Vertue's notebooks were published in full by the *Walpole Society* between 1930 and 1955,[10] since when they have been recognized as one of the principal sources for the study of British art and artists. Vertue was also a prolific engraver, for which purpose he made careful copies (Fig. 92) after numerous works of art, including paintings in the Royal Collection (cf. Fig. 15), to which he was given access through Frederick, Prince of Wales, the father of George III. George III lent the Tudor history paintings in the Royal Collection (title-page, Figs. 38, 40, 48) to the Society of Antiquaries (formally established in 1717), since they were proving to be of particular interest to members. In 1771 the Society commissioned Edward Edwards to make a watercolour copy (Fig. 73) of *The Field of the Cloth of Gold* and this was followed in 1779 by a watercolour copy by Samuel Hieronymous Grimm of *The Embarkation of Henry VIII* (Fig. 90). These two watercolours were used as the basis for engravings executed for the Society of Antiquaries by James Basire, published in 1774 and 1781 respectively.[11] It seems that the other two royal paintings (*The Meeting of Henry VIII and the Emperor Maximilian I* and *The Battle of the Spurs*) were not engraved. However, the copyists S.H. Grimm and Charles Sherwin, together with Basire, were further employed making prints of the murals at Cowdray House (Figs. 37, 39, 59, 60, 62).[12]

By contrast with this diligent recording of the past from a wide range of sources, which culminated in compendia such as Joseph Strutt's *Honda/Angel-cynnan or, A compleat View of the Manners, Customs, Arms, Habits, etc. of the Inhabitants of England* (1777–8, in two volumes), *A Complete View of Dress and Habits of the People of England* (1796–9) and *Sports and Pastimes of the People of England* (1801), William Kent employed a different approach. Kent (1685?–1748) was a painter, architect, designer, landscape gardener, decorator, dealer, and artistic adviser.[13] Trained in Rome as a painter, he also met his first important patron in Italy, the Earl of Burlington. His contribution to the neo-Palladian movement in England was of considerable significance (he was involved with the Horse Guards and the Royal Mews, Holkham Hall, Chiswick House, Houghton Hall and Rousham House amongst many other buildings), and he often served in a dual capacity as architect and interior designer. He entered royal service in 1727/8 as Surveyor or Inspector of Paintings in the Royal Palaces, and then in 1739 he became Principal Painter to George II. Some of Kent's finest decorative paintings in terms of subject-matter and style occur at Kensington Palace. Kent painted three narrative pictures for Caroline of Ansbach, the wife of George II, who had a particular interest in history and lived mainly at Kensington. The paintings depict incidents in the

84. *Master Crewe as Henry VIII* by Sir Joshua Reynolds. 1776.
Canvas, 139.7 x 110.5 cm. Private collection

85. *Allegory of the Reformation* from J. Foxe, *Actes and
Monuments of Martyrs. . .* , 9th edition, London, 1684.
Engraving, 17.5 x 16.2 cm. Windsor Castle, The Royal Library.
(Cat. No. 19)
This woodcut symbolizes Henry VIII's victory over Pope Clement
VII, who has fallen from his horse. Bishop John Fisher and
Reginald Pole attend the Pope, while Henry delivers the Bible to
Cranmer and Cromwell.

86. *The Great Hall, Hampton Court* from Joseph Nash,
The Mansions of England in the Olden Time, 2nd series, London,
1840. Lithograph, 27.5 x 40.5 cm. The London Library

life of Henry V – *The Battle of Agincourt* (?), *The Meeting between Henry V and the Queen of France* (Fig. 88) and *The Marriage of Henry V*.[14] These are still in the Royal Collection, and it is interesting to observe that the characterization of Henry V is based on an historical portrait that was already in the collection (Fig. 89).[15] Kent again combines imagination with artistic intelligence, based no doubt on genuine research, in his drawing in the British Museum showing *Ambassadors from the King of France before Henry VIII at Hampton Court* (Fig. 82), but the seeds of his approach are apparent in an earlier anonymous drawing, also in the British Museum, of *Henry VIII in his Presence Chamber* (Fig. 83).[16]

If these artists of the seventeenth and eighteenth centuries were comparatively restrained in their re-creation of the past, by the nineteenth century what may be called the archaeological spirit had given way to a form of historicism steeped in romanticism, as in James Stephanoff's watercolour of *The Banquet* (Fig. 79). As with the earlier paintings based on Shakespeare's *Henry VIII* (Figs. 67, 68, 71, 74), the watercolour by Stephanoff is comparable with a host of works produced during the nineteenth century inspired by incidents in British history.[17] To a certain extent, the element of costume drama that is central to such depictions was anticipated by Sir Joshua Reynolds in his 'mock-heroic' portrait of *Master Crewe as Henry VIII* (Fig. 84),[18] which was

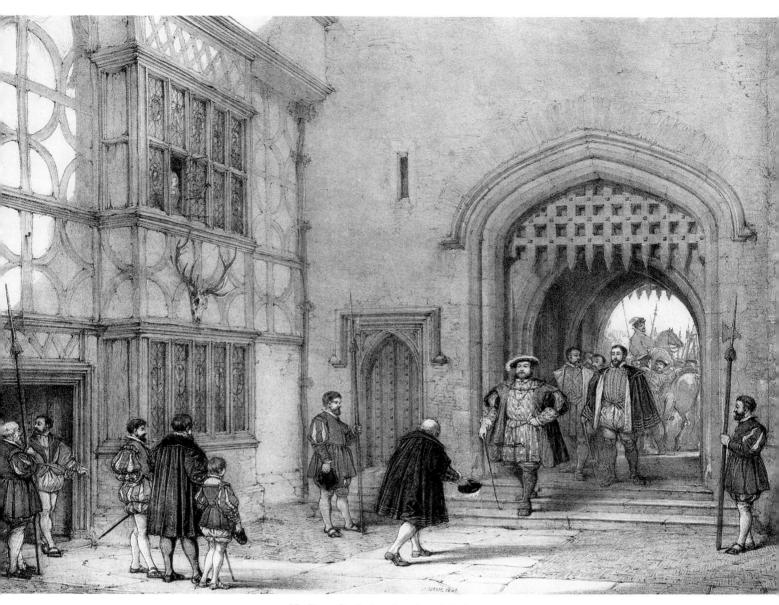

87. *Hever Castle, Kent* from Joseph Nash,
The Mansions of England in the Olden Time, *The Studio* edition,
1906. Photogravure, 14 x 19 cm. Private collection. (Cat. No. 44)

derived from the image of *The Whitehall Mural*. But it also attests the popularity of Henry VIII in eighteenth-century masquerades, for which specific pattern books were published, such as Thomas Jeffery's, *A Collection of the Dresses of Different Nations, Ancient and Modern, particularly after the Designs of Holbein, Vandyke, Hollar and others* (1757 and 1772).

The final phase of this development in the imaginative re-creation of the past is best represented by the illustrations made by Joseph Nash (1809–78) for his publication *The Mansions of England in the Olden Time* (1839–49), issued in four volumes, where the search for the appropriate style has

become too self-conscious. The settings are authentic, but in each illustration Nash introduces a costume drama, supposedly in an appropriate style to suit the particular location, and certain solecisms occur. The examples reproduced here are of Hampton Court (Fig. 86) and Hever Castle (Figs. 87, 93), where Anne Boleyn is traditionally thought to have been born. This duality is apparent also in the accompanying text, which combines historical fact with anecdote. For *Bay Window in the Gallery, Hever Castle, Kent*, part of the text reads: 'For, according to tradition, this bay was the favourite seat of Anne Boleyn's. Its elevated situation commands a view for a considerable distance up the road – the road King Harry used to travel. From the window,

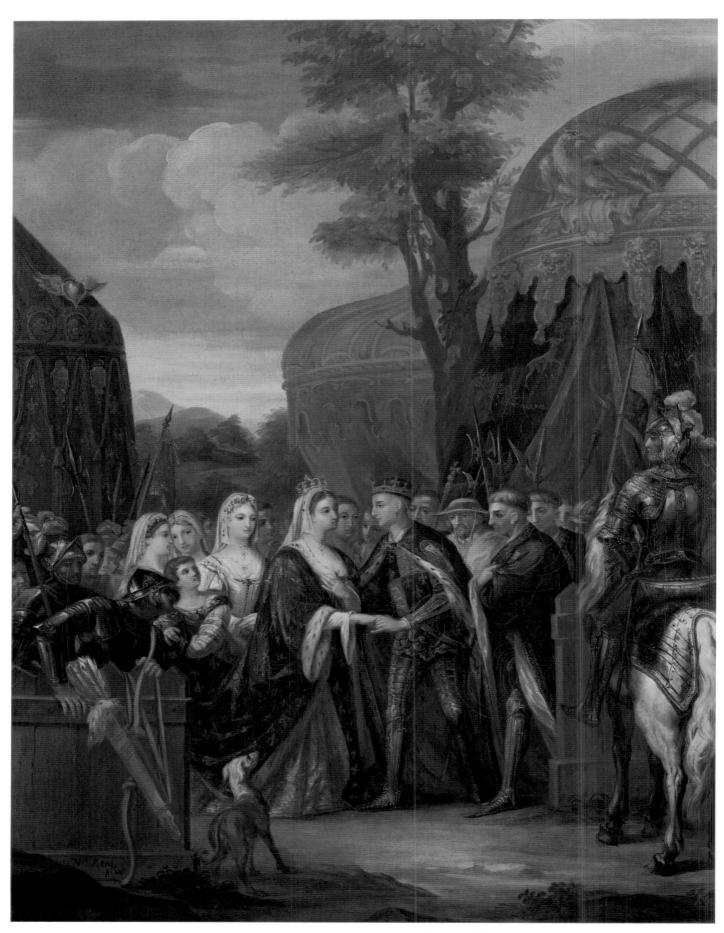

88. *The Meeting between Henry V and the Queen of France* by William Kent.
*c.*1730. Canvas, 76.2 x 61 cm. The Royal Collection

HENRY THE FIFTH

89. *Henry V* by an unknown artist. *c*.1520.
Panel, 56.5 x 36.2 cm. The Royal Collection

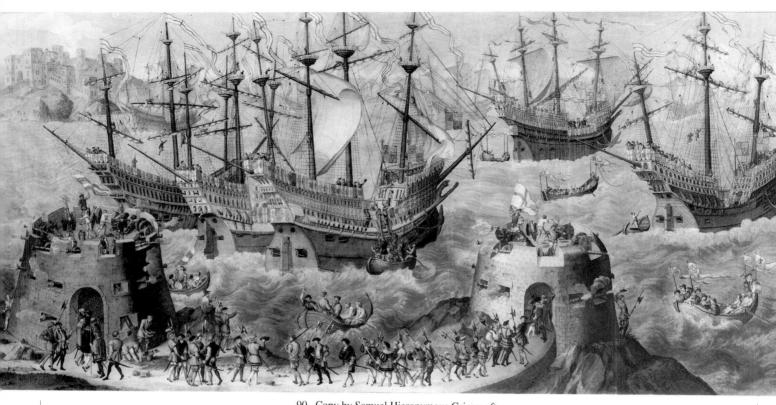

90. Copy by Samuel Hieronymous Grimm after
The Embarkation of Henry VIII at Dover by an unknown artist
(see title-page). 1779. Drawing, 76.4 x 136.2 cm. London,
Society of Antiquaries. (Cat. No. 40)

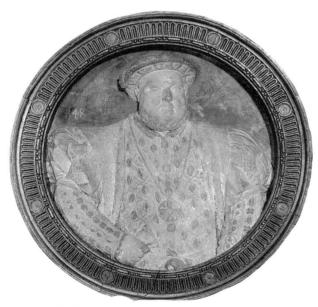

91. *Henry VIII* by an unknown artist. *c.*1550–75.
Stone medallion, diameter 37.7 cm.
The Royal Collection. (Cat. No. 37)

Anne signalled farewell as the royal cavalcade clattered out of sight.' Nash's prints understandably proved to be immensely popular and were not without influence, being reissued in 1869–72, 1906 and 1912.[19] However, in such fictions the real significance of Henry VIII as represented by Hans Holbein the Younger has become subsumed under the weight of the narrative and has evaporated.

HENRY VIII: THE TUDOR DYNASTY AND THE CHURCH

1. R. Strong, *The Cult of Elizabeth: Elizabethan Portraiture and Pageantry*, London, 1977; R. Strong, *Portraits of Queen Elizabeth I*, Oxford, 1963.

2. C. Plummer (ed.), J. Fortescue, *The Governance of England*, Oxford, 1885, p.125.

3. J.T. Micklethwaite, 'Notes on the Imagery of Henry the Seventh's Chapel, Westminster', *Archaeologia*, XLVII, 1883, p.368.

4. For Edward's household see A.R. Myers, *The Household of Edward IV*, Manchester, 1954.

5. Two early portraits of Edward survive, one is in the Royal Collection (Fig. 3) the other belongs to the Society of Antiquaries. An attempt at dating these two is in J. Fletcher, 'Tree ring dates for some Panel Paintings in England', *Burlington Magazine*, CXVI, 1974, pp.256–7.

6. For the development of this pose see L. Campbell, *Renaissance Portraits*, New Haven, 1990, pp.69–72 and 96.

7. L. Campbell, op. cit., p.197.

8. For a summary of the evidence on portraits of Henry VII see R. Strong, *Tudor and Jacobean Portraits*, London, 1969, Vol. 1, pp.149–52.

9. A payment in Henry VII's Chamber Accounts is to 'Tentiwald servant for pictures' (S. Bentley, *Excerpta Historica*, London, 1831, p.107). Tentiwald was one of the Flemish ambassadors.

10. British Museum, Add. MS. 59899 f.79v.

11. See the description of Maynard's visit in J.B. Paul (ed.), *Compota Thesaurariorum Regum Scotorum*, Edinburgh, 1877, Vol. II, p.341.

12. O. Millar, *The Tudor, Stuart and Early Georgian Pictures in the Collection of Her Majesty The Queen*, London, 1963, pp. 52–3; J. Fletcher, op. cit., pp.256–7.

13. R. Strong, *Tudor and Jacobean Portraits*, op. cit., pp.149–50; G. Gluck, 'The Henry VII in the National Portrait Gallery', *Burlington Magazine*, LXIII, 1933, pp.100–8; L. Campbell, op. cit., pp.159–60.

14. J. Newman, *North East and East Kent*, Harmondsworth, 1983, p.208; N. Pevsner, *Worcestershire*, Harmondsworth, 1968, p.162; N. Pevsner and B. Cherry, *London, The Cities of London and Westminster*, revised edn., Harmondsworth, 1973, p.494.

15. O. Millar, op. cit., pp.52–3.

16. G. Scharf, 'On a Votive Painting of St. George and the Dragon, with Kneeling Figures of Henry VII, his Queen and Children, formerly at Strawberry Hill, and now in the possession of Her Majesty the Queen', *Archaeologia*, XLIX, 1886, pp.244–95.

17. On the pageants of Henry VII's reign see S. Anglo, *Spectacle, Pageantry and Early Tudor Policy*, Oxford, 1969, pp.1–108.

18. M. Levey, *Painting at Court*, New York, 1971, pp.13–78; L. Campbell, op. cit., pp.196–208.

19. H. Wayment, 'Twenty-Four Vidimuses for Cardinal Wolsey', *Master Drawings*, 23–4, No. 4, pp.505–16; H. Wayment, 'The Stained Glass in the Chapel of the Vyne', *National Trust Studies 1980*, London, 1979, pp.35–48.

20. On the Reformation Parliament and the developing theoretical position of the king see the following: F.L. Baumer, *The Early Tudor Theory of Kingship*, Yale, 1940; A.G. Dickens, *The English Reformation*, London, 1964, pp.157–75; W. Ullman, 'This Realm of England is an Empire', *Journal of Ecclesiastical History*, 30, 1979, pp.175–203.

21. R. Strong, *The English Renaissance Miniature*, London, 1983, pp.189–90.

22. ibid., pp.27–9.

23. For Holbein, see pp.60–76 below.

24. Much has been written on this and on the surviving cartoon. The discussion here takes a different approach: R. Strong, *Holbein and Henry VIII*, London, 1967; S.R. Foister, *Holbein and his English Patrons*, unpublished Ph.D. thesis, Courtauld Institute of Art, London, 1981, p.233; J. Rowlands, *Holbein: The Paintings of Hans Holbein the Younger*, Oxford, 1985, pp.96–115.

25. The drawing is in the Royal Library, Windsor (RL 12267). The painting is in the Kunsthistorisches Museum, Vienna (Fig. 70).

26. As recorded by Baron Waldstein in 1600. *The Diary of Baron Waldstein, A Traveller in Elizabethan England*, trans. and ed. G.W. Groos, London, 1981, pp.56–7.

27. On the location of the mural and the significance of the privy chamber, see S. Thurley, *English Royal Palaces 1450–1550*, unpublished Ph.D. thesis, Courtauld Institute of Art, London, 1990, pp.150–64, and the same writer's forthcoming publication of the Whitehall Palace excavation report, east side. The conclusions are different from those in J. Rowlands, op. cit., and R. Strong, *Holbein and Henry VIII*, op. cit.

28. See H.M. Colvin, *The History of the King's Works*, Vol. 4, 1982, pp.495–500; P. Binski, *The Painted Chamber at Westminster*, Society of Antiquaries, London, 1986.

29. C. van Mander, *Livre des Peintres*, trans. H. Hymans, Paris, 1884, I, p.218; L. Campbell, op. cit., pp.81–4.

30. The Whitehall privy chamber measured approximately 24 x 34 ft (7.3 x 10.4 m) (S. Thurley, op. cit., Vol. II, Fig. 92). The overall size of the original mural has recently been calculated as 11 ft 10 in x 8 ft 10 in (3.6 x 2.7 m), J. Rowlands, *The Age of Dürer and Holbein, German Drawings 1400–1550*, exhibition catalogue, British Museum, London, 1988.

31. See S. Thurley, op. cit., pp.177–9.

32. O. Millar, *Holbein and the Court of Henry VIII*, exhibition catalogue, Buckingham Palace, The Queen's Gallery, 1978–9, pp.129–30; J. King, *Tudor Royal Iconography*, Princeton, 1989, pp.81–5.

33. P. Tudor-Craig, 'Henry VIII and King David', *Early Tudor England, Proceedings of the 1987 Harlaxton Symposium*, ed. D. Williams, Woodbridge, 1989, pp.183–205.

34. S. Gardiner, *Obedience in Church and State*, ed. P. Janelle, Cambridge, 1930, pp.89–97; F.L. van Baumer, *The Early Tudor Theory of Kingship*, Yale, 1940, Appendix, A.

35. On the Coverdale Bible and its title-page, see J.N. King, op. cit., pp.54–65; C. Dodgson, 'Woodcuts designed by Holbein for English Printers', *Walpole Society*, XXVII, 1938–9, pp.1–4.

36. On the Great Bible, see A.G. Dickens, *The English Reformation*, London, 1981, pp.189–97; J.N. King, op. cit., pp.70–4; *Cranmer, Primate of all England*, ed. P.N. Brooks, exhibition catalogue, British Museum, London, 1989–90.

37. H. Farquhar, 'Portraiture of our Tudor monarchs on their coins and medals', *British*

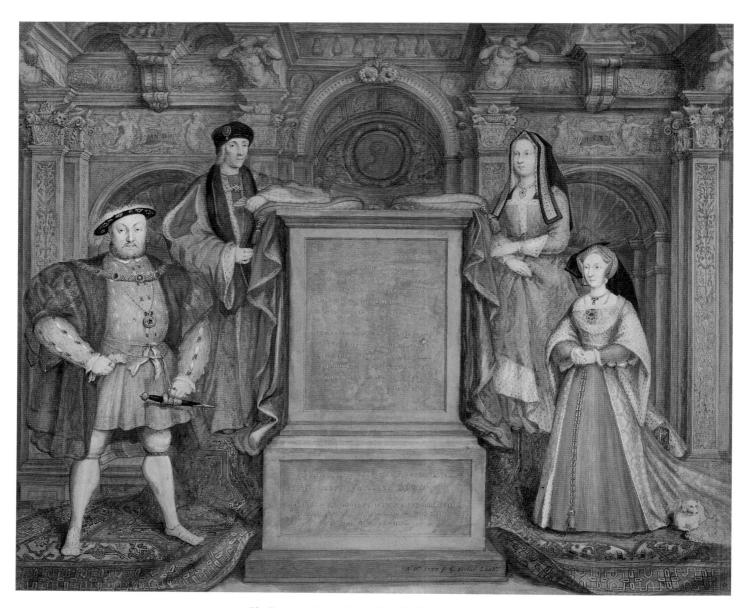

92. Copy by George Vertue after *The Whitehall Mural* by
Remigius van Leemput (after Hans Holbein the Younger)
(see Fig. 15). 1737. Drawing, 45.7 x 57.3 cm.
Windsor Castle, The Royal Library. (Cat. No. 38)

93. *Bay Window in the Gallery, Hever Castle, Kent*
from Joseph Nash, *The Mansions of England in the Olden Time*,
2nd series, London, 1840. Lithograph, 27.5 x 40.5 cm.
The London Library. (Cat. No. 43)

Numismatic Journal, 4, 1907, pp.79-143; G.C. Brooke, *English Coins from the Seventh Century to the Present Day*, London, 1950, pp.174–86; P. Grierson, 'The Origins of the English Sovereign and the Symbolism of the Closed Crown', *British Numismatic Journal*, 33, 1964, pp.118–34; C.E. Challis, 'Mint Officials and Moneyers of the Tudor Period', *British Numismatic Journal* 45, 1975, pp.51–76.

38. On this, see E. Auerbach, *Tudor Artists*, London, 1954, pp.23–48 and 59–72.

39. On this, see A.B. Wyon and A. Wyon, *The Great Seals of England from the Earliest Period to the Present Time*, London, 1887.

40. An important intermediary stage was the creation of the *Golden Bulla*, the seal used on the treaty of 1527. This retained the standardized portrait of the king but he was seated on a Renaissance throne surrounded by grotesque work. See A.B. and A. Wyon, op. cit., plate XIX (103).

41. On this, see J. Enoch Powell and Keith Wallis, *The House of Lords in the Middle Ages*, London, 1968, pp.580–2 and 601–3.

42. Public Record Office E351/3223.

43. On this, see R. Strong, 'Edward VI and the Pope, A Tudor anti-papal allegory and its setting', *Journal of the Warburg and Courtauld Institutes*, XXIII, 1960, pp.311–13; R. Strong, *Tudor and Jacobean Portraits*, op. cit., pp.344–5.

44. Translation from R.N. Wornum, *Some Account of the Life and Works of Hans Holbein*, London, 1867, p.324.

45. W.A. Shaw (ed.), *Three Inventories of the Years 1542, 1547, and 1549-50 of Pictures in the Collections of Henry VIII and Edward VI*, London, 1937, pp.30, 35 and 56.

HENRY VIII AS SOLDIER DIPLOMAT

1. S. Chrimes, *Henry VII*, London, 1977, p.277.

2. S. Anglo, *Spectacle, Pageantry and Early Tudor Policy*, Oxford, 1969, p.117.

3. J. Scarisbrick, *Henry VIII*, London, 1981, p.23.

4. ibid., p.24.

5. ibid., p.81.

6. T.B. James and A.M. Robinson, *Clarendon Palace*, Reports of the Research Committee of the Society of Antiquaries, No. XLV, London, 1988, pp.16–17 and 98–9.

7. Whitehall building accounts 1531/1: Public Record Office E351/3322.

8. References to the room at Windsor can be found in Bodleian Library Rawl. MS. D. 780 f.91. It should be noted that during the first part of Henry's reign biblical murals were painted at Greenwich (St. John) and Whitehall (Adam and Eve).

9. *The Embarkation*: O. Millar, *The Tudor, Stuart and Early Georgian Pictures in the Collection of Her Majesty The Queen*, London, 1963, pp.54–5; *Battle of the Spurs*: O. Millar, op.cit., p.54; *The Embarkation*: Public Record Office E351/3223; *The Field*: *The Diary of Baron Waldstein, A Traveller in Elizabethan England*, trans. and ed. G.W. Groos, London, 1981, p.43.

10. The direct parallel is with the Cowdray House paintings (see Fig. 34), or with the paintings still in 'Wolsey's Closet' at Hampton Court Palace.

11. A policy of restoration may eventually help to clarify some of these problems. *The Embarkation of Henry VIII at Dover* was cleaned in 1988–90. For the *Battle of the Spurs*, see pp.124–6. *The Field of the Cloth of Gold* will be cleaned in due course.

12. On this, see S. Anglo, 'The Hampton Court painting of the Field of Cloth of Gold Considered as an Historical Document', *Antiquaries Journal*, XLVI, 1986, pp.287–307.

13. H. von Erffa and A. Staley, *The Paintings of Benjamin West*, New Haven and London, 1986, p.203 under No. 77.

14. J. Scarisbrick, op. cit., p.73.

15. W. Laird Clowes, *The Royal Navy*, London, 1897, I, pp.405–8; M. Rule, *The Mary Rose. The Excavation and Raising of Henry VIII's Flagship*, London, 1982, p.21.

16. S. Anglo, op.cit., pp.137–69; J.G. Russell, *The Field of the Cloth of Gold*, London, 1969.

17. S. Anglo, op. cit., p.169.

18. W.H. St. John Hope, *Cowdray and Easebourne Priory*, London, 1919, pp.59–65.

19. For a complete history of Cowdray, see W.H. St. John Hope, op. cit.

20. On Browne, see *Dictionary of National Biography* and for his king-making role H.W. Chapman, *The Last Tudor King*, London, 1958, pp.80–4.

21. See W.H. St. John Hope, op. cit., pp.40 and 43.

22. J. Scarisbrick, op. cit., p.450.

23. M. Rule, op. cit., pp.13–38.

24. J. Scarisbrick, op. cit., p.507.

HENRY VIII AND PRINCELY MAGNIFICENCE

1. G.R. Elton, 'Henry VIII', in *The Historical Association Book of the Tudors*, ed. J. Hurstfield, London, 1973, p.46.

2. C. Galvin and P. Lindley, 'Pietro Torrigiano's Portrait Bust of King Henry VIII', *Burlington Magazine*, CXXX, 1988, pp.892–902.

3. H. Colvin, *The History of the King's Works III Pt. I 1485–1660*, London, 1975, pp.196–206.

4. Most probably the painting in the National Gallery of Art, Washington, D.C. (see D.A. Brown, *Raphael and America*, Washington, 1983, pp.135–40), here Fig. 13.

5. H. Dow, 'Two Italian portrait busts of Henry VIII', *Art Bulletin*, XLII, 1960, pp.291–4, and J. Larson, 'A polychrome terracotta bust of a laughing child at Windsor Castle', *Burlington Magazine*, CXXXI, 1989, pp.619–24.

6. S. Chrimes, *Henry VII*, London, 1977, p.299.

7. J. Scarisbrick, *Henry VIII*, London, 1981, pp.13–14.

8. J. Scarisbrick, op. cit., p.11.

9. Cited by S. Anglo, *Spectacle, Pageantry and Early Tudor Policy*, Oxford, 1969, pp.116–17.

10. Cited by S. Anglo, op. cit., p.125.

11. G.R. Elton, op. cit., p.51.

12. G.R. Elton, op. cit., p.54.

13. J. Rowlands, *Holbein: The Paintings of Hans Holbein the Younger*, Oxford, 1985, pp.88 and 96. Also see I.W. Ives, *Anne Boleyn*, Oxford, 1986, pp.276–7 and 286–8.

14. J. Rowlands, op. cit., p.96.

15. R. Strong, *Holbein and Henry VIII*, London, 1967, p.42.

16. J. Rowlands, op. cit., p.226 under L14(b).

17. On Robert Spencer, see the biography by J.P. Kenyon, *Robert Spencer Earl of Sunderland 1641–1702*, London, 1958; and on the history of the collection at Althorp House, see K.J. Garlick, 'A Catalogue of Pictures at Althorp House', *Walpole Society*, XXXXV, 1974–6, historical note, particularly p.xiii. Robert Spencer held diplomatic posts in Madrid (1671), Paris (1672), Cologne (1673) and The Hague (1678).

18. W.A. Shaw (ed.), *Three Inventories of the*

Years 1542, 1547 and 1549–50 of Pictures in the Collections of King Henry VIII and Edward VI, London, 1937, p.33: 'Item, a table like a booke, with the pictures of Kyng Henry theight and Quene Jane'. No. 45 in the inventory of 1547.

19. For whom, see P. Mellen, *Jean Clouet*, London, 1971.

20. R. Strong, 'Holbein and Cartoon for the Barber-Surgeons Group Rediscovered – A Preliminary Report', *Burlington Magazine*, CV, 1963, pp.4–14.

21. For these, see R. Strong, *Gloriana. The Portraits of Queen Elizabeth I*, London, 1987.

HENRY VIII AND THE ANTIQUARIAN TRADITION

1. See J.D. Mackie, *The Earlier Tudors 1485–1558*, Oxford, 1952, pp.611–14; E.M.W. Tillyard, *Shakespeare's History Plays*, London, 1944, pp.29–64; and M.M. McKisack, *Medieval History and the Tudor Age*, London, 1971.

2. Quotations are from the Arden Shakespeare, *Henry VIII*, ed. R.A. Foakes, rev. edn., London, 1964.

3. R.A. Foakes, op. cit., pp.xxxv–xxxix; and Appendix II, pp.183–215.

4. R.A. Foakes, op. cit., p.lxi.

5. R.A. Altick, *Paintings from Books. Art and Literature in Britain, 1760–1900*, Columbus, 1985, pp.45–9; and S.A. Bruntjen, *John Boydell (1719–1804), A Study of Art Patronage and Publishing in Georgian London*, New York and London, 1985.

6. R.A. Altick, op. cit., pp.291–3 and 477.

7. R.A. Altick, op. cit., p.292.

8. On Laughton's portrayal of Henry VIII, see S. Callow, *Charles Laughton – A Difficult Actor*, London, 1988, pp.59–63.

9. L. Halliwell, *Film Goer's Companion*, 9th edn., Grafton, 1988, p.334.

10. *Walpole Society*: XVIII, 1929–30; XX, 1931–2; XXII, 1933–4; XXIV, 1935–6; XXVI, 1937–8; XXIX, 1940–2; XXX, 1948–50.

11. Both reprinted by the Society of Antiquaries in 1989 and reissued with an accompanying text by the Librarian, B. Nurse, *The Embarkation of Henry VIII at Dover and The Field of the Cloth of Gold 1520: Eighteenth-Century Engravings for the Society of Antiquaries of London*, London, 1989.

12. On the paintings at Cowdray House, see J. Ayloffe, 'An Account of some ancient English Historical Paintings at Cowdray, Sussex', *Archaeologia*, III, 1776, pp.239–72.

13. On Kent, see the monographs by M. Jourdain (1948) and M.I. Wilson (1984).

14. O. Millar, *The Tudor, Stuart and Early Georgian Pictures in the Collection of Her Majesty The Queen*, London, 1963, Nos. 505–7.

15. ibid., No. 6. The connection was made by R. Strong, *And when did you last see your father? The Victorian Painter and British History*, London, 1978, pp.15–16.

16. Inv. 1854-6-28-74.

17. R. Strong, *And when did you last see your father?*, op.cit., Appendix, pp.155–68, entitled 'Subjects from British History from the Ancient Britons to the Outbreak of the Napoleonic Wars exhibited at the Royal Academy, 1769–1904'.

18. *Reynolds*, ed. N. Penny, exhibition catalogue, Royal Academy of Arts, London, 1986, No. 97.

19. For this theme in general, C. Wainwright, *The Romantic Interiors*, London and New York, 1989.

94. *View of Hampton Court Palace* by an unknown artist. *c.*1640.
Canvas, 80 x 183.5 cm.
The Royal Collection. (Cat. No. 5)
Henry VIII's royal lodgings, built 1529–40, occupy the right side
of the painting. These were demolished in 1689 by William III,
and their site is that of the present King's Apartments. The left of
the painting shows the surviving part of the Tudor Palace
built by Wolsey 1515–29.

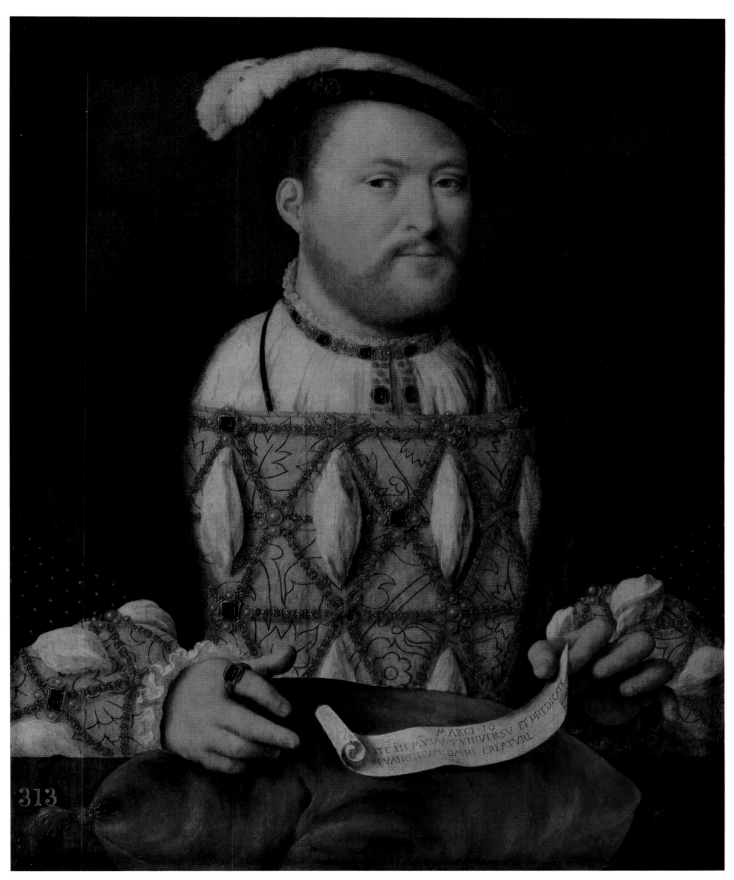

95. *Henry VIII* by Joos van Cleve. *c*.1535.
Panel, 72.4 x 58.6 cm. The Royal Collection. (Cat. No. 16)

CATALOGUE

The catalogue lists works exhibited in the 1990 exhibition and included in this book. Under 'Literature', references are only to the most essential books or articles, where further bibliographical information can be found. The exhibition history of individual works has been omitted. The following publications have been abbreviated:

AYLOFFE 1776: J. Ayloffe, 'An Account of some ancient English Historical Paintings at Cowdray, Sussex', *Archaeologia*, III, 1776, pp.239–72.
CAMPBELL 1985: L. Campbell, *The Early Flemish Pictures in the Collection of Her Majesty The Queen*, Cambridge, 1985.
EVANS 1956: J. Evans, *A History of the Society of Antiquaries*, Oxford, 1956.
MILLAR 1963: O. Millar, *The Tudor, Stuart and Early Georgian Pictures in the Collection of Her Majesty The Queen*, London, 1963.
ST. JOHN HOPE 1919: W. St. John Hope, *Cowdray and Easebourne Priory*, London, 1919.
SEABY 1990: *Seaby Standard Catalogue of British Coins 1990*, ed. S. Mitchell and B. Reeds.
STRONG ICON: R. Strong, *The English Icon: Elizabethan and Jacobean Portraiture*, London and New York, 1969.
STRONG PORTRAITS: R. Strong, *Tudor and Jacobean Portraits*, 2 vols., London, 1969.
STRONG 1983: R. Strong, *The English Renaissance Miniature*, London, 1983.

1. After Hans Holbein the Younger
Henry VIII (Fig. 97)
Late sixteenth century. Oil on canvas, 239.4 x 148 cm
An early copy of the figure of the king in *The Whitehall Mural* by Hans Holbein the Younger (see Cat. No. 14). This painting was formerly hung in the Cross Gallery at Somerset House, the Blue Room in St. James's Palace and in the Queen's Gallery at Kensington Palace.
Literature: Millar 1963, No. 36.
Her Majesty Queen Elizabeth II (St. James's Palace)

2. Unknown artist
Richard III (Fig. 9)
*c.*1518–23. Oil on panel, 56.5 x 35.6 cm
One of four portraits of English kings probably painted for Henry VIII for a historical portrait gallery (for two of the others see Figs. 3, 89) and first recorded in Tudor inventories of 1542 and 1547. This is almost certainly the earliest surviving image of Richard III and is the source of numerous derivations. The painter may have been Flemish. The outline of the left shoulder was altered at a very early date to suggest that the king was deformed. Considerable care has been taken over the painting of the jewellery. The figures in the spandrels may be intended to represent the Emperor Constantine and St. Helena.
Literature: Millar 1963, No. 14; *Kings and Queens*, exhibition catalogue, Buckingham Palace, The Queen's Gallery, 1982–3, No. 4; P. Tudor Craig, *Richard III*, exhibition catalogue, National Portrait Gallery, London, 1973, pp.80–94.
Her Majesty Queen Elizabeth II (Windsor Castle)

3. Unknown artist
The Family of Henry VIII (Figs. 1, 35)
*c.*1545. Oil on canvas, 141 x 355 cm
Henry VIII in the centre is flanked by the young Edward VI and Jane Seymour, whose posthumous likeness is based on the portrait by Hans Holbein the Younger in Vienna (Fig. 70); on the left is Princess Mary (Mary I) and on the right Princess Elizabeth (Elizabeth I). The background is a view of the Great Garden at Whitehall Palace, showing the carved King's Beasts mounted on columns. The buildings visible through the archway on the left can be identified as part of the palace and the Westminster Clockhouse; through the archway on the right can be seen the north transept of Westminster Abbey and one of the turrets of Henry VIII's tennis court. The figure on the far right may be the king's jester, Will Somers (see Fig. 23). This important dynastic portrait hung in the Privy Gallery at Whitehall Palace during the reign of Charles I.
Literature: Millar 1963, No. 43; *The Hamilton Kerr Institute, Bulletin*, I, 1988, pp.109–10.
Her Majesty Queen Elizabeth II (Hampton Court)

4. Attributed to William Stretes (active *c.*1537–53)
Edward VI (Fig. 51)
*c.*1550. Oil on panel, 167 x 90.8 cm
Inscribed on an early *cartellino* at left, *Kinge Edward. 6*
This is a good version of the prime official standard portrait of Edward VI. It was probably painted *c.*1550 and the image proved to be popular. Stretes succeeded Hans Holbein the Younger as the King's Painter. The pose is an adaptation of that devised by Holbein for Henry VIII in *The Whitehall Mural* (Fig. 15). The portrait was first recorded in the collection of John, 1st Baron Lumley (d. 1609), and it was only acquired for the Royal Collection by Queen Victoria in 1882.
Literature: Millar 1963, No. 49.
Her Majesty Queen Elizabeth II (Hampton Court)

5. Unknown artist
View of Hampton Court Palace (Fig. 94)
*c.*1640. Oil on canvas, 80 x 183.5 cm
The earliest views of the east front of Hampton Court are those dating from the sixteenth century by Anthonis Wyngarde (Ashmolean Museum, Oxford) and an anonymous view in the Pepys Collection, Magdalene College, Cambridge. Both offer a more accurate picture of Henry VIII's royal lodgings, which were demolished in 1689. Nevertheless, this painting gives a good impression of the turreted Tudor skyline which preceded Sir Christopher Wren's Baroque palace.
Literature: Millar 1963, No. 439.
Her Majesty Queen Elizabeth II (Hampton Court)

6. Roundels from the ceiling of the Great Watching Chamber, Hampton Court Palace (Fig. 8)
1535. Leather maché
These roundels are made of a rapid-setting leather-based compound. They were set up in 1535 for Henry VIII and were taken down in the nineteenth century. They are typical of the sort of heraldic decoration used in Tudor palaces.
Hampton Court Palace

7. Great Seal of Henry VII (Fig. 27)
Modern wax impression, diameter 11.2 cm
The Latin inscription on the seal translates as 'Henry, by the grace of God, King of England and France and Lord of Ireland'. The seal of Richard III had been almost identical to the fifth seal of his predecessor Edward IV. The only change was the substitution of the name Ricardus for Edwardus. Henry VII's seal was also very similar in design, although it was slightly bolder in execution.
Literature: A.B. Wyon and A. Wyon, *The Great Seals of England from the Earliest Period to the Present Time*, London, 1887, pp.65–6, Pl. XVII.
London, Public Record Office

8. Third Great Seal of Henry VIII (Fig. 28)
Modern wax impression, diameter 12.2 cm
The Latin inscription of the seal

translates as 'Henry VIII, by the grace of God, King of England, France and Ireland. Defender of the Faith, Supreme Head of the English Church and of Irish Churches'. Henry VIII's third Great Seal, first issued in 1542, shows for the first time a realistic portrait of the monarch. The figure of the king bears close comparison to the miniature by Holbein, *Solomon and the Queen of Sheba* (Fig. 19) and an even closer comparison to the image of Henry seen on the gold half-sovereign of Fig. 24e. A record survives of payments made 'to the said Morgan for makinge workmanship and gravinge of the greate seale of Englond' (PRO E315/251 f.87v). 'Morgan' was Morgan Wolff, one of the king's goldsmiths.
Literature: A.B. Wyon and A. Wyon, *The Great Seals of England from the Earliest Period to the Present Time*, London, 1887, p.69, Pl. XIX (101).
London, Public Record Office

9. Henry VII silver groat (Fig. 24a)
First issue, 1485, London Royal Mint
The first issues of Henry VII's reign showed a young beardless head with a large foliated crown. The image of the facing bust was almost indistinguishable from images of earlier fifteenth-century kings.
Literature: Seaby 1990, p.139.
Museum of London

10. Henry VII silver groat (Fig. 24b)
Third issue, 1504, London Royal Mint
A major change in the representation of the king is seen on the silver groat of the third issue. A German die-striker, Alexander Bruchsal, was employed to make a new portrait of the king in profile. This bust was the first recognizable portrait of an English monarch to appear on a coin.
Literature: Seaby 1990, p.142.
Museum of London

11. Henry VIII silver half-groat (Fig. 24c)

First issue, 1509–26, Canterbury Mint
The first issues of Henry VIII's reign reused the dies from the latter part of the reign of Henry VII. Although this seems strange today, at the time the novelty of the profile bust would have made the economy of reusing his father's profile seem perfectly natural.
Literature: Seaby 1990, p.148.
Museum of London

12. Henry VIII silver groat (Fig. 24d)
Third issue, 1543, London Royal Mint
The bust of the king is shown three-quarters facing, crowned, bearded and wearing a mantle with a fur collar. The portrait of Henry on the coins of later issues followed the pattern of images in other art forms – compare, for instance, Figs. 28, 31.
Literature: Seaby 1990, p.151.
Museum of London

13. Henry VIII gold half-sovereign (Fig. 24e)
Fourth or fifth issue, 1544–7, London Royal Mint
The figure of the king is enthroned holding a sceptre and orb; at his feet is a Tudor rose. The image can be closely compared to that on the Great Seal (Fig. 28) and to Holbein's miniature *Solomon and the Queen of Sheba* (Fig. 19). In all three instances the king adopts a more aggressive and realistic pose than in earlier depictions.
Literature: Seaby 1990, p.147.
Museum of London

14. Remigius van Leemput (d. 1675) after Hans Holbein the Younger
The Whitehall Mural (Henry VII, Elizabeth of York, Henry VIII and Jane Seymour) (Fig. 15)
1667. Oil on canvas, 88.9 x 98.7 cm
A copy commissioned by Charles II in 1667 of the mural painted by Hans Holbein the Younger in 1537 for Henry VIII's privy chamber in Whitehall Palace. The mural was destroyed in the fire of 1698, but was already showing signs of deterioration before that date. The

cartoon by Holbein for the figures on the left side of the composition is in the National Portrait Gallery, London (Fig. 14). The inscription in the centre refers to the equal significance that should be attached to the achievements of both Henry VII and Henry VIII: the former bringing peace after the Wars of the Roses and the latter initiating the Reformation. The likenesses of Henry VII and Elizabeth of York are based on standard portraits, whilst that of Jane Seymour is dependent on Holbein's own earlier portrait now in Vienna (Fig. 70). The pose of Henry VIII became the standard image of the king and was frequently repeated (see Cat. No. 1). Leemput was employed by Charles II principally as a copyist.
Literature: Millar 1963, No. 216; *Kings and Queens*, exhibition catalogue, Buckingham Palace, The Queen's Gallery, 1982–3, No. 5.
Her Majesty Queen Elizabeth II (Hampton Court)

15. Girolamo da Treviso the Younger (c.1497–1544)
The Four Evangelists Stoning the Pope (Fig. 54)
c.1540. Oil on oak panel, 68 x 84.4 cm
This work was painted in *grisaille* heightened in places with gold, and is best described as a Protestant allegory. It dates from the years when the artist was employed by Henry VIII (1538–44). The four Evangelists are labelled. On the ground with the Pope are two women, also labelled, personifying Avarice and Hypocrisy. The city in the background is probably identifiable as Jerusalem. The candle over the city may refer to the true light of the Gospels, whereas the extinguished candle under the cauldron in the foreground may signify the false light associated with Roman doctrine. The features of the Pope resemble those of Julius II (1503–13) but, in fact, chronologically this figure should be Paul III and so no specific identification may have been intended. The composition is partly based on a woodcut in the

Coverdale Bible, which contains three illustrations of stoning scenes (Leviticus XXIV, Numbers XV, and Joshua VII). The artist died at Boulogne on 10 September 1544, where he was working as a military engineer during the siege (see Fig. 62).
Literature: Shearman, *The Early Italian Pictures in the Collection of Her Majesty The Queen*, Cambridge, 1983, No. 115.
Her Majesty Queen Elizabeth II (Hampton Court)

16. Joos van Cleve (active 1511–1540/1)
Henry VIII (Fig. 95)
c.1535. Oil on panel, 72.4 x 58.6 cm
Inscribed on a scroll in Latin: 'Go ye into all the world, and preach the gospel to every creature' (Mark, XVI, 15). The same text occurs on the title-page of the Coverdale Bible of 1535 (Cat. No. 17, Fig. 25), which was designed by Hans Holbein the Younger and printed in Antwerp, where Joos van Cleve had re-established himself by 1535. On the grounds of style and costume the portrait dates from the mid-1530s, but how closely the scriptural reference allies the king to the publication of the Coverdale Bible is open to discussion. The artist is not recorded in England and therefore must have had recourse to a secondary source for the image of Henry VIII, who is here shown in a flattering light. The portrait was acquired in exchange by Charles I from the Earl of Arundel in 1624.
Literature: Campbell 1985, No. 16.
Her Majesty Queen Elizabeth II (Hampton Court)

17. Hans Holbein the Younger (1497/8–1543)
Title-page of the Coverdale Bible (Fig. 25)
1535. Folio 27.4 x 16.7 cm
The Coverdale Bible, although dedicated to Henry, never gained official sanction. Thomas Cromwell and Thomas Cranmer were almost certainly responsible for the Bible's eventual publication, and the fact that Holbein was asked to design the title-page places the

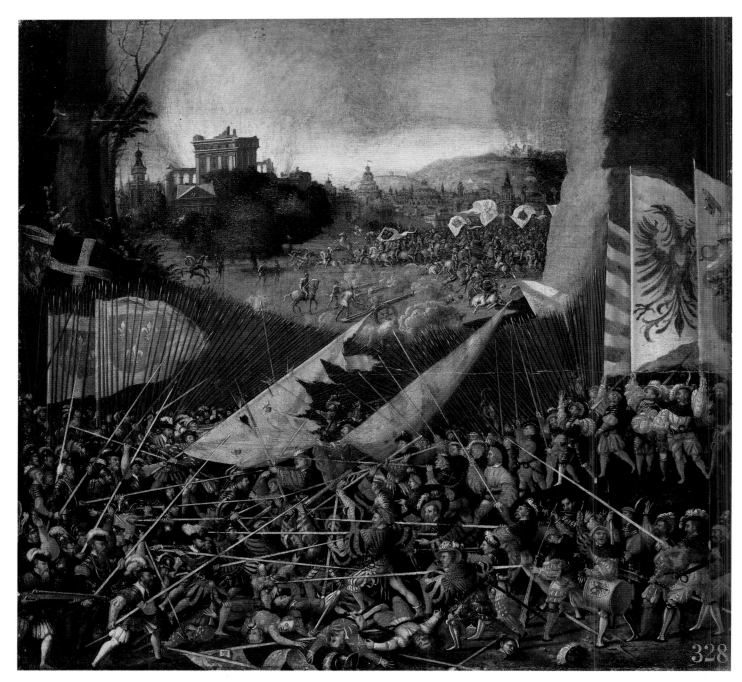

328

96. *The Battle of Pavia* by an unknown artist of the German
school. *c*.1530. Panel, 60.4 x 60.4 cm.
The Royal Collection. (Cat. No. 28)

97 (right). *Henry VIII* by an unknown artist. Late sixteenth
century. Canvas, 239.4 x 148 cm. The Royal Collection.
(Cat. No. 1)

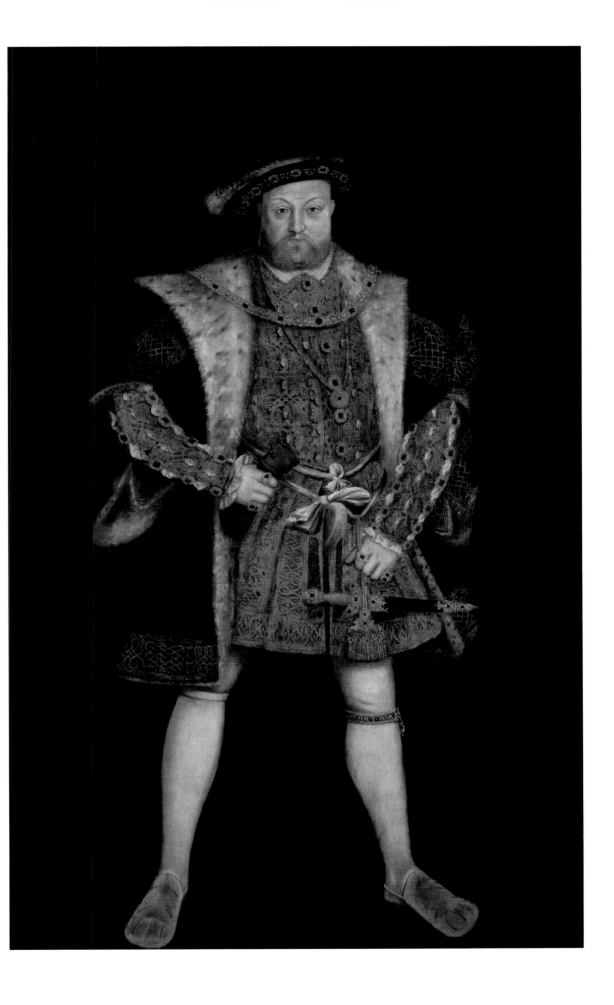

artist within the reformist circle at court. The image of the king appears not to be a portrait of Henry himself, but the iconography of the page clearly refers to Henry's new position as head of the English Church.
Literature: C. Dodgson, 'Woodcuts designed by Holbein for English Printers', *Walpole Society*, XXVII, 1938–9, pp.1–4.
London, Sion College Library

18. Unknown artist
Title-page of the Great Bible (Fig. 26)
1539. 35.5 x 24 cm
Unlike the Coverdale Bible, the title-page of the Great Bible was an officially approved image of Henry VIII. The portrait of the king is entirely recognizable and the iconography of the borders relates directly to the king's newly adopted role in the late 1530s. The artist responsible is not known, but there is clearly a debt to Holbein in both the image of the king and the figures that surround him.
Literature: J.N. King, *Tudor Royal Iconography*, Princeton, 1989, pp.70–4.
Her Majesty Queen Elizabeth II (Windsor Castle, The Royal Library)

19. Unknown artist
Allegory of the Reformation (Fig. 85)
From J. Foxe, *Actes and Monuments of Martyrs with a General Discourse of Later Persecutions horrible, troubles and Tumults, Stirred up by Romish Prelates in the Church...*, 9th edn., London, 1684
Engraving, 17.5 x 16.2 cm
The engraving is taken from the second volume of the ninth edition of Foxe's *Actes and Monuments*. It was originally produced for the second edition and specifically celebrates Henry's triumph over Pope Clement VII. The unhorsed pontiff is tended by Bishop Fisher and Cardinal Pole, while Henry delivers the Word of God to Cranmer and Cromwell. The imagery of this engraving combines the iconography of the biblical

title-pages (Figs. 25, 26) with anti-papal paintings such as Girolamo da Treviso's *The Four Evangelists Stoning the Pope* (Cat. No. 15, Fig. 54) and *Edward VI and the Pope* (Fig. 36).
Literature: J.N. King, *Tudor Royal Iconography*, Princeton, 1989, pp.158–63.
Her Majesty Queen Elizabeth II (Windsor Castle, The Royal Library)

20. Unknown artist
The Meeting of Henry VIII and the Emperor Maximilian I (Fig. 38)
c.1540. Oil on panel, 99.1 x 205.7 cm
The composition is divided horizontally into three sections: the meeting of Henry VIII and Maximilian I (foreground), the king and emperor with their infantrymen near an encampment (middle), and the Battle of the Spurs (above), with distant views of Thérouanne and Tournai. The style is predominantly Flemish. Comparison should be made with a woodcut of 1553 by Cornelis Anthoniszoon (Fig. 41). The painting is first recorded in the Royal Collection in an inventory of 1549–50. The cannons shown at the edges of the composition may be four of the artillery pieces known as the Twelve Apostles, which were taken on the campaign of 1513 (see pp. 48–9 above).
Literature: Millar 1963, No. 22.
Her Majesty Queen Elizabeth II (Hampton Court)

21. Unknown artist
The Battle of the Spurs (Fig. 40)
c.1545. Oil on canvas, 131.4 x 263.5 cm
Inscribed by a later hand: *The Bataile of Spurrs. anno. 1513*
The style of this painting is perhaps more Italian than Flemish. As with Cat. No. 20, comparison should be made with a woodcut of 1553 (Fig. 41), which depicts the siege of Thérouanne on the occasion of the Battle of the Spurs. Significantly, Hans Holbein the Younger is documented in 1527 as having painted this subject as part of the temporary decorations for the

celebrations at Greenwich marking the ratification of a treaty between France and England. No record of Holbein's composition has been identified, but it is known that his painting was displayed on one side of a triumphal arch, in a dual-purpose building dividing a banqueting area from a stage (J. Rowlands, *Holbein: The Paintings of Hans Holbein the Younger*, Oxford, 1985, p.223). For a detailed account of the restoration of this painting see pp.124–6.
Literature: Millar 1963, No. 23.
Her Majesty Queen Elizabeth II (Hampton Court)

22. Unknown artist
The Embarkation of Henry VIII at Dover (title-page, Figs. 43, 44)
c.1545. Oil on canvas, 168.9 x 346.7 cm
The painting shows the harbour at Dover, with two forts (the Archcliff and the Black Bulwarks) in the foreground. Dover Castle is shown in the upper left corner and the coast of France is in the far distance on the right. Henry VIII can be seen aboard the *Henri Grace-de-Dieu*, which appears in the right half of the composition equipped with golden sails. Clearly more than one hand worked on this painting: the figures in the foreground appear to be by a Flemish artist, while the figures on the larger vessels may be by an English artist. The painting seems to have been first recorded in the Royal Collection in 1588–9. It was cleaned and restored in 1988–90. See pp. 49–52 above.
Literature: Millar 1963, No. 24.
Her Majesty Queen Elizabeth II (Hampton Court)

23. Unknown artist
The Field of the Cloth of Gold (Figs. 48, 65, 66)
c.1545. Oil on canvas, 168.9 x 347.3 cm
The composition records several events that took place during the meeting of Henry VIII and Francis I at the Field of the Cloth of Gold in France in 1520. On the left the English king is seen arriving at the town of Guisnes, while the right

foreground is dominated by the elaborate palace specially created for the English entourage. In the centre foreground is depicted the meeting of the two monarchs and in the upper right corner there is a large tournament field. As with *The Embarkation of Henry VIII* at Dover (Cat. No. 22), there is a division of labour in the painting. The figures in the right foreground are related in style to those in the foreground of *The Embarkation*. The smaller figures in the left foreground and in the background are not dissimilar to those on the large vessels in *The Embarkation* and may be by an English artist. The painting seems to have been first recorded in the Royal Collection in 1588–9. See pp. 52–4 above.
Literature: Millar 1963, No. 25; S. Anglo, 'The Hampton Court Painting of the Field of the Cloth of Gold considered as an Historical Document', *Antiquaries Journal*, XLVI, 1966, pp.287–307; J.G. Russell, *The Field of the Cloth of Gold*, London, 1969.
Her Majesty Queen Elizabeth II (Hampton Court)

24, 25, 26. James Basire (1730–1802)
The Departure of Henry VIII from Calais (Fig. 59)
1788. Engraving, 59 x 90.5 cm
The Encampment of Henry VIII at Marquison (Fig. 60)
1788. Engraving, 59.5 x 46.5 cm
The Siege of Boulogne (Fig. 62)
1788. Engraving, 65.7 x 169.3 cm
Each inscribed with the full title in the lower margin and below the composition *Drawn from the original by S.H. Grimm* (left) and *Engraved by James Basire 1788* (right)
The prints were made after a mural once in the Dining Parlour at Cowdray House, subsequently lost in the fire of 1793. They were published by the Society of Antiquaries in 1788. See pp. 54–6 above.
Literature: Ayloffe 1776, pp.239–72; St. John Hope 1919, pp.36–59.
Her Majesty Queen Elizabeth II

(Windsor Castle, The Royal Library)

27. James Basire (1730–1802)
The Encampment of Henry VIII at Portsmouth (Fig. 37)
1778. Engraving, 58.9 x 188 cm
Inscribed with the full title on the lower margin and below on the right *Engraved by James Basire*
The print was made in 1778 from a drawing by Charles Sherwin after a\mural once in the Dining Parlour at Cowdray House, subsequently lost in the fire of 1793. It was published by the Society of Antiquaries at an earlier date than the rest of the series (Cat. Nos. 24–6). See p.56 above.
Literature: Ayloffe 1776, pp.239–72; St. John Hope 1919, pp.36–59; Evans 1956, p.161; M. Rule, *The Mary Rose. The Excavation and Raising of Henry VIII's Flagship*, 2nd edn., London, 1983, pp.32–3.
Her Majesty Queen Elizabeth II (Windsor Castle, The Royal Library)

28. Unknown artist, German school
The Battle of Pavia (Fig. 96)
c.1530. Oil on panel, 60.4 x 60.4 cm
The Battle of Pavia was fought on 24 February 1525 following the invasion of Italy by Francis I. The French had hoped to capture Pavia before moving on to Milan, but the imperial army intervened and defeated the invasion force, capturing Francis I. The French are on the left of the painting, identifiable by the fleur-de-lis on their standards, while the imperial troops on the right carry standards emblazoned with the Habsburg eagle. Pavia is shown in the background. The painting formed part of the collection of Henry, Prince of Wales (1594–1612), the elder brother of Charles I. The Battle of Pavia was frequently represented by Flemish, French and German artists, but few paintings were based on exact knowledge of the location.
Her Majesty Queen Elizabeth II (Hampton Court)

29. Hans Holbein the Younger (1497/8–1543)
Henry VIII (Fig. 69)
c.1536. Oil on oak panel, 28 x 20 cm
The portrait is discussed in the text, pp. 69–76. It was acquired by Robert Spencer, 2nd Duke of Sunderland (1641–1702), and recorded in inventories of the Spencer collection in 1746, 1750 and 1802 (K.J. Garlick, 'A Catalogue of Pictures at Althorp', *Walpole Society*, XLV, 1974–6, pp.96, Nos. 71, 114 and 122 respectively). The portrait was acquired in 1934 by Baron Heinrich Thyssen (1875–1947), the founder of the Thyssen-Bornemisza collection. The painting is surrounded by what is known as a Sunderland frame, specially chosen by Robert Spencer for many of his pictures.
Literature: *The Thyssen-Bornemisza Collection*, Lugano, 1969, No.136, pp.155–6; Strong Portraits, p.158; J. Roberts, *Holbein*, London, 1979, pp.17 and 90; J. Rowlands, *Holbein: The Paintings of Hans Holbein the Younger*, Oxford, 1985, p.144, No. 61.
Lugano, Thyssen-Bornemisza Collection

30. After Joos van Cleve (active 1511–d. 1540/1)
Francis I (Fig. 76)
c.1530–4. Oil on panel, 37.5 x 31.7 cm
There are numerous versions of this portrait of Francis I (1494–1547), most probably derived from one or more prototypes painted by Joos van Cleve while he was at the French court (*c*.1529–4). Although not by Joos van Cleve's own hand, the quality is reasonable. The portrait seems to have been first recorded in the Royal Collection in the inventory of 1547.
Literature: Campbell 1985, No. 19.
Her Majesty Queen Elizabeth II (Windsor Castle)

31. Joos van Cleve (active 1511–d. 1540/1)
Eleanora of Austria (Fig. 77)
c.1530–4. Oil on panel,

71.4 x 58.7 cm
A very similar, but smaller, portrait of the same sitter is in Vienna and appears to have been painted after the present portrait, but both are autograph. Eleanora of Austria (1498–1558) was the sister of Charles V. She first married Emmanuel, King of Portugal, and subsequently married Francis I. After the French king's death in 1547 she remained in the Netherlands before returning to spend the rest of her life in Spain. The portrait was no doubt painted in France. Several other versions are known. The inscription on the letter is in Spanish.
Literature: Campbell 1985, No. 15.
Her Majesty Queen Elizabeth II (Hampton Court)

32. Unknown artist
Elizabeth I with a Feather Fan (Fig. 80)
c.1585. Oil on panel, 57.2 x 43.8 cm
A version of a well-known likeness of Elizabeth I painted during the early 1580s. The artist is either English or Anglo-Netherlandish. The queen was famous for her elegant hands and auburn hair, which, together with the form of her dress and jewellery, gave her appearance great distinction.
Literature: Millar 1963, No. 47; R. Strong, *Portrait of Queen Elizabeth I*, Oxford, 1963, p.69.
Her Majesty Queen Elizabeth II (Hampton Court)

33. Attributed to Marcus Gheeraedts the Younger (active *c*.1561–d.1635)
Unknown Woman in a Masque Costume (Fig. 57)
c.1590–1600. Oil on canvas, 217 x 135.3 cm
There are three inscriptions in Latin attached to the tree on the left and a sonnet in English in the cartouche in the lower right corner. The portrait is first recorded in the Royal Collection during the reign of Queen Anne, but there is evidence that it was owned by Charles I and so it may even have been in the collection before his reign. The sitter has previously been identified incorrectly as

Elizabeth I or Lady Arabella Stuart. Strong suggests a date of *c*.1590–1600. Similar inscriptions are found on other portraits that date from the last decade of the sixteenth century and which are also associated with the artist.
Literature: Millar 1960, No. 87; Strong Icon, 1969, p.288, No. 284.
Her Majesty Queen Elizabeth II (Hampton Court)

34. Attributed to Lucas Hornebolte (*c*.1490/5–1544)
Henry VIII (Fig. 98)
c.1525. Watercolour on vellum, diameter 4 cm
Inscribed *REX HENRICUS OCTAVVS*
The artist, originally from Flanders and from a family of miniature painters, is first recorded in Henry VIII's service in 1525. It is likely that he instructed Hans Holbein the Younger in the art of miniature painting. An important group of miniatures in the Flemish style most probably by Hornebolte is known, one of which (Fitzwilliam Museum) is a finer version of the present minature and where the king's age is given as thirty-five. Hornebolte's image is therefore an approved likeness of Henry VIII before the iconography established by Holbein.
Literature: Strong 1983, p.189 (No. 2).
Her Majesty Queen Elizabeth II (Windsor Castle)

35. Attributed to Lucas Hornebolte (*c*.1490/5–1544)
Henry VIII (Fig. 99)
c.1525. Watercolour on vellum, diameter 4.7 cm
Inscribed *H.R.VIII:ANo:ETATIS.XXXVo*
The king's age as inscribed on the miniature is the same as that shown on the important example in the Fitzwilliam Museum, Cambridge, to which Cat. No. 34 is also related. However, here the king is shown bearded. This group of miniatures is now regarded as the work of Lucas Hornebolte. Another example depicting the king is in the collection of the Duke of Buccleuch. This is close to Cat. No.

34 and also records the king's age as thirty-five. These miniatures of the king were given to Charles I by the 2nd Earl of Suffolk: only two remain in the Royal Collection.
Literature: Strong 1983, pp.34 and 189 (No. 4).
Her Majesty Queen Elizabeth II (Windsor Castle)

36. After Hans Holbein the Younger *Henry VIII* (Fig. 100)
Sixteenth century. Watercolour on vellum, diameter 3.6 cm
The likeness is derived from the image of the king in *The Whitehall Mural* (see Cat. No. 14, Fig. 15). Although painted copies of the figure are fairly common, they are less frequently found in miniature.
Her Majesty Queen Elizabeth II (Windsor Castle, The Royal Library)

37. Unknown artist
Henry VIII (Fig. 91)
c.1550–75. Stone medallion carved in relief with traces of gesso and pigment, diameter (excluding frame) 37.7 cm
The likeness of the king conforms with the iconography developed by Hans Holbein the Younger in *The Whitehall Mural* (Cat. No. 14, Fig. 15). The early history of the relief is not known. The frame is of a later date.
Her Majesty Queen Elizabeth II (Hampton Court)

38. George Vertue (1683–1756)
Copy after *The Whitehall Mural* by Remigius van Leemput (after Hans Holbein the Younger) (Fig. 92)
1737. Pen and watercolour with gouache, 45.7 x 57.3 cm
Signed and dated *Ao.Dmi.1737 f. G. Vertue Londni*
This drawing is copied after the painting by Remigius van Leemput, Cat. No. 14, Fig. 15. It was subsequently engraved by Vertue.
Literature: A.P. Oppé, *English Drawings. Stuart and Georgian Periods in the Collection of His Majesty the King at Windsor Castle*, London, 1950, No. 625.
Her Majesty Queen Elizabeth II (Windsor Castle, The Royal Library)

39. Edward Edwards (1738–1806)
Copy after *The Field of the Cloth of Gold* by an unknown artist (Fig. 73)
1771. Watercolour over pencil, 60 x 119.5 cm
Inscribed *Size of the Original Picture 11 feet 3 by 5 feet 6* (centre), signed and dated *E. Edwards 1771* (right)
The artist was a follower of Paul Sandby. He worked for John Boydell and also made drawings for Horace Walpole and made designs for the theatre. Eventually, he was appointed to the Chair of Perspective at the Royal Academy (1788). The drawing was commissioned in 1771 by the Society of Antiquaries, and it was subsequently presented to George III. The engraving made from it was published in 1774. The commissioning of this print was of some consequence, since a paper of suitable dimensions had to be specially made for the Society of Antiquaries. This was achieved by James Whatman, who produced a size of paper that was subsequently referred to as Antiquarian and which for more than a century was the largest sheet of drawing or book paper ever made in England (Evans 1956, pp.160–1). Several other prints commissioned by the Society of Antiquaries during the 1770s and 1780s were on a similar scale (Cat. Nos. 26–7).
Her Majesty Queen Elizabeth II (Windsor Castle, The Royal Library)

40. Samuel Hieronymous Grimm (1733–94)
Copy after *The Embarkation of Henry VIII at Dover* by an unknown artist (Fig. 90)
1779. Watercolour over pencil, 76.4 x 136.2 cm
Born in Switzerland, Grimm lived in France before coming to England in 1768. He was principally a topographical artist, but he also made drawings for Gilbert White's *Natural History* and for numerous antiquarians. His skills extended to caricatures, and he also produced illustrations to Shakespeare. This drawing after the

painting (Cat. no. 22, title-page, Figs. 43, 44) was commissioned in 1779 by the Society of Antiquaries. It was engraved by James Basire and published in 1781. Grimm was frequently employed as a copyist by the Society (see, for example, Cat. Nos. 24–6 and 41).
London, Society of Antiquaries

41. Samuel Hieronymous Grimm (1733–94)
The Coronation Procession of Edward VI (Fig. 39)
1785. Watercolour over pencil, 75.4 x 152.2 cm
Henry VIII died on 28 January 1547 and the coronation of Edward VI (aged nine) took place on Sunday 20 February. The procession was held on the previous day, beginning at the Tower of London and ending at Westminster. It was punctuated by pageants, speeches and music, mostly based on those devised for the coronation of the ten-year-old Henry VI in 1432. There had been little time for preparation, and great reliance was placed on precedent. The result was a 'totally undistinguished royal entry into London – perhaps the most tawdry on record' (S. Anglo, *Spectacle, Pageantry, and Early Tudor Policy*, Oxford, 1969, pp.281–94). The drawing was made after a mural once in the Dining Parlour at Cowdray House and was engraved by James Basire for the Society of Antiquaries. The engraving was published in 1788.
Literature: Ayloffe 1776, pp.239–72; St. John Hope 1919, pp.36–59.
London, Society of Antiquaries

42. James Stephanoff (*c*.1786–1874)
The Banquet (Fig. 79)
1832. Watercolour and gum arabic, 56 x 71 cm
Signed and dated *J. Stephanoff 1832*
The artist was primarily a history painter, but he also executed literary and religious scenes, and specialized in depicting incidents from the lives of artists. He collaborated in a large rendering of the *Coronation of George IV*. All

his work was in watercolour. He was appointed Historical Painter in Watercolour to William IV in 1830 and contributed several illustrations to W.H. Pyne's *The History of the Royal Residences* (1819). The drawing illustrates the meeting of Henry VIII and Anne Boleyn at Cardinal Wolsey's residence in London (York Place, later Whitehall Palace) and may have been inspired by a scene in Shakespeare's *Henry VIII* (Act I, scene IV).
Her Majesty Queen Elizabeth II (Windsor Castle, The Royal Library)

43. Joseph Nash (1809–78)
Bay Window in the Gallery, Hever Castle, Kent (Fig. 93)
From *The Mansions of England in the Olden Time*, 2nd series, published by T. Mclean, 26 Haymarket, London, 1840
Lithograph, 27.5 x 40.5 cm
The book was issued without text in four series between 1839 and 1849. The two illustrations of Hever Castle were included in the second series. A text was supplied for the second edition (1869–72) and further editions of this popular work followed in 1906 (see Cat. No. 44) and 1912.
The London Library

44. Joseph Nash (1809–78)
Hever Castle, Kent (Fig. 87)
From *The Mansions of England in the Olden Time*, new edn., Special Winter Number of *The Studio*, London, Paris, New York, 1906. Edited by Charles Holme with an introduction by C. Harrison-Townsend.
Photogravure, 14 x 19 cm
This is Plate L1 of a later popular edition of Nash's work, which was reduced in scale and also in quality of finish.
Private collection

 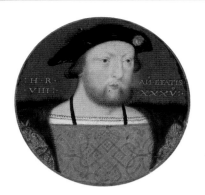

98. *Henry VIII* by
Lucas Hornebolte. *c*.1525. Watercolour on
vellum, diameter 4 cm. Windsor Castle,
The Royal Library. (Cat. No. 34)

99. *Henry VIII* by
Lucas Hornebolte. *c*.1525. Watercolour on
vellum, diameter 4.7 cm. Windsor Castle,
The Royal Library. (Cat. No. 35)

100. *Henry VIII* after
Hans Holbein the Younger. *c*.1550. Vellum,
diameter 3.6 cm. Windsor Castle,
The Royal Library. (Cat. No. 36)

FURTHER READING

RD Altick. *Paintings from Books, Art and Literature in Britain 1760-1900*. Columbus, 1985.
S Anglo. *Images of Tudor Kingship*. London, 1992.
S Anglo. *Spectacle, Pageantry and Early Tudor Policy*. Oxford, 1969.
E Auerbach. *Tudor Artists*. London, 1954.
FL van Baumer. *The Early Tudor Theory of Kingship*. New Haven, 1940.
L Campbell. *Renaissance Portraits. European Portrait Painting in the 14th, 15th and 16th Centuries*. London and New Haven, 1990.
SB Chrimes. *Henry VII*. London, 1972.
HM Colvin. *The History of the King's Works*. Vol IV. London, 1982.
AG Dickens. *The English Reformation*. London, 1964.
P Gwyn. *The King's Cardinal. The Rise and Fall of Thomas Wolsey*. London, 1990.
F Hepburn. *Portraits of the Later Plantagenets*. Woodbridge, 1986.
JN King. *Tudor Royal Iconography*. Princeton, 1989.
M Levey. *Painting at Court*. New York, 1971.
O Millar. *Holbein and the Court of Henry VIII*. Exhibition catalogue. Buckingham Palace, The Queen's Gallery, 1978.
O Millar. *The Queen's Pictures*. London, 1977.
J Pope-Hennessy. *The Portrait in the Renaissance*. London, 1966.
J Roberts. *Holbein*. London, 1979.
J Rowlands. *Hans Holbein: The Paintings of Hans Holbein the Younger*. Oxford, 1985.
J Scarisbrick. *Henry VIII*. London, 1981.
D Starkey, ed. *Henry VIII: A European Court in England*. London, 1991.
D Starkey. *The Reign of Henry VIII, Personalities and Politics*. London, 1985.

R Strong. *The English Icon: Elizabethan and Jacobean Portraiture*. London and New York, 1969.
R Strong. *The English Renaissance Miniature*. London, 1983.
R Strong. *Gloriana, the Portraits of Queen Elizabeth I*. London, 1987.
R Strong. *Holbein and Henry VIII*. London, 1967.
S Thurley. *The Royal Palaces of Tudor England*. New Haven, 1993.
EK Waterhouse. *Painting in Britain 1530 to 1790*. Harmondsworth, 1962.
FA Yates. *Astrea: The Imperial Theme in the Sixteenth Century*. London, 1975.
WG Zeeveld. *Foundations of Tudor Policy*. London, 1948.

PHOTOGRAPHIC ACKNOWLEDGEMENTS

The works in the Royal Collection are reproduced by Gracious Permission of Her Majesty the Queen.
The publishers wish to thank all museums, institutions and individuals who have contributed towards the reproductions in this book. Further acknowledgement is made to the following: British Museum: 20 (BM Royal MS2A fol. 3), 21 (fol. 30), 22 (fol. 79), 23 (fol. 16), 83 (Inv. 1854-6-28-74); Cambridge, Masters and Fellows of Corpus Christi College: 29 (MS20 fol. 68r); Cambridge, Masters and Fellows of Trinity College: 12; English Heritage: 2, 8, 34; Dr John Gregg: 64; London, National Portrait Gallery: 4, 14, 36, 81; Public Record Office: 30 (PRO.KB27/1024), 31 (PRO.KB27/1130); By kind permission of Sudeley Castle, Gloucestershire: 55.

APPENDIX

The Restoration of 'The Battle of the Spurs'

Ian McClure and Renate Woudhuysen-Keller

The painting (see Fig. 40, and Fig. i below) was not damaged by fire or smoke in the Hampton Court Palace fire of 1986, but water from fire hoses caused severe blanching of the varnish and flaking of the paint layer. The water also made the glue-paste of the existing lining swell, creating buckles and ripples. The tension across the canvas increased, causing the substantial wooden stretcher to twist under the strain.

After removing the deteriorated layer of varnish, it became clear that the painting was extensively overpainted. Under the several layers of later paint, areas of the original paint were cupped and distorted. A filling had been applied over these areas during an early restoration some time in the seventeenth century, to smooth them out before the picture was repainted. This filling now had to be removed, together with all later restoration, before the painting could be relined. Otherwise the original paint would be held in its distorted position by the restoration under way at present.

An X-ray detail (Fig. ii) of the left side of the painting shows the extensive network of damages. It also shows the whitish halo of filling around each sharply defined loss obscuring

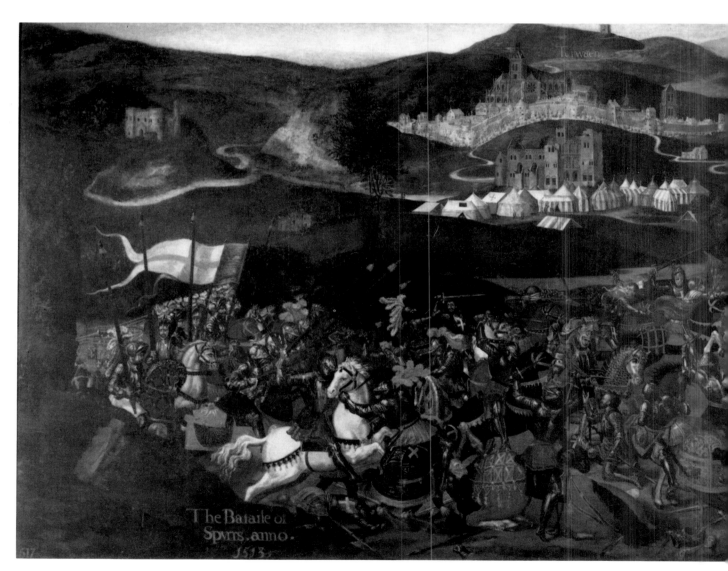

i

original paint. Details before (Fig. iii) and after removal of overpaint and putty (Figs. iv and v) show that the original paint is in good condition in many places. The most dramatic gain is in the landscape background, top right (Figs. vi, vii and viii).

It has emerged that the painting has undergone three quite separate campaigns of restoration by filling and repainting. Although further examination is necessary, it is likely that these restorations were undertaken before 1725. This is suggested by the absence of Prussian blue from the pigments used for restoration,[1] and the use of lead-tin yellow, a pigment which was increasingly rarely used after the middle of the eighteenth century. The present lining dates from the middle of the nineteenth century.

The first restoration involved the application of a light grey putty, mainly lead white with other small quantities of pigment, to large losses in the background, directly onto the herring-bone woven canvas and over areas of cupped original paint. It was applied with more care to losses in the foreground, where the details of the battle-scene would be irksome to repaint. A thin green glaze was applied over the landscape as well as a lead-tin yellow layer in the sky. The grey putty has proved extremely difficult to remove, due in part to its firm adherence to a relatively young paint film.

The second, yellow, putty was applied more precisely, principally to a series of vertical losses, caused most probably by the painting being rolled and then crushed. The repainting was also a precise colour match, but was applied thickly and extensively over the landscape, sky and banners. The third

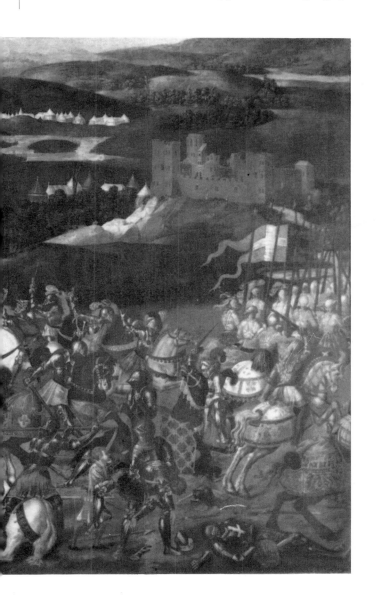

ii

iii

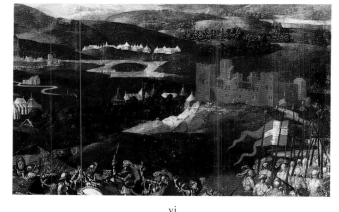

vi

iv

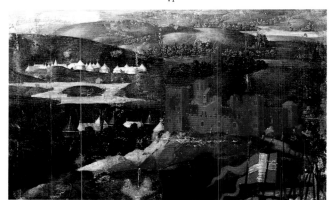

vii

viii

putty layer, almost the colour of the original grey ground, had been applied to areas of flaking paint and had been retouched locally.

A description of the materials and technique of the painting will be published in the future. Despite the fairly extensive damage and loss, large areas of hitherto hidden original paint will be recovered during the present conservation programme, revealing the true quality of the painting, which in 1613 was described by the Duke of Saxe-Weimar as 'a beautiful picture'.

1. The method of producing Prussian blue was first published in England in 1724 in Philosophical Transactions, by Woodward. See R.D. Harley, *Artists' Pigments*, 1600–1835, London, 1970, 2nd edn., 1982, pp.70–4.

v